14 JUL 2014

2 6 APR 2019

D1427124

30128 80052 395 6

Blackwell Manifestos

In this new series major critics make timely interventions to address important concepts and subjects, including topics as diverse as, for example: Culture, Race, Religion, History, Society, Geography, Literature, Literary Theory, Shakespeare, Cinema, and Modernism. Written accessibly and with verve and spirit, these books follow no uniform prescription but set out to engage and challenge the broadest range of readers, from undergraduates to postgraduates, university teachers, and general readers – all those, in short, interested in ongoing debates and controversies in the humanities and social sciences.

Already Published

The Idea of Culture Terry Eagleton
21st-Century Modernism Marjorie Perloff
The Future of Theory Jean-Michel Rabaté
Inventing Popular Culture John Storey
Myths for the Masses Hanno Hardt
Provoking Democracy Caroline Levine
Living with Theory Vincent B. Leitch
Uses of Literature Rita Felski
The State of the Novel Dominic Head
In Defense of Reading Daniel R. Schwarz
The Myth of Popular Culture Perry Meisel
What Cinema Is! Andrew Dudley
A Future for Criticism Catherine Belsey
After the Fall Richard Gray
After Globalization Eric Cazdyn and Imre Szeman
Art Is Not What You Think It Is Donald Preziosi and Claire Farago
The Idea of Latin America Walter D. Mignolo

Art Is Not What You Think It Is

Donald Preziosi and Claire Farago

WILEY-BLACKWELL

A John Wiley & Sons, Ltd., Publication

This edition first published 2012
2012 Blackwell Publishing Ltd

Blackwell Publishing was acquired by John Wiley & Sons in February 2007.
Blackwell's publishing program has been merged with Wiley's global Scientific,
Technical, and Medical business to form Wiley-Blackwell.

Registered Office
John Wiley & Sons Ltd, The Atrium, Southern Gate, Chichester, West Sussex, PO19
8SQ, UK

Editorial Offices
350 Main Street, Malden, MA 02148-5020, USA
9600 Garsington Road, Oxford, OX4 2DQ, UK
The Atrium, Southern Gate, Chichester, West Sussex, PO19 8SQ, UK

For details of our global editorial offices, for customer services, and for information
about how to apply for permission to reuse the copyright material in this book please
see our website at www.wiley.com/wiley-blackwell.

The right of Donald Preziosi and Claire Farago to be identified as the authors of this
work has been asserted in accordance with the UK Copyright, Designs and Patents
Act 1988.

Library of Congress Cataloging-in-Publication Data is available for this title
ISBN hardback: 9781405192408
ISBN paperback: 9781405192392

A catalogue record for this book is available from the British Library.

Set in 10.5/13 pt Minion by Toppan Best-set Premedia Limited
Printed in Singapore by Ho Printing Singapore Pte Ltd

1 2012

CONTENTS

LIST OF FIGURES

PREFACE

ART IS NOT WHAT YOU THINK IT IS

This book is made up of a linked series of incursions into the current state of discussions on the idea of art, and is published as a volume in Blackwell's "Manifesto" series of books. Our title – *Art Is Not What You Think It Is* – aims to make manifest what is largely *missing or unsaid* in recent debates about what art is said to be.

It is designed to provoke reconsiderations of many conventional assumptions widely shared today about the nature, uses, and fate of art, including some voiced in recent texts by prominent critics, historians, and theorists in a variety of fields. What frames this manifesto is what motivates most such declarations. These are, first, that current conventional wisdoms about a subject are unsatisfying and need direct addressing; secondly, that a concerted focus on what is *un*said requires careful articulation on multiple fronts; and, finally, that such an articulation necessarily forms the basis for the elaboration of new perspectives linked more substantively to wider horizons of intellectual and social progress. To put it succinctly, a manifesto is more reinvention than re-upholstery.

The chapters or "incursions" making up our volume bring to bear upon the very idea of art a variety of arguments drawn from multiple disciplinary sources and professional traditions: art history, aesthetics, cultural studies, philosophy, theology, anthropology, sociology, and so on in ever widening circles characteristic of modern life in the sense that Bruno Latour defines it in his essay "Crises," which

> looks at how the world is constructed of hybrids. Through the example of a newspaper, he explains how we are constantly making sense of multiples. As such, we translate these multiples into a strategic way of understanding within the boundaries or categories we are already familiar with. Latour

explains how in order to deconstruct this way of thinking we have to incor-
porate multiples into a more "collective" way of thinking. However, in doing
so, we have to understand the basis of the multiples as well, otherwise we are
neglecting their original form. Latour moves on to explain the basis for the
three "object domains" as being: naturalization or the real, socialization of
the collective, and deconstructive or narrative. When these domains cross
each other the result is Latour's idea of *translation*. Whereby naturalization
functions to extract concepts and project them on to a screen of knowledge
while socialization erases the politics on this screen to produce purity, and
while deconstruction undoes this purity to look beyond the screen to see the
real truth. At the end of the essay Latour poses the question: What happens
when we combine these forces in the modern? Why are we scared to do so?
Latour explains how "we remain suspended between belief and doubt"
because we believe the world has never been modern.[1]

The passage you have just read was written by one of our very capable
undergraduates in a course on the idea of art. It lucidly articulates much
of what is at stake in our project. Our chapters are not intended as exhaus-
tive historical accounts of discussions about art within or related to such
disciplinary interests. Instead they aim to foreground the necessary histori-
cal, critical, and theoretical linkages between such fields, as well as the
necessity of keeping the awareness of such relationships clear and alive for
the reader.

In that sense, this is a book for remembering or *manifesting* what has
been forgotten in what we think we know about art, so that, in reimagining
what we thought we knew, we may project a variety of ways forward beyond
the continual "turns" of disciplinary attention which increasingly resemble
the circularity of a carousel. Much of the work of this book is aimed at
reckoning with conundrums in the modern discourse on art, many of
which are the specific product of cultural and historical developments
peculiar to the European traditions of thought about art and its social,
cultural, political, philosophical, and religious functions.

A quick example comes to light in the subtext of a recent letter to the
editor of *The New York Times*, dated January 30, 2011, prefaced with
the heading "It's the Art that Matters":

To the Editor:
Deborah Solomon, reviewing Phoebe Hoban's biography of Alice Neel,
wonders "how a woman who was so narcissistic and needy became such an
empathetic chronicler of other lives" ("The Nonconformist," Jan. 2).

Redrawing the picture of Neel's life this way underlines a wrongheaded approach to her painting typical of postmodern art and criticism: hype the artist's personal foibles in place of her art. The answer to Solomon's misleading question is, of course, "because she was brilliantly talented." Neel's paintings are great because they were greatly painted, not because they are chronicles of personalities. She was a master of color, line, form, and composition, as well as an incisive translator of facial expression. It's about time she was recognized purely as a great painter, rather than treated as a handy object for prurience and voyeurism. She is still stereotyped as odd and outré simply because she was less inhibited than the average repressed, fashion-obsessed denizen of the New York art world.

The world is full of "narcissistic and needy" people, but such a state is clearly a motivation, to someone who is a highly talented and keen observer, to become an "empathetic chronicler of other lives."

Dana Gordon, New York

The conundrum manifest in the letter concerns the simultaneous connection and disconnection between (in this example) artistic talent and social empathy. The greatness of the artist is both linked to her (presumably content-less) professional talent *and* separate from her powers of observation: she's a ("purely") great painter (a master of color, line, and form, etc.) and not simply a keen observer and an "empathetic chronicler" of other lives. What is revealed in the writer's comments on what is portrayed as the reviewer's "redrawing the picture" of the artist's life (how and why is a life a "picture"?) is precisely what is obscured in these oscillations: the *assumed* independence of the elements in the equation. Not unlike those staples of academic artistic analysis *form* and *content*, or matter and spirit.

However, these distinctions are no mere abstract categories resulting from dispassionate scientific analysis, but represent distinctions that, within a particular historical tradition, are congruent with long-standing and deeply entrenched debates over the social roles and responsibilities of the artist and of art-making practices. What was at stake in European debates for many centuries beginning deep within the Christian tradition was the relationship of an artwork made by human hands to some "higher" form of truth. Let us say this clearly: our modern, secular discourse emerges from a Christian context that contemporary discussions of art ignore because they trace the roots of the discourse on art only to Kant and to the European classification of the fine arts that emerged in the eighteenth century, often gesturing to sixteenth- and seventeenth-century sources of these ideas but largely ignoring the broadly religious context in which even ancient sources

were embedded in the Early Modern discourse. Religious theories of images have been considered irrelevant largely because we have mined the history for ideas that are recognizably modern.

What difference does it make to look back a century before Enlightenment thinkers established the modern system of the arts on European terms? We attempt in this short book to understand the structural logic of our inherited, initially European, understanding of art and aesthetic response. Our provocation, partly a historical argument, partly a critical intervention, participates in ongoing reconsiderations elsewhere of what secularity is – on what grounds have distinctions between the religious and the secular spheres been posited? And it is important to emphasize that we approach the problem on *historical* grounds – we have no desire to establish a *new* ontology of art. Our aim is to identify and come to terms with the ontological apparatus that we have inherited.

This is no trivial matter on many levels, particularly in the so-called Western tradition, where the very idea of divinity itself is linked to the idea of artifice, the universe itself pictured by many as the artifact of a divine artificer. One recent research initiative by two historians of Renaissance art closely resonates with our *logic of the index* argument. Christopher Wood and Alexander Nagel have developed a thesis about what they call the "principle of substitution" to explain the referential authority of a given work of art to its predecessors in a chain leading to a point of origin.[2]

The interest in the *indexicality* of things, envisioned as a direct relationship between a sign and its referent, is long-standing in the field of art history and elsewhere. Some of the most influential accounts of the history of art have been offered as histories of style based on such a model. Since the mid-1970s, traditional notions of "style" have been replaced in some quarters by discussion of the ontology of work of art modeled on the photographic image as a physical imprint. As philosopher Roland Barthes argued the case, the photograph imprints the order of the natural world onto the photographic emulsion, subsequently onto the photographic print, giving the photograph its documentary status and undeniable veracity. Yet at the same time, this transfer or trace, being a literal manifestation of the world itself, is fundamentally uncoded, a "message without a code." Rosalind Krauss argued in widely influential terms that the same logic of the index that necessarily governs the photograph governs the contemporary production of much abstract and conceptual art. The fundamental problem that Modernism since Marcel Duchamp's early twentieth-century *Readymades* articulates is the opacity of the image in relationship to its

meaning.[3] In their own application of the principle of indexicality, Nagel and Wood offer an alternative account grounded in a different sense of historical time from the linear conception of time as succession that enables most histories of style. What all these lines of investigation share is the ontology of indexicality itself discussed in strictly material and structural terms.

Why is indexicality so insistent in our accounts of art? We are interested in opening up the discussion of aesthetics by identifying the "logic of the index" in its many strategic manifestations as they bear upon the *historical* idea of art. The point is how these historical ideas of art inform contemporary concerns. Our own discussions below focus on the ontological claims made for Christian sacred objects and images, and our project follows the historical consequences of this ontology. The relic is the most sacred kind of Christian object in a hierarchy ordered according to proximity to the divine. The single main purpose of locating the power of a relic in the divine is to establish its truth – that is, its manifestation of the truth of the central Christine doctrine of salvation. The miracle-working power of a relic attests to the Christian promise that eternal life would be bestowed upon those who are worthy of God's grace. On what grounds grace is to be bestowed has been the subject of intense negotiations throughout history, and especially in sixteenth-century western Europe (where both our project and Wood and Nagel's are situated).

In the case of a relic, the sign and its divine referent are identical, contained in the same object. The truth of an image made without human intervention, such as the Shroud of Turin, which is a contact relic, also depends on its direct contact with the divine. Its truth is construed according to the logic of indexicality: the image is made when the shroud, a material of human manufacture, comes into direct contact with the divine. Our book explores how giving the human artist independent status in making sacred representations is problematic because it calls into question the truth of the manufactured object or image. For what guarantees the truth of an object or image made by human hands, given human fallibility?

Bridging this gap between human and divine agency is the subject of extensive theological writings about art well before and during the Early Modern era when the status of the artist rose to new heights. Wood and Nagel hypothesize that the model of referentiality was created in response to "theological doubts about the image."[4] At points in their argument, they also claim that the artist was unimportant, or that novelty was thought

impossible, and that "the referential authority of the relic or cult image is never explained," or that its authority was "mythical," "magical," a "theological riddle," or even "a sample of a vanished lifeworld."[5]

To take this position is to doubt Christianity's central claims about the ontology of sacred objects and images. To suggest that the Catholic Church, its theologians, and its lay practitioners did not believe in the divine authority of relics and authentic cult images, or to suggest that this authority was left unexplained or was due to magical thinking, is to disregard a very considerable body of evidence on Christian thought. One of our main purposes for writing the present book has been to articulate the consequences of attending to the Christian ontology of images at the European roots of modern ideas of art. We argue that the religious underpinnings of our modern, secular notions of art deserve attention. We argue, to put this in the briefest, starkest possible terms, that the "logic of the index" originating in the Christian hierarchy of sacred objects governs historical ideas of the truthfulness of artifice.

What are the consequences of ignoring those Christian sources? The most significant of these is to take as literal Romanticist beliefs about the artist as a unique poet/genius and the sole agent of his self-expression, and about secularity as a freeing of the shackles of orthodox religion, an attempt to make a clearing in a space impossible to comprehend anymore. Secularization was to be a kind of truce. The brilliant move was to substitute the notion of artistry for the religious. Napoleon "liberated" objects so that citizens of the new republic could appreciate their artistic value as part and parcel of French patrimony/patriarchy – an aesthetic as well as political cleansing.[6] The result was to deflect attention away from the religious context of sacred artifacts – freeing the material art from its connections with either Protestant or Catholic arguments for their significance. Art with a capital A was the invention that made secularity possible. As Napoleon strategically understood.

Notes

1 Alexandria Heine, "Visuality in Our Lives," blog assignment for Nov. 26, 2010, Critical Issues in Art History, University of Colorado, citing Bruno Latour, "Crisis," in *We Have Never Been Modern*, trans. Catherine Porter (Cambridge, MA: Harvard University Press, 1993), 1–12.

2 Alexander Nagel and Christopher S. Wood, "Toward a New Model of Renaissance Anachronism," *Art Bulletin* 87 (2005): 403–432, with responses by Michael Cole, Charles Dempsey, and Claire Farago; Christopher S. Wood, *Forgery, Replica, Fiction: Termporalities of German Renaissance Art* (Chicago: University of Chicago Press, 2008); Alexander Nagel and Christopher S. Wood, *Anachronic Renaissance* (New York: Zone Books, 2010). Both Nagel and Wood also published articles leading to their two books, cited in their respective bibliographies.

3 Rosalind Krauss, "Notes on the Index: Part 1 and Part 2," in *The Originality of the Avant-Garde and Other Modernist Myths* (Cambridge, MA: MIT Press, 1985), 196–220, citing Roland Barthes, "Rhetorique de l'image" (1964). Krauss's essay on the Index (Part 1) was originally published in *October* 3 (Spring 1977): 68–81.

4 Wood, *Forgery, Replica, Fiction*, 39.

5 Wood, *Forgery, Replica, Fiction*, 12–14, 35. Wood cites Richard Trexler's classic study of Florentine popular sacred images as the source of his understanding or relics and sacred images. According to Wood, "devotions to icons were an aspect of a manipulative, interventionist approach to religion that was completely consistent with the merchant's developing confidence in his capacity to control his own destiny" (14–15, paraphrasing Richard C. Trexler, "Florentine Religious Experience: The Sacred Image," *Studies in the Renaissance* 19 (1972): 7–41).

6 See Jean-Louis Deotte, "Rome, the Archetypal Museum, and the Louvre, the Negation of Division," in Susan Pearce (ed.), *Art in Museums* (London: Athlone Press, 1995), 215–232, for the argument that the foundation of the modern civic museum was a political and an ethical art. Museums "liberated" art.

ACKNOWLEDGMENTS

The production of this volume has involved the very generous support of many colleagues, friends, and students on three continents and in several countries between 2007 and the present. Parts of our research project were presented as lectures, seminars, and workshops on several dozen occasions over the past four years, where our audiences made important contributions to our unfolding ideas. Although our debts are so numerous that it would not be possible to mention everyone by name, some of the many persons who provided us with invaluable advice, commentary, and critique are acknowledged here.

We thank the University of Melbourne which hosted us on several occasions as visiting faculty and research scholars, and twice (2007 and 2008) as resident MacGeorge Fellows. In Melbourne, we are especially grateful for the encouragement, support, and intellectual challenge and stimulation of Jaynie Anderson, Barbara Creed, Jeanette Hoorn, Alison Inglis, Susan Lowish, Charles Green, Lyndell Brown, David Marshall, Christopher Marshall, Nikos Papastergiades, Kate MacNeill, Robyn Slogett, Paul James, Stephanie Trigg, John Frow, and Louise Hitchcock. We are grateful to the directors and staffs of the MacGeorge House in Ivanhoe, and of Queens College and Trinity College on the university campus, which provided lodging during 2007, 2008, and 2009. We also thank Jenny Green, Julia Murray; Lindy Allen, Philip Batty, and Mike Green at the Melbourne Museum; Judith Ryan, Ted Gott, and Petra Kayser at the National Gallery of Victoria; and Luke Morgan and Andrew Benjamin at Monash University. In Canberra, we are grateful to the National Humanities Institute at the Australian National University for organizing a workshop on issues relating to our project, and we are very grateful for the support of Kylie Message, Howard and Frances Morphy, and Caroline Turner; Margo Neale at the Australian National Museum; and Tiina Roppola and Luke and Marguerite

Roberts and their family. In Brisbane we thank Andrew McNamara at the Queensland University of Technology, Julie Ewington at the Queensland Art Gallery, and Rex Butler. In Sydney we thank our hosts at the Power Institute of the University of Sydney, Mary Roberts, Louise Marshall, and Catriona Moore, and also Tony Bennett of the University of Western Sydney for stimulating conversations in Melbourne and London. In Alice Springs we thank The Papunya Tula Gallery and especially Paul Sweeney; Petronella Morel; and the archive staff of the Strehlow Research Institute. We are most especially grateful to the artists and staffs of the Art Centres in Kintore and Kiwirrkura, the Warlukurlangu Art Centre in Yuendumu, the Keringke Arts Centre in Santa Teresa Mission, and in particular Gloria Morales, Judy Lovell, and our guide Martin Ludgate. In July 2009 we were privileged to accompany curators Philip Batty and Judith Ryan and their staff on a field trip to the Western Desert in Central Australia in connection with the forthcoming exhibition, entitled *Origins: Old Masters of the Central Desert*, which opens at the National Gallery of Victoria in September 2012 and travels to the Musée du Quai Branly. We are particularly grateful to Susan Lowish, Philip Batty, and Julia Murray for their careful readings of the material presented below on Aboriginal art, though we remain solely responsible for any remaining errors and omissions.

In New Zealand, we thank Jonathan Mane Wheoke, curator at the Te Papa Tongarewa Museum, and at Victoria University in Wellington, Roger Blackley, Peter Brunt, David Maskill, Jenny Rowse, and Tina Barton, Director of the University Art Gallery; in Christchurch, Jenny Harper, Director of the Christchurch Art Gallery; at the University of Canterbury, Karen Stevenson and Ian Lochhead.

In North America, we are grateful in many ways to Max Boersma, James Cordova, Afroditi Davos, Jae Emerling, Christoph Heinrich, Amelia Jones, Pamela Jones, Dana Leibsohn, Kira van Lil, Jeanette Favrot Peterson, Ruth Phillips, and Christina Stackhouse; in Great Britain, in London and Oxford, Nicholas Mann, Matthew Landrus, Martin Kemp, Juliana Barone, Neil Cummings, Marysia Lewandowska, and, at Tate Britain, Victoria Walsh; in the Netherlands, Caroline van Eck of the University of Leiden, and Hendrik Folkerts and Eric de Bruijn of the Stedelijk Museum in Amsterdam, and also the staff and students of Amsterdam's de Appel Art Centre; in Denmark, Maria Fabricius Hansen at the University of Aarhus, and, at the University of Copenhagen, Henrik Reeh, and curator Henrik Holm of the National Museum in Copenhagen; in Greece, Assimina Kaniari at the University of Technology and Eleni Mouzakiti in Athens, and Konstantinos Ioannidis,

then at the University of Ioannina; in Milan, Mario Valentino Guffanti and Maria Cristina Busti.

In Istanbul we were most grateful for the opportunity to present a joint lecture on aspects of our book project at Bogaziçi University's Department of History, under the aegis of a Getty Foundation initiative in support of a new doctoral program in art history at that university. The Getty Foundation also supported a visiting professorship and residency there for Donald Preziosi in fall 2010. We are especially grateful to Ahmet Ersoy, Paolo and Miyuki Aoki Girardelli, Çigdem Kafesioglu, Elif Onlu, and Nilay Ozlu.

It is a pleasure also to acknowledge the very generous fellowship support of our home universities, the University of California at Los Angeles and the University of Colorado at Boulder, for various aspects of the extended research project and the several residencies abroad which made possible the production of this book. Last and certainly not least, we are indebted to the many students in our classes who contributed so much to the live discussion over the four years that this project germinated.

Donald Preziosi and Claire Farago
Boulder, Colorado
March 14, 2011

INTRODUCTION
ART AND/AS MANIFESTO

The idea of art is to change and improve the world.
Les Promesses du passé, Centre Pompidou, Paris[1]

If a metaphysician could not draw, what would she think?
Gaston Bachelard, *The Poetics of Space*[2]

Art is not what you think it is. In fact, it is not exactly an *it* at all. In modern times art is commonly taken to be a very particular kind of thing, a product or commodity believed to present, represent, or express the intentions, desires, beliefs, values, or mentalities of its producer(s): an embodied effect of those mentalities or desires. On the face of it, this may not seem problematic. Yet in fact the very idea of art has long oscillated between referring to a *what* as well as a when or a how: both a kind of thing and a way of making or using things. As artistry, artifice, or skill more generally, art is manifested in every aspect of social life. But not necessarily as *art*. It is everywhere and consequently nowhere: a certain degree of skill or artfulness in fabricating something is one way that art has been defined historically. But when and why is something properly distinguished as art within all that is artful?

Few phenomena in our lives are as inescapable as what we commonly refer to as art (Figure I.1). It is at once attractive and disturbing, comforting and threatening, amusing and terrifying. Art's ability to evoke adoration, passion, outrage, destruction, or death is on a par with religion's capacity to incite both comfort and genocide.

Art Is Not What You Think It Is, First Edition. Donald Preziosi, Claire Farago.
© 2012 Blackwell Publishing Ltd. Published 2012 by Blackwell Publishing Ltd.

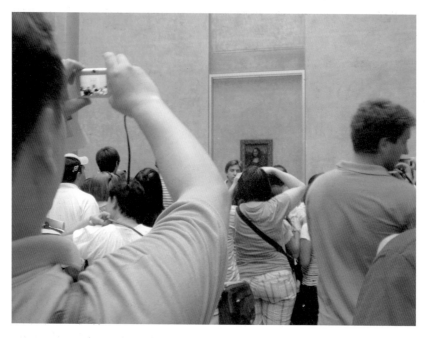

Figure I.1 Crowds photographing the *Mona Lisa* at the Louvre, July 2010. Photo Donald Preziosi.

And for precisely the same reasons: both art and religion are aspects of something more fundamental and essential; complementary phenomena crafted in response to the most fundamental questions about the nature of signification and of being in the world; and about our relationship to things (the paperclip, the computer, the cathedral, the haircut).

But then again neither art nor religion is what you may think it is. They are neither universal categories nor neutral designations, but historical constructions specific to a time and place. They are not exactly *its* either, but different ways of investing things with meaning. Therein lies the paradox about them both, and the most intractable conundrum about art itself for our time. We cannot know anything about the world (or about the world of "art") without artifice.

The activity of the artist or fabricator has a long history in Western and other discussions about how to think and what and how to believe. Behind Bachelard's statement cited above stand two and a half millennia of discussion and debate, starting before Plato's discussion about the role of

phantasms in the process of gaining knowledge. Good phantasms were those (like mathematical diagrams) that help you think; bad phantasms were delusions that caused you to think poorly. It's not necessary to bring Plato to Bachelard but, in juxtaposing them, even a simple visual analogy gains a cultural signature, a history in Western thought (an issue taken up below).

Now compare Bachelard's statement with the first epigram, from a wall-text of an exhibition at the Centre Pompidou in Paris in 2010 about the function or idea of art being to change the world for the better. Which of course implies its obverse: that art may also change the world for the *worse*. Implicit here is another issue taken up below: the effect of art when seen as an intervention, inflection, or intrusion into social space. What artistry does, that is, in affecting existing perceptions and social habits – the actual perceiving by ourselves and others, precisely by its being there in that world.

So if that world can be changed, minimally or profoundly, what kind of effects are desired? And who controls the changes effected? Who if anyone (critic, politician, preacher, salesperson) guides the ramifications of the effected change? And where are the boundaries drawn on the efficacies of art? Is the world of art as broad as the world we know or as narrow as a set of entities or commodities of a designated type? Does "art" include the pages of the book you are reading now? Or the way you did your hair this morning? What would be a reasonable compromise (assuming you wanted to make one) between all these options?

And if it's all "art," what functions does a continuing faith in the special-ness of (more or less conscious) artistry actually serve? The question of what art is and does offers access to central questions of contemporary thought that entail a wider range of social, political, ethical, and theological conundrums than are routinely considered in academic discussions of art.

What Is a Manifesto for?

A manifesto is an intervention into commonly thought assumptions. The term itself derives from the Latin *manifestare*, to make public or obvious certain principles or intentions, and it was first widely used in modern times in mid-seventeenth-century Italy. In a very broad sense we link our manifesto to structurally and functionally similar movements or develop-ments in a wide variety of practices and traditions. All manifestos are modes of artistry and artifice in themselves. Certain well-known artifacts

or works of artistry come to mind: Thomas More's text *Utopia* (1516), intended as a social critique but also functioning (in New Spain at least) as an actual blueprint for constructing communities where colonized subjects could congregate and be supervised in "ideal" settlements. Or the planned and actual realizations of "ideal cities" whether in Hellenistic Greece, Renaissance Europe, the Spanish missions in California, or the Mormon colonies in the North American desert. All are akin to *manifestos* in that they make palpably apparent certain intentions or desires regarding a particular aspect of social life such as dwelling or organizing social classes relative to one another in space and time, or the relationship of the material world to a putative immaterial force or divinity.

The examples just noted share the utopian motivation of bringing to attention what some individual or community would wish to serve as a model or paradigm of some situation, practice, or system of relations for audiences (however they may be construed). Plato's *Republic*, composed during the early years of realizing modular city-planning designs in the colonial expansion zones of the Hellenic world – though not at home, within Plato's own Athens – projected ideal relationships between the different classes and occupations of citizens, to be mapped onto and embodied by the topography of the polis.

Renaissance paintings of ideal cities, such as the panel in the Walters Art Gallery in Baltimore shown in Figure I.2, were intended for the enjoyment of an educated patron. Indeed, its artistic system of central-point perspective might be considered the paradigmatic manifestation of a hierarchically

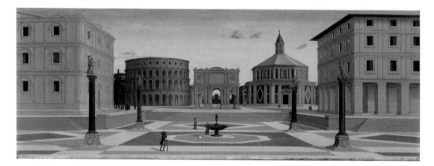

Figure I.2 Bartolomeo Corradini (Fra Carnevale) (Urbino, active 1440–1484). *The Ideal City*, ca. 1480–1484. Oil on panel. The Walters Art Museum, Baltimore. Photo courtesy of the museum.

ordered social organization mapped onto the portrayal of spatial relation-
ships that appear to approximate human vision (the eye/I of the beholder).
But does an ideal city painting really constitute a (visual, mute) manifesto
regarding ideal relationships or ratios between individuals, classes, and
occupations in the life of a city or community? Was it really intended as
such? The answer depends on how the object was used.

The statement from the Centre Pompidou on "the promises of the past,"
refers to the (failed, abandoned, dismantled, or destroyed) utopian artistic
practices in the "old East" societies of Europe before the fall of the Berlin
Wall. The idea or purpose of art being to transform the world and thereby
contribute to making it better is perhaps a succinct example of a manifesto.
A staging of a utopian activism (performance) and a way of manifesting
the role of the Parisian avant-garde in supporting those artistic gestures,
created in a society that repressed critique by eliminating the usual features
of the art system such as funding for artists or projects, provision of exhibi-
tion spaces, existence of a standing audience for art. Social critique was
suppressed in any form, yet art-making continued (indeed even flourished)
under these harsh conditions. Moreover, it evolved as a non-commodified
form of practice.

The exhibition *Les Promesses du passé* might be taken as the emblematic
claim of art itself in modernity – as the instilling of possible worlds; as
installing into the fabric of the world of the everyday (an)other world,
thereby (and not so incidentally) problematizing or de-naturalizing what
is habitually taken as real or natural. Art as exhortatory – as manifesto: the
manifestation of artistry and artifice as such. The manifestation of its own
questioning gesture. What has been recuperated as a pan-human sign
of humanness functioning in the interstices of an authoritarian social
structure where the role of art (paradoxically, ironically) is free because it
functions without being commodified – outside the art system – where
every person is potentially an artist who manifests his or her own "style"
(Figure I.3).

A manifesto, again, is a form of social practice; an activity of asserting
some paradigmatic, ideal, or preferable set of relationships – who lives
where in relation to others, for example; who is permitted to speak to
whom under what conditions and with what obligations and responsibili-
ties; who are permitted to marry whom or to practice as artists or judges
in a community; who are allowed to publicize their (political, economic,
religious, philosophical, social) manifestos, at Hyde Park Corner, in Central
Park, or on the Internet. In which case, then, any declaration of principles,

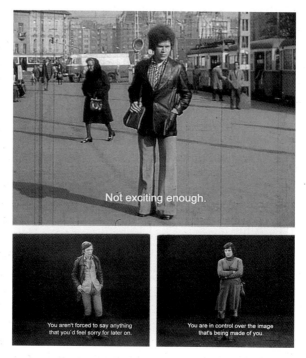

Figure I.3 Tibor Hajas (Hungarian, 1946–1980). *Self Fashion Show*, 1976. Film still, 35 mm transferred to 16 mm. Collection Erste Group and Béla Balász Studio, Budapest. Photo courtesy Kontakt.

intentions, and predilections by whatever means or in whatever medium could be claimed as taking a position in relation to actual social practices.

The examples just given have in common a certain notion of decorum, a fittingness of (inter)relationships which suggests that various kinds of manifesting entail a variety of ideas about relations thought to be ideally proper – the proper distance between the dwellings of the rich and the poor, between the ruler and the ruled over, between priests and congregations, between utilitarian and aesthetic activities or practices, between the sites of personal hygiene and of food preparation in a dwelling.

Or the proper distance between an observer and a phenomenon under observation – a distance that might also be signaled by giving an account of (or concealing) one's viewing position, one's own voice in proclaiming ideas about something. It would seem, then, that manifestos in whatever

form bear relationships to the actualities of some situation or set of circumstances that are akin to that between (on the one hand) a design or plan and (on the other) both the perceived or imagined state of things as currently existing, and as ideally embodied, cured, corrected, or completed. In other words, a manifesto entails an (implicit or explicit) interrogation of concordances (actual or imagined) in a perceived state of things. It calls for actions and consequences.

Not everything is a manifesto, but many kinds of things, many activities, and not least artistry itself under its many guises, may be used to effectively and provocatively manifest or declare what is to be done. If artistic practices potentially have profound philosophical or religious ramifications by enhancing, refuting, or simply making possible any belief system in the first place, they also have profoundly political effects simply by the fact of their being there in the (actual, imagined, or virtual) world. In other words, any artistic act, however minimal, and using whatever means, has effects. Furthermore, its effects may not be manageable or controllable by the maker. This then has profound implications for what art is and does. However we construe the term, whatever we take to be its "idea," art is not simply a problem, it is one of the most profound of all problems at the heart of social life. This situation is even more complex in that art is not quite reducible to any one causal agent, whether understood as social mores, ethnic makeup, or the psychology or organic architecture of the human brain.[3]

What would it mean to question – indeed to *trouble*, as a manifesto properly should – what has conventionally been taken in the Western tradition and elsewhere to be the very idea of art? What exactly is art if it could have problems that require urgent attention? Is some art by contrast really unproblematic? Contemporary philosopher Giorgio Agamben once claimed that if we really want to engage the problem of art in our time, nothing is more urgent than clearing away what is usually taken for granted about it, calling into question everything that aesthetics entails, including above all the system of relationships in which it has been embedded – framed – and which gives it its substance, namely the split between the artist as producer and the beholder that defines the way we currently use art in society. Is the social subject (whether the artist or the viewer) enhanced or, more fundamentally, formed by this framing? What would be gained by exposing – manifesting – underlying assumptions of what are commonly taken to be the nature, functions, and aims of what we call art? In the current debates, another contemporary philosopher Jacques Rancière

has been a leading voice in calling these very assumptions into question. What Rancière calls the "aesthetic regime" of art maintains as its foundation a historically reductive understanding of art as autonomous. He has called for a broader, more nuanced understanding of what art is and does, a philosophical project that defines the "future of the image" in terms of a heterogeneous community of dissenting equals. Rancière's project resonates with our own call to arms.

The modern Western idea of art is that it is primarily an expression, representation, embodiment, or sign of the intentions of its producer: a figure, profile, or emblem of the (inner) truth(s) of the maker. Historically, the latter has variously referred to the person or persons who materially fabricated the work; the product's sponsor, enabler, agent, or promoter; or the system of artistic or cultural production itself, the social and cultural environment within which it appears and functions. It may include a particular person, people, place, or time, or specific social, historical, philosophical, or theological forces, intentions, or desires said to be "behind" or manifested in (and as) the work. The enterprises of modern forms of knowledge production such as art history, art criticism, aesthetic philosophy, and museology – as well as their many ancillary or subsidiary formations such as the heritage, travel, and fashion industries – are all dependent upon the fundamental hypothesis: the accepting as natural, given, or in other words beyond discussion, of a certain concordance between what are distinguished as cause and effect.

Therein lies the enduring paradox of the dualistic distinction between a work of artistry and the forces or circumstances that are thought to have brought it into being, between an artifact and its cause. While those forces can be imagined to be prior to and ontologically independent of their effects, in practice their concordance is nonetheless fragile and problematically circular, and ultimately indeterminate. Moreover, how things are to be understood or interpreted, or even merely seen and read, requires external justification and support, including legal, religious, and social enforcement. The governmentality of art and its role in fabricating socialized subjects requires substantive consideration.

The presumption of such a concordance has explicit philosophical and theological roots in many societies. Our intervention into the age-old debates about the nature and function of art concerns their epistemological structure. How have arguments about art been articulated in the Western tradition? How do these historical ideas impose on current understandings of what art is and does? According to some belief systems (and not only

their monotheist varieties) the universe as a whole is actually pictured as being a creation, requiring an artist or maker (sometimes but not necessarily individuated) with an existence or agency independent of and thus seemingly logically prior to its creation. The cosmos thus conceived is likened to a material work of art or human artifice, an allegory writ large of a certain (and necessarily culturally specific) idea of art. Artistry and metaphysics are inextricable in culturally specific ways.

The modern idea of art (fine art) is in fact structured according to ontological distinctions between subjects and objects, between "sentient" producers or agents and the material effects of production which are commonly assumed (in some traditions) to be non-sentient: a linkage (through distinction) between mind and matter, a juxtaposition of thought and stuff. Paradoxically, in many traditions, those productions, whether construed as events or as things resulting from events, are treated as if they were sentient. The idea of art, as something antecedent to a world of art objects as exemplifications of that idea, turns out to be a very complex and problematic notion. It would seem that there is no idea of art that is not tied to a certain metaphysics. In the Western tradition, the work is commonly construed as a sign: that is, as *form* or *idea* (from the Greek *eidos*) of something pre-existing its manifestations or exemplifications. Within the Christian religious tradition, where theoretical considerations about images required a very intensive and profound reckoning with older Greco-Roman philosophical perspectives, the central problem was that of guaranteeing the truth of re-presentations of the ineffable, immaterial, and eternal.

A quick example: within that tradition, broadly conceived, the most sacred object was the relic, understood to be the direct manifestation of the divine, made without human intervention. The understanding of the artist as the agent responsible for an image of Christ or another sacred subject introduced an ontological problem: what guarantees the (divine, eternal) truth of a representation made by human art?

The fundamental problem lies with the binary or dualistic nature of the paradigm, whether called form versus content, the immaterial versus the material, or some other combination assigning a higher value or reality to that which is taken as prior. As powerfully articulated by Nietzsche in the late nineteenth century and repeated many times since as the central epistemological challenge of contemporary thought, there is no meaning independent of the words or signs used to designate them. In such a view, there can be no transcendent meanings; no ideal signification, no privileged reference, no universal equation or concordance between designations

and things. No "divine" principle of intelligibility, in other words; no final meaning or truth that is not itself an artifact of signifying practices themselves.

Reckoning with the metaphysical subtexts of Western philosophy has been one of the most formidable problems of contemporary thought: the duality of form and content is a specifically Western configuration which leaves open the possibility of transcendence – since the duality maintains that there is something beyond and prior to the material manifestation or embodiment (or "re-presentation") of the idea. How to rethink that transcendence while also considering the situation of art in a globalized economy, with all that it entails, is the key challenge for contemporary writing about art as such.

Who Are We and Why Are We Writing This Book?

This book is by a couple of art historians and theorists who have just spent many months in another hemisphere half a world away from home and normal professional haunts precisely to get a fresh slant on the idea of art. We welcome the opportunity to contribute to the Blackwell Manifestos series intended for a broad spectrum of readers because it impels a broader picture than disciplinary protocols and institutional obligations normally encourage. As a result, much in this book is aimed at dispelling historical amnesia and troubling the fantasies that promote art as a form of escapist entertainment: entertainment as containment. No art system is a self-enclosed, self-regulating environment. Sensitivity to this circumstance is heightened by living in impossible and dangerous times, in capitalist societies where the gap between populations and their tiny ruling minorities is widening grotesquely, where the financial interests of large corporate entities effectively control political life, while humanly induced climate changes affect the quality of all life on our beautiful blue planet in ways not fully comprehensible at present, if they ever will be.

Interventions are urgently needed in the public sector to voice not only the immediate consequences of inaction in the face of environmental and social disaster, but also to articulate issues of social justice persuasively. Our decision to situate ourselves in the global South of Australasia was driven by the desire to understand how the Euro-American axis of the art system offers only a partial perspective of a global network.

Our outsider's perspective on both Euro-American and Australian art made us aware of what Michel Foucault calls the processes of recuperation, the recasting of prior representations in new form. We learned something uncanny about the contemporary effects that the historical, initially European idea of art has produced. Australia was a final chapter in the European colonization of the rest of the world, with the main campaigns of settlement taking place in the nineteenth century. By this time, one might have expected that the medieval scheme of the European imaginary consisting of the civilized self and its exotic other would have been exhausted, having been replaced by more nuanced appreciations of cultural difference based on centuries of exploration and interaction. Yet the facts suggest otherwise. By the end of the eighteenth century, an international discourse mounted in Europe had established indigenous peoples as examples of primordial humans, with Australian Aboriginals considered the most primitive of all, playing the role of Europe's Old Stone Age peoples. Nineteenth-century reconstructions of Neanderthal physiognomy were actually based on comparisons with modern indigenous Australian specimens, the anatomical evidence reinforced by circular arguments about the "primitive state" of Aboriginal culture. The most widely known "reconstruction" was by comparative anatomist Thomas Henry Huxley, entitled *Evidence as to Man's Place in Nature* (1863), published in support of Charles Darwin's theory of evolution nearly a decade before the appearance of *The Origin of Species* (1871) (Figure I.4).

Progressive science in Europe situated indigenous peoples in Australia and elsewhere at the bottom of an evolutionary and cultural hierarchy that was fully elaborated only in the 1920s. The label "primitive" is still difficult for many to dismiss regarding indigenous Australian culture, and the current living conditions of First Australians, the sorry aftermath of European colonial policies, are an ongoing tragedy and national embarrassment. Yet these harsh historical and contemporary conditions also produced an unexpected corollary: Australia and New Zealand (where a consolidated group of Maori leaders struck a somewhat better deal with their British colonizers at first contact) are also the source of some of the most sophisticated and thoughtful critiques of culture available anywhere. This includes a fundamental rethinking of art-making in phenomenological terms as a form of knowledge production involving complex bodily interactions with the immediate environment. The work of American anthropologist Nancy Munn and others studying indigenous cultural practices in Australasia

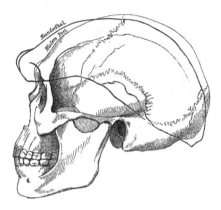

Figure I.4 Comparison of Neanderthal and Aboriginal skulls, after T. H. Huxley, *Evidence as to Man's Place in Nature* (London: Williams & Norgate, 1863), fig. 31.

suggests ways to rethink the highly charged European category of art in culturally less biased terms, as we'll discuss in the final, Eighth Incursion of this book.

This book is organized as an interwoven series of incursions into multiple aspects of the contemporary discourse on the arts. Incursions aimed at making palpably manifest the contradictions, conundrums, and consequences of the normative systems within which ideas about art appear and function today. These are critical forays into the ways that art/artistry/artifice are regarded. They are concerned with art (as commonly construed today) as a problematic phenomenon. Not merely art and its problems, but the quandary that is art in today's society. The seven essays below present overlapping, mutually implicative, and mutually supportive perspectives to focus attention on what is at stake today in maintaining the contemporary global system of the arts.

The function of the critic continues to be situated partly inside and partly outside the art system in which commodities circulate, with the academic practices of art history and the professional practices of curating exhibitions and writing art criticism. At present, critique is an endangered species, practically non-existent in the commercial art world where most of what passes for art criticism is actually artistic promotion. On the other hand, some artists are also practicing as critics of the commercial art system, sometimes by abandoning object-making practices, sometimes by acting as curators or writers. This situation in itself makes it impossible to

separate the art system from its critical frame or from its political contexts or effects – even art that has no political content is political in refusing to be politically engaged.

How This Book Is Organized

It is not a question of applying a concept but of enabling a thinking.
Parveen Adams[4]

This book is not a history of the contemporary discourses and practices of art criticism, art history, aesthetic philosophy, or museology. Nor is it an account of particular art movements, styles, or modes of art production, staging, marketing, and academic art criticism. Nor is this book limited to discussions of modern or contemporary art. It is the matrix itself – that topology of relations between differing ideas about the artist, the artwork, and their functions – which is our subject. To understand art as part of a matrix, rather than simply as a thing, a process, a skill, or even a way of using things, this critical intervention looks at the longer history of the modern idea of art, particularly its foundational moments in the sixteenth century. If, as Terry Eagleton argues in the first volume in this series of Manifestos, *The Idea of Culture* (2000), the cultural is what we can change, then art is what changes those (not so gracefully aging) Enlightenment twin siblings, *culture* and *nature*, precisely by problematizing the naturalness of their distinction.

The ideas of art and culture are inseparable. Eagleton claims that the vision of the world made up of unique, self-determining nation-states, each carving out its distinctive path to self-realization, is not merely akin to aesthetic thought: it *is* an aesthetic artifact. The work of art, he argues, is modernity's solution to one of the nation's most difficult problems: how to relate the particular and the universal. The artwork promises a new way of conceiving of that relationship by representing a kind of totality that exists only in and through its sensuous particulars. The state can represent the unity of culture only by repressing its internal contradictions: a masquerade of aesthetic decorum.

In order to begin discussing our contemporary ideas about art and artistry we must first counter the assumption that the modern idea of art began with German Idealist philosophers such as Immanuel Kant or G. W. F. Hegel. Although it may be widely (and vaguely) appreciated that our familiar modern ideas about art were not conceived *ex nihilo* in the

eighteenth century, the attention accorded to earlier (mostly European) thinkers in discussions of contemporary art has tended to resemble the reluctant toleration accorded to so-called primitive societies outside Europe by those nineteenth-century scientists and philosophers who were bent on creating the parochial fiction of Europe as the brain of the earth's body. By contrast, the discussion here begins with religious ideas about art that precede the Enlightenment philosophers.

The religiosity of the modern idea of art is structural and systemic. To paraphrase a recent observation by Judith Butler, if we take "secularization" as a way in which religious traditions "live on" within post-religious domains then, with respect to the art matrix, we're not really talking about two different frameworks, secularism versus religion, but two forms of religious understanding intertwined with one another.[5] The old structure about the relationship of artistic representation to divine truth continues to haunt and trouble contemporary ideas of art.

Incursions into the Idea of Art

These incursions into important facets of the idea of art are doubly layered, consisting of seven narrative texts and references to further readings. In some cases, the latter are fairly extensive and are meant to offer the reader links to further aspects of the arguments.

The First Incursion ("Artistry and Authorship") pays attention to the other side of the Enlightenment, to lay out the background of contemporary understandings of the idea of art. Going beneath the increasingly opaque glass floor of the European Enlightenment, this incursion looks genealogically at the topology of relations between artist, artwork, and the aims and functions of both. It considers some of the important ways in which Western Christian religious uses of images and ideas of authorship and responsibility in the Early Modern period (ca. 1400–1700) provided a structure or template for subsequent post-Enlightenment "secular" understandings of art, artist, and artwork.

The Second Incursion ("The Dangers of Art and the Trap of the Visual") looks at specific historical reasons why artifice constituted a potential threat to hegemonic religious power and social discipline in sixteenth-century Europe and its expanded field of surveillance beyond the subcontinent. From the standpoint of religious institutional authority, the driving issue has not been the freedom of the artist per se but the problem of securing

the truth of an artistic representation. This incursion then reconsiders the category of the visual in promoting the modern European nation-state and the still circulating, now highly commodified idea of the artist as Romantic hero in a longer (and more complex) historical trajectory than existing accounts of contemporary art usually recognize.

The Third Incursion ("To See the Frame that Blinds Us") looks at the art system obliquely from the orbits of contemporary Euro-American art-making, art history, art criticism, and aesthetics. A series of interrelated case studies of Australian Aboriginal painting clarify what was forgotten, erased, or occluded in early European modernity's invention of (secular) art. Aboriginal acrylic painting, which had its origins in the 1970s, rapidly assumed international artistic and commercial prestige. The creation of Aboriginal art for an international market is poignantly paradigmatic of the modernist commodification of (fine) art in a very specific sense: as the abstraction and extraction – the reification – of particular visual or optical properties of indigenous cultural practices. The effect is to make such abstractions consonant with late modernist (Western) artistic formalism which has its roots in Christian theories of images.

The Fourth Incursion ("Deconstructing the Agencies of Art") continues the discussion of artistic agency by considering the effects of recent collaborative practices among artists who engage communities in ways other than as creators of aesthetic commodities. The recent phenomena of international biennales and community-based art practices help to articulate ideas about artistic agency as distributed rather than authorial. The political and ethical implications of these practices on the role of art in society are potentially profound.

The Fifth Incursion ("Intersections of the Local and the Global") looks closely into the epistemological and semiological implications of the previous forays with respect to ideas about causality and the nature of artistic signification within the European tradition. How is describing a society from the "inside" different from describing it from the "outside"? This incursion is located on the border between the critical apparatus of academic discourse and the extra-European cultural productions it describes. It addresses prospects for a "unified field theory" of artistic signification at the heart of the art matrix – as debated in two recent and seemingly very different claims in anthropology and art history, one by Alfred Gell and the other a collaborative forum for a world art studies.

The Sixth Incursion ("Into the Breach of Art and Religion") explores the relations between art and religion in three registers. First, stepping outside

the art system proper, in connection with the recent Muhammad cartoon controversy, this incursion examines contradictory notions of signification that exist between artwork and audiences in heterogeneous viewing situations. Second, regarding a recent altercation between the Hopi Tribal Council and the Warburg Institute of the University of London, it considers the presence of antithetical systems of value about the transmission of cultural beliefs. Finally, it looks at Plato's discussion of the proper place of the arts as an enduring conundrum underlying the necessity of maintaining social order.

The Seventh Incursion ("The Art of Commodifying Artistry") examines the mechanisms by which museums transmit cultural beliefs. The particular uncanniness of museums of art is due to the fact that their content and ways of staging and framing that content seem at times virtually indistinguishable. Citing examples from New Zealand and the United States, this section argues that the conflation of art and the artistry of museum display is structurally present in any museum. It then reconsiders the relationship between autonomous art and the commodity form, a long-standing problem of modern aesthetic philosophy and one of the central questions of contemporary culture and politics. This concluding provocation considers other ways to frame art-making, as embodied, multimodal cognitive processes functioning in distributed, local networks of agency.

By the same token, this project also functions in a distributed network of agency. In 1972 Gregory Bateson framed the intellectual challenge in the following way:

> My goal is not instrumental. I do not want to use the transformation rules when discovered to undo the transformation or to "decode" the message. To translate the art object into mythology and then examine the mythology would be only a neat way of dodging or negating the problem of "what is art?"[6]

To take Bateson's articulation of the problem one step further, we neither dodge nor negate the problem of "What is art," but interrogate the grounds for believing in art as a what or a when or a how.

Notes

1 Wall-text at the exhibition *Les Promesses du passé: une histoire discontinue de l'art dans l'ex-Europe de l'Est*, Galiere Sud, Centre Pompidou, April 14–July 14,

2010; exh. cat. ed. Christine Macel and Joanna Mytkowska (Paris: Centre Pompidou, ca. 2010).

2 Gaston Bachelard, *The Poetics of Space*, trans. Maria Jolas (Boston: Beacon Press, 1969), 212.

3 Three recent notable attempts to relate artistry and cognitive activity are Semir Zeki, *Splendours and Miseries of the Brain: Love, Creativity and the Quest for Human Happiness* (Oxford: Wiley-Blackwell, 2008); Barbara Stafford, *Echo Objects: The Cognitive Work of Images* (Chicago: University of Chicago Press, 2008); and John Onians, *Neuroarthistory: From Aristotle and Pliny to Baxandall and Zeki* (New Haven: Yale University Press, 2008).

4 Parveen Adams (ed.), *Art: Sublimation or Symptom?* (New York: Other Press, 2003), xv.

5 Judith Butler, "The Sensibility of Critique," in Wendy Brown (ed.), *Is Critique Secular? Blasphemy, Injury, and Free Speech*. Townsend Papers in the Humanities no. 2 (Berkeley: University of California Press, 2009), 119–120.

6 Gregory Bateson, *Steps to an Ecology of Mind* (New York: Ballantine Books, 1972), 130.

Further Reading

Giorgio Agamben, *The Man without Content*, trans. Georgia Albert (Stanford: Stanford University Press, 1999). [*L'uomo senza contenuto*, Milan: Quodlibet, 1994.]

David B. Allison (ed.), *The New Nietzsche* (Cambridge, MA: MIT Press, 1985).

Tony Bennett, *Pasts beyond Memory. Evolution, Museums, Colonialism* (London: Routledge, 2004).

David Carroll, *Paraesthetics: Foucault, Lyotard, Derrida* (London: Methuen, 1997).

Thierry de Duve, *Kant after Duchamp* (Cambridge, MA: MIT Press, 1995).

Jacques Derrida, *The Truth in Painting*, trans. Geoff Bennington and Ian McLeod (Chicago: University of Chicago Press, 1987). [*La Verité en peinture*, Paris: Flammarion, 1978.]

Terry Eagleton, *The Idea of Culture* (Oxford: Blackwell, 2000).

Jae Emerling, *Theory for Art History* (London: Routledge, 2005).

Michel Foucault, *The Archaeology of Knowledge*, trans. A. M. Sheridan-Smith (London: Tavistock, 1974).

Michel Foucault, "Nietzsche, Genealogy, History," in *Language, Counter-Memory, Practice: Selected Essays and Interviews*, ed. Donald F. Bouchard (Ithaca, NY: Cornell University Press, 1977).

Ian J. McNiven and Lynette Russell, *Appropriated Pasts: Indigenous Peoples and the Colonial Culture of Archaeology* (Lanham, MD: AltaMira Press, 2005).

Alan Megill, *Prophets of Extremity: Nietzsche, Heidegger, Foucault, Derrida* (Berkeley: University of California Press, 1985).

Donald Preziosi, *Rethinking Art History: Meditations on a Coy Science* (New Haven: Yale University Press, 1989).

Jacques Rancière, *Aesthetics and its Discontents* (London: Polity Press, 2009). [*Malaize dans l'esthetique*, Paris: Galilee, 2004.]

FIRST INCURSION
ARTISTRY AND AUTHORSHIP

Ideas about the artist, the artwork, and the uses and functions of both are neither self-evident, nor fixed, nor universal. They are facets of an evolving topological matrix of relationships in which what appears natural at a given time occludes earlier relationships that continue as ghosts haunting the present. This incursion argues that art cannot be adequately understood apart from its position in that matrix.

I walked around the room, snooping in corners, and discovered a plastic crate full of ten-inch-square mushroom paintings. Murakami has created four hundred different mushroom designs, so the exam given to new staff to test whether they are ready to wield a brush in his name is to paint a mushroom. . . . On the ground, leaning against the wall was another battalion of works-in-waiting. A total of eighty-five canvases were on the way to becoming what Murakami casually calls "big-face-flowers" but are officially titled Flowers of Joy. Gagosian Gallery sold the fifty on display in its May 2007 show for $90,000 apiece.

Sarah Thornton, *Seven Days in the Art World*[1]

Few artists work on the scale of Takashi Murakami, but the few who do depend on an enormous, dispersed network of museums, galleries, curators, dealers, agents, collectors, critics, art magazines, corporate sponsors,

Art Is Not What You Think It Is, First Edition. Donald Preziosi, Claire Farago.
© 2012 Blackwell Publishing Ltd. Published 2012 by Blackwell Publishing Ltd.

public relations personnel, art handlers, shipping companies, and insurance firms – not to mention the experts and technicians that such celebrity artists hire with the income from their diversified enterprises. Murakami's current ambition: to make an even bigger statement than his widely exhibited, 18½-foot tall self-portrait in platinum-plated aluminum entitled *Oval Buddha* (2007),[2] something on the order of the 44-foot high bronze Great Buddha of Kamakura, cast in 1252 (Figure 1.1).

The marriage of high art and consumerism is itself not new, of course. Murakami credits Andy Warhol for his work ethic, but think also of Salvador Dali, that consummate and outlandish self-promoter in all media. The difference is that, by making signature-style commodities, Warhol's famous Factory was perceived as a brilliant unmasking of contemporary art's most hallowed commitments to the originality of the artist. Dali on the other hand was treated with suspicion, a tarnished member of the avant-garde precisely because of his entrepreneurial flair – at least this was

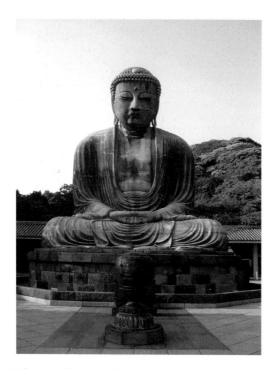

Figure 1.1 Daibutsu (Great Buddha) of Kamakura, Japan, 1252. Cast bronze. Photo Creative Commons Wikipedia.

the case until the current generation of retrospectives which recuperate him as a high modernist entrepreneur, perhaps because the model of what counts as high art has shifted in that direction.[3]

And the competition is stiff: Damien Hirst makes an artistic statement by recreating a human skull in platinum set with diamonds and real teeth for a $100 million price tag and takes his own work directly to the auction block to bypass the gallery system (Figure 1.2).[4] It's difficult to think that anything remains of the aesthetic quality of art except from a cerebral point of reference for a cultural form that depends on the capitalist system for its transcendental value. Yet it's also hard to deny that the work has presence. As Grant Kester put it in a recent assessment of the public sphere, in the very act of resisting commodification, the work of art becomes subordinate to its values. This situation produces a "kind of cognitive dissonance in which artists are compelled to demonstrate the radical difference between their creations and mere commodities."[5]

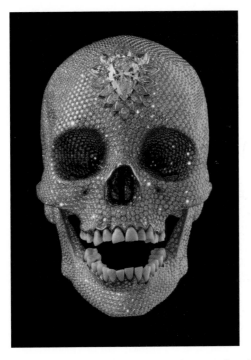

Figure 1.2 Damien Hirst (British, b. 1965). *For the Love of God*, 2007. Diamonds and platinum on human skull. Photo courtesy of White Cube, London.

If signaling a distinction between the commodification and the auton-
omy of art is necessary for maintaining credibility on the cutting edge of
contemporary production, actually maintaining that distinction is difficult,
even for those who try harder than Hirst or Murakami. Consider the street
artist Banksy, whose concealed identity was once a useful component of
his illegal working procedures, but is now part of his mystique. Banksy's
guerrilla tactics are now familiar on several continents and his visual pranks
are preserved and collected more often than treated as acts of vandalism.
In May 2010 Banksy released an autobiographical feature-length film struc-
tured as a documentary criticizing the art system's absorption of his attacks
on the commodified art world. Appropriately entitled *Exit through the Gift
Shop*, the film was an instant commercial and critical success, and who can
say where spoof ends and commodity begins?

While our understanding of art is always changing, and most of us prob-
ably assume that art is a universal phenomenon, our most commonplace
notions today about art and about the artist would not have been recog-
nized more than about two centuries ago. Our first incursion articulates
the historical concept of the modern, initially European, *idea of the artist
considered as the primary agent or cause of the artwork*. Ideas about the artist
were always bound up with notions of *causality* and *responsibility* about
how and why an object or artifact or artwork got to be what to our eyes it
may be today. However, the *agency* of an art-maker would not have been
recognized in earlier times as more or equally important than that of the
work's patrons, financers, or political or religious sponsors, who may have
been thought to be the real, *effective* producer or enabler of a work.

At the same time, after a couple of centuries of having been *disciplined*
by such recent institutions and professions as art history, art criticism,
aesthetic philosophy, and museology, what the made object might appear
to be to our eyes is more than likely to have been quite strikingly different
from how it might have been perceived when it was originally produced,
as indeed a close reading of the histories of those professions make abun-
dantly clear. What those disciplines accomplished during their brief history
was to *stage together* all the world's artifacts so as to be meaningfully useful
to our own modern purposes. Which had the very palpable effect of
masking, marginalizing, or making irrelevant or superfluous whatever
earlier or original meanings, functions, and purposes they may have had.

Our point is quite simple yet fundamentally important: ideas about art
have never existed in a vacuum. Criteria for who or what an artist or maker
(or a product or an audience) is have varied considerably over time both

in the same social environment and across the landscapes of different socie-
ties, in relation to shifting conceptions of agency and responsibility in the
production of works. Ideas about artistry and authorship are themselves
artifacts of different perspectives on the uses or functions to which art-
works have been put. Which suggests – minimally – that to gain the critical
distance necessary to think systemically about art, we need to understand
the interplay of three general facets of the (modern, Western) idea of art
– the *work* itself, the *agent(s) or force(s) responsible* for its material mode or
appearance, and the *functions to which* a work may be put.

While abstractly and generally these may be in concordance with each
other, at given times and places they are nevertheless differently in flux, and
not necessarily at the same rates, nor are they necessarily moving in the
same directions. In short, each has its own (semi-autonomous) history, and
each has a dynamically evolving relationship with the other elements in
this topological matrix. Any idea of art is entailed with a structure or system
or relations in which each of the elements or components is dynamically
connected to all of the others. Changes to any one will have implications
for differently recognizing, understanding, or articulating the others in this
topology. Each term, in other words, is a (momentary or relatively endur-
ing) idea defined by its relationships with complementary ideas.

The matrix is also multidimensional. If relations between work, author-
ship, and function or destination might be envisioned as operating on one
plane or dimension, then each of the three elements is also related to other
circumstances to which ideas of artistry and artifice may be strongly or
weakly connected, such as legal or religious or political needs and require-
ments with respect to who is permitted to receive or respond to a work or
event. At the same time, such circumstances that may seem external to an
outside observer may very well be construed internally as connected in an
essential or determinate fashion to the nature and functions of the artwork
as well as to the nature of responsibility or agency.

Again, notions of *causality* play a definitive role in how virtually any-
thing about an artwork is to be construed. In answering the question "Who
exactly is (or was) responsible for the appearance or form of a work?" a
wide range of responses might be elicited, depending upon the identity or
social position (age, class, ethnicity, gender, etc.) of the questioner; the
social relationship of the questioner to those practicing or sponsoring
the work; or the time of questioning and the *uses to which* such knowledge
may be put. In some societies, as a woman (or a man), you may not be
permitted to even *see* men's (or women's) work.[6]

Appropriate responses to the question of causality may range from the individual(s) materially responsible for the work in its final state, to their patrons or agents or sponsors, to the "spirit" of a person, people, place, or time. In any case, distinctions will always be made between immediate and proximate causes and final or ultimate causes and responsibilities. To an outsider, the artist may be the person physically making the work while to that same individual or to others of that community, the artistry's primary or real cause is an immaterial being or tribal goddess. Such variations occur historically even within the same social or cultural tradition at different times and in different places in the same social landscape. And these variations have had as much to do with factors that in the eyes of an outsider even at the same time may not appear to be of consequence. Why indeed – to anticipate issues discussed below in our sixth incursion – is a particular artifact considered *blasphemous* in one context (say a religious fundamentalist community) but harmless (theologically mute) in another?

None of these ideas came out of a historical vacuum. What follows briefly examines the critical, historical, and theoretical background of current (Western) notions about the idea of art.

The Artist as Agent

The idea that the artist is the *primary* agent responsible for the appearance of the work of art emerged with full force in sixteenth-century Europe, as is well documented in the rich literature dealing with artists and works of art, in changing artistic practices including the emergence of new theoretical writings, in the Early Modern growth of artistic patronage associated with dynastic and religious institutions on a previously unprecedented scale, and in other collecting practices enabled by the accumulation of wealth among a growing class of educated professionals and merchants.

Paradoxically to our eyes – and akin to the rise of the celebrity artist today – acknowledgment and praise of the individual artist/artisan went hand in hand with ever larger and more complex workshops that employed specialized assistants who materially produced a wide array of products in the master's name. In fact, the representation of the individual artist as an *autonomous agent* developed together with collaborative production techniques that *defied the designated agency of the work while still stressing its originality*. Raphael's enormous workshop is the classic case in point, indicating that a complex relationship existed between the basic elements

in what we're calling the art matrix. Driving acknowledgment of the individual artist was competition (and opportunity) for patronage and by profit-making strategies in a burgeoning market economy.

Important to the rising status of an elite core of artisans whose public face and signature style belied the actual working conditions responsible for artistic production (which remained more closely allied to the collaborative routines of the workshop) is the idea that the maker practices a synthetic activity of sensate *judgment*, or discernment. The intellectual independence of the artist emerged as a new topic in the circle of Michelangelo, for example, who was credited with the innate faculty of *sapere vedere*, which grants absolute status to the judgment of sense. "To know how to see" (that is, knowing how to see) translates into the ability to draw or design with the same *reasons* as one sees.[7]

While there was certainly nothing novel in the idea of the artist's agency, the positioning of the artisan as an *independent* agent transformed and refocused medieval discussions of the "mechanical" or "productive" arts, aligning the craftsman's working methods with those of the poet, whose "furor" in the process of creation was based on ancient Platonic ideas, now put to new purposes. Aligning artists with poets was not the only possibility, however. As early as the twelfth century, Hugh of St. Victor classified the seven mechanical arts within a neo-Aristotelian scheme of human knowledge. The rising status of certain artisans was also increasingly associated with the mathematical sciences, since painters, sculptors, and architects all employed proportion, based on geometry, to render things in perspective, to portray the human body, to design beautiful and sound buildings. Epistemological tensions exist in the rich literature on art that emerged by the sixteenth century because there were no direct precedents for the new status granted to the *arti del disegno*, as Vasari distinguished painting, sculpture, and architecture from the crafts in his monumental set of individual biographies framed as three successive stages of development. The consensus of scholarship to this day maintains that the modern system of the arts developed fully only in the eighteenth century, when the arts and sciences were systematically distinguished from each other, partly as a consequence of discussions about the unity of the arts, and comprehensive theories of aesthetics were formulated. Recently the transitional period from roughly 1400 to 1700 has become a focus of renewed attention as a time when the study of nature assumed many dynamic new forms. We still have a lot to learn about the artisanal forms of knowledge that contributed to modern conceptions of art and science.

A short book such as this is not intended to offer a history of complex developments taking place over several hundred years. To understand the historical idea that the artist is the primary agent responsible for the appearance and coherence of an art work, we need to think not only in terms of a history of events but also in terms of the topological matrix and in terms of the Christian theory of images that provides our modern understanding of the artist as an independent agent with an essential pre-history. The Christian account not only preceded the modern discourse on the artist, but to a great extent it continued to provide an anchoring point for it. It would be overly simplistic to reduce this complex history to a linear progression. In the fifth incursion, we will expand on these issues regarding sixteenth-century concerns with the truth of sacred images that scholastic theologians had already articulated in the thirteenth century. In both cases, we will argue, the arguments establish the source of the artist's mental image or idea as divine because what is ultimately at stake is the ontological status accorded to his materialized representation.

Even when a specific text does not mention religious issues, even when a specific work of art is not religious, whenever painters or poets were considered to be divinely inspired, the arguments would have carried a religious resonance in a deeply Christian society. Histories of the modern secular idea of art have concentrated on the humanist tradition and treated its classical sources as secular, but "classical" ideas about artifice and artifi-cers circulated in a culture where Christian theology made very specific demands on the concordance between the agent responsible for the image (God working through the artist, or the artist working through God), the appearance of that image, and the way that image functioned for its users. *This tension is at the foundation or the ground zero of modern ideas about art.*

The Nobility of the Artist

In its scholastic theological formulation, the more closely an entity was *in contact with* God (the "first intelligible object"), the more divine and noble it was. Commenting on Aristotle, Thomas Aquinas defined something perfectible as *"receptive of a perfection,"* so material substances received likenesses ("similitudes" of the intelligible) by way of human sensory powers. Aristotle's account of the way sense impressions are received by the imagination as if they were a stamp or a signet ring impressed on a wax tablet is quite audible in this scholastic language, and these mechanistic

analogies are tremendously important for the modern idea of the artist. Aquinas also compared "intelligible forms" to the mental images (*fantastic forms*) used by the artist in making things: similitudes conceived from intellective things are similar to manifestations generated by art.[8]

When Leonardo da Vinci, for example, claimed that "painting is born of nature; but to be more correct, . . . [painting is] the *grandchild* of nature because all perceptible things are born from nature, and painting is born from the nature of those things,"[9] he was referring to nature as eternal, and was thereby claiming nobility for the artist by his *proximity* to the intelligible acts of God. Leonardo went a step beyond Aquinas, however, when he claimed that painting "truthfully" imitates the appearances of nature because the artist has knowledge of the first principles of mathematics that ground the science of optics, concerned with explaining the action of light.

Aquinas, like St. Bonaventure, Hugh of St. Victor, and other medieval theologians, distinguished between the craftsman's initial free act of contemplation, in which his active intellectual powers *united with God* so that the "exemplary form" was made alive in him, and the subsequent menial operation of fabrication that produced a useful or delightful object. Aquinas characterized the artist's "quasi-idea" as analogous to the working of the divine mind, but the distinction between the divine source of the artist's idea and the human source of his menial labor was important to maintain. This distinction guaranteed the truth of the artistic representation within a Christian ontology of images. The most truthful image was one made without human artistic intervention at all – like a contact relic or a divine apparition – because it was in direct contact with the divine. Scholastic theologians explained the artist's role on the same model (as we will discuss further in the fifth incursion).

The *dangerous* innovation in Leonardo's argument – from a Christian ontological standpoint – was in granting the artist an active, independent role. The artist was no longer simply a passive recipient of God's "offspring" by which God communicates its likeness in "multiplication of itself." Increasingly in the sixteenth-century literature on art, distinctions between "exemplary forms" (the *concetto*, or idea, in the artist's mind) and actual painted or sculpted images are explained in ways that stress the artist's agency. Medieval discussions pertaining to the productive arts that were first formulated by theologians were widely diffused in courtly poetry, vernacular literature, scientific writings on mechanics, optics, and anatomy, and other sources that artists and humanists who wrote about the arts read.

The description of Michelangelo's conceptual powers as "divine" at the height of the Catholic Reformation was related (more cautiously than Leonardo's bold claims for painting made 50 years earlier) to the same medieval conception of the artisan's agency as subordinate to God: by calling Michelangelo's conceptual powers "divine," contemporary writers like Pietro Aretino and Vasari asserted the independent role of the *craftsman as agent* by simultaneously emphasizing his dependence on a higher source of inspiration. Ostensibly this would ensure the truth of an artistic representation in line with the church's ontological point of pressure. Yet it's also worth mentioning that the same underlying structure of beliefs enabled Aretino and Vasari to disagree vehemently on a central issue: the appropriateness of Michelangelo's own judgment in interpreting the sacred Last Judgment.

Truth in and of Art

To put this in terms of the topological matrix, the agency assigned to the artist could vary according to who was speaking, to whom, and to what purpose. But the options depended on the only theory of images that was available. In its Christian formulation, the truth of the artistic representation was crucial for it justified the use of images in religious worship altogether. The underlying issue was ontological – was Michelangelo *really* in touch with the divine in interpreting his scriptural source and departing from existing visual tradition (for example, in the nudity of his figures and the inclusion of scenes from Dante's *Divine Comedy*)?

The Renaissance literature on art is new, extensive, and its sources are heterogeneous – to establish the connotative range of terms is a complex task. Primary literary sources make it clear that the term *art* was conceived quite differently than it is today. *Art* could signify procedures, and as such it was the equivalent of terms like *method* or *compendium*. Despite the diversity of sources, the *artifice* of a work of art was discussed mostly in terms derived from literary theory. The core issue was whether the artifice – which included everything visible in the work – was *appropriate* to the subject matter and to the audience for whom that subject was depicted.

Today we often use the words *art* and *image* almost interchangeably, but this was not always the case. In the Renaissance literature, there is a fundamental *tension* between a theological theory of *images* (the nature of sacred images and their proper use) and a rich tradition for describing *artifice*

grounded in literary theory transferred to the visual arts about how to make a work of art.

This means that *ontological issues were discussed in rhetorical terms*. What guarantees the truth of a sacred image made by human hands? If the image or its invention is divinely revealed to the artisan, the truth of the artistic image is guaranteed by the artist's close relationship with God. But how does one distinguish between the true images of a prophet revealed by God from the false illusions implanted by demons? For the beholder, it is important to be guaranteed that the worshiper worships the *holy figure represented* in the image, rather than the material image itself, whose artifice is due to human hands.

For us today, the important point is to understand how these *tensions* run through a vast variety of texts and artistic practices. The more closely the artist's inborn talent can be aligned with its divine source, the more the *truth* of the sacred image is guaranteed, and the more *reliable* that image is. The texts dealing with the resolution of the iconoclastic controversy that are so important to the subsequent history of the Western idea of art do not even mention the artist. They are concerned with the relationship between God and the worshiper. The main thrust of these arguments is to justify the use of images and the main justification is that human ways of knowing involve sense experience. To put the argument in the starkest terms first voiced by Byzantine apologists such as the patriarch Photios, writing in 867, images made by human art are only mnemonic devices.[10] When these arguments came to the fore in the sixteenth century under pressure from Protestant reformers, ecclesiastical writers like Gabriele Paleotti and Giovanni Andrea Gilio attempted to redirect artistic invention to conform to sense experience. That is, a certain heightened form of optical naturalism (similar to the kind of painting that Leonardo advocated) that was thought to keep the worshiper focused on the scriptural story or holy figure, rather than being distracted or seduced by the artist's virtuosity.

The Christian literature is itself grounded in the same ancient philosophical writings as the many other kinds of classicizing texts that humanist authors used. When we imagine that our modern ideas of art are grounded in the Kantian notion that the work of art is an object meant for individual contemplation, we forget that significant ontological issues were articulated centuries earlier regarding the appropriate appearance of sacred images. It is generally agreed that the systematization of the fine arts at the beginning of the eighteenth century received impetus from seventeenth-century

models of scientific truth. What is less known is the way in which these models of truth are dependent on artistic representations driven, in part, by the redirection of artistic license under pressure of the Catholic Counter-Reformation. One extreme position in the range of possibilities was to ban artistic representations of sacred subjects altogether.

The Pauline doctrine that Christ is made in the image (*eikon*) of God provided the terms in which the iconophile defense of images was expressed. It may seem counter-intuitive to connect arguments made by writers such as Leonardo da Vinci on the discursive powers of the painter's *ingegno*, or Vasari's praise of Michelangelo's *divino intelletto*, with Protestant charges about idolatry. In fact both Protestant theological arguments against images and Italian defenses of art agree in one significant respect: they redirect the ontological connections traditionally made between the image and its referent *in* the image to the maker *of* the image (the artist or patron). The agency responsible for the artistic product has shifted, and the grounds of discussion shift from ontological to epistemological considerations.

In refocusing theories of sacred images toward a concern with the *mentality of the image-maker*, writings on the artist's powers of invention introduced what might be called "meta-signifiers" of the work of art as a sign: that is, *those responsible* for fabricating the image, whether the patron as artist or the artisan who materially fabricated the object. As new concerns entered the debate on theories of imagery, a confusing range of new possibilities emerged in ordering the topological field or matrix consisting of the *work* itself, the *agent(s) or force(s)* held responsible for its material mode or appearance, and the proper (or improper) *functions* to which a work may be put.

As arcane as these arguments may sound today, they are the basis for discussing the range and limits of all artistic images in the Western style of representation for the next three centuries. And there is a double forgetting in operation: the first amnesic moment concerns the ways in which theologians and other ecclesiastical writers who established the doctrinal views regarding sacred images are indebted to the *same* ancient sources that were used by humanist writers to discuss and celebrate the powers of the artist/artisan and his exquisite artifice.

Contemporary amnesia about the historical grounds for what is taken today as natural about art, artist, and agency is less a passive forgetting and more an action taken in the present against a past that is forced to disguise itself, as Michel de Certeau has argued, in the case of historical time in general, as we shall see in the following Incursions.

Notes

1 Sarah Thornton, *Seven Days in the Art World* (New York: W. W. Norton, 2008), 216–217.

2 Permission to reproduce an image of this artwork was turned down during this book's production process. For a reproduction see http://arttattler.com/archivemurakami.html (accessed July 4, 2011).

3 See, e.g., *Salvador Dali: Liquid Desire*, exhibition organized by the National Gallery of Victoria (NGV International), June 13–Oct. 4, 2009, with the collaboration of Fundacio Gala Salvador Dali, Figueres, Spain, and the Salvador Dali Museum, St. Petersburg, FL.

4 In June 2007 Hirst's exhibition *Beyond Belief* opened at the White Cube gallery in London featuring *For the Love of God*, modeled on an eighteenth-century human skull, recreated in platinum and adorned with 8,601 diamonds and the specimen's original teeth. It was eventually bought by a consortium including the artist and his gallery for £50 million ($100 million at the time). *Beautiful Inside My Head* was a two-day auction at Sotheby's, London, on Sept. 15–16, 2008. While it raised £111 million ($198 million), a record price for a living artist, the sale was reputedly propped up by the artist's business colleagues. Hirst has always used assistants, fabrication procedures which have also been compared to Warhol's factory system. Arifa Akbar, "A Formaldehyde Frenzy as Buyers Snap up Hirst Works," *Independent* (Sept. 16, 2008), at http://www.independent.co.uk/arts-entertainment/art/news/a-formaldehyde-frenzy-as-buyers-snap-up-hirst-works-931979.html (accessed July 4, 2011).

5 Grant Kester, "Crowds and Connoisseurs: Art and the Public Sphere in America," in Amelia Jones (ed.), *Contemporary Art since 1945* (Oxford: Blackwell, 2006), 254.

6 This is the case, for example, in indigenous Australian groups who, in adapting ancestral designs to make acrylic paintings that now circulate in the public domain, have developed a variety of (not always successful) coping strategies to satisfy traditional social rules in a changed situation. In the case of a recent touring exhibition originating at the Herbert F. Johnson Museum in the United States, entitled *Icons of the Desert: Early Aboriginal Paintings from Papunya*, exh. cat. ed. Roger Benjamin with Andrew C. Weislogel (Ithaca, NY: Cornell University Press, 2009), the curators, museum, and indigenous advisers decided not to reproduce certain potentially transgressive images in the Australian edition of the catalogue for this reason.

7 Gianpaolo Lomazzo, *Trattato dell'arte de la pittura* (Milan, 1584), 262–263, and *Idea del Tempio dell'arte* (Milan, 1585), ch. 11, in R. Ciardi (ed.), *Scritti sulle arti*, 2 vols. (Florence: Marchi & Bertolli, 1973–1974), 282.

8 Thomas Aquinas, *Commentary on the Metaphysics of Aristotle*, 2 vols., trans. John P. Rowan (Chicago: University of Chicago Press, 1961), VII.L6: C1381–1416.

9 Leonardo da Vinci, *Codex Urbinas* (1270), translation cited in Claire Farago, *Leonardo da Vinci's "Paragone"* (Leiden: Brill, 1992), 305–306 n. 8.

10 When the patriarch Photios, building upon the arguments developed by his predecessor Nikephoros a century earlier, lectured in 867 on the proper use of images to commemorate their restoration in Hagia Sophia, he explained the function of the image in optical terms. Photios stressed the absence of real presence in artificial images and argued that images are necessary to religious devotion because the senses, and sight above all, are our natural human way of learning. For the homily of 867, see Cyril Mango, *The Homilies of Photius, Patriarch of Constantinople* (Cambridge, MA: Harvard University Press, 1958), 293–294.

Further Reading

Hans Belting, *The End of the History of Art?* trans. Christopher S. Wood (Chicago: University of Chicago Press, 1987).

Hans Belting, *Likeness and Presence: A History of the Image before the Era of Art*, trans. Edmund Jephcott (Chicago: University of Chicago Press, 1994).

Howard Caygill, *The Art of Judgement* (Oxford: Blackwell, 1989).

Michel de Certeau, "Psychoanalysis and its History," in *Heterologies: Discourse on the Other*, trans. Brian Massumi, foreword by Wlad Godzich (Minneapolis: University of Minnesota Press, 1986), 393–395.

Terry Eagleton, *The Ideology of the Aesthetic* (Oxford: Blackwell, 1990).

David Freedberg, *The Power of Images: Studies in the History and Theory of Response* (Chicago: University of Chicago Press, 1989).

W. J. T. Mitchell, *Iconology: Image, Text, Ideology* (Chicago: University of Chicago Press, 1986).

Erwin Panofsky, *Idea: A Concept in Art Theory* (Columbia: University of South Carolina Press, 1968).

Larry Shiner, *The Invention of Art: A Cultural History* (Chicago: University of Chicago Press, 2001).

David Summers, *The Judgment of Sense: Renaissance Naturalism and the Rise of Aesthetics* (Cambridge: Cambridge University Press, 1987).

David Summers, *Michelangelo and the Language of Art* (Princeton, NJ: Princeton University Press, 1981).

SECOND INCURSION
THE DANGERS OF ART AND THE TRAP OF THE VISUAL

It is never possible to guarantee that the intended message being conveyed by an image is received and properly understood by viewers. Historically, it has been argued that viewers are distracted from the message by the artistry itself. Such a distinction between content and form supports a belief that *both* have lives of their own: spirit or idea on the one hand, and visuality on the other, each with its own history.

Who sees? Who is capable of seeing, what, and from where? Who is authorized to look? How is this authorization given or acquired? In whose name does one look? What is the structure of the field of vision?
Ariella Azoulay, *Death's Showcase*[1]

Yinka Shonibare's *Nelson's Ship in a Bottle* (2010) is displayed at one of most coveted venues for exhibiting provocative contemporary art in London: the Fourth Plinth of Trafalgar Square commissioned by the mayor of London and, in this case, sponsored partly by the Guaranty Trust Bank of Nigeria (Figure 2.1). In place of plain canvas, this scale replica of the *HMS Victory* has 37 sails made of richly patterned textiles associated with African dress. The type of textile is Shonibare's signature style and it is important to his work that the fabric is not actually African-made, but a product of the global neo-colonial network of trade. Cheap, machine-spun, wax-print, batik-inspired textiles have been produced in Indonesia

Art Is Not What You Think It Is, First Edition. Donald Preziosi, Claire Farago.
© 2012 Blackwell Publishing Ltd. Published 2012 by Blackwell Publishing Ltd.

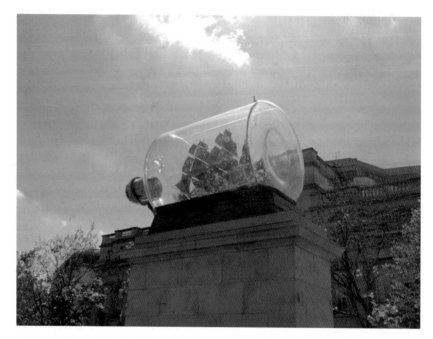

Figure 2.1 Yinka Shonibare (British, b. 1962). *Nelson's Ship in a Bottle,* 2010. Mixed media. Installation view, Fourth Plinth, Trafalgar Square, London. Photo Claire Farago.

and elsewhere in Asia for the African colonial market since the nineteenth century. The artist first used the material in place of canvas in 1994, when he stretched fabric bought at the ethnically diverse Brixton Market in south London to simulate abstract paintings. Shonibare intended his materials to be mistaken for a direct reference to his "African identity". He achieved international acclaim as critics realized that he was actually using markers of ethnic difference to interrogate clichés of otherness. Born in London of aristocratic African parents and raised in Lagos, Nigeria, one of the world's liveliest and wealthiest metropolitan cities with a complex colonial history and a highly globalized and diverse culture, Shonibare has lived as ethnically "impure" a life as the fabric that established him on the short list of YBAs (Young British Artists) is "inauthentic."

A good fit after all. As Nigerian artist/critic Olu Oguibe explains, the body of work that first achieved widespread recognition for the artist was entitled *Double Dutch* for several reasons.[2] First, the play on the British and

Dutch traders who supplied western Africa with the Asian fabrics that are still worn as everyday apparel by postcolonial Africans, especially in former British colonies. Second and third, *Double Dutch* also refers to a rope skipping game popular among African diaspora populations in which the rope skipper contends with two opponents at once, *and* to a language game similar to pig Latin, played by children everywhere to display their mental and verbal agility. Three metaphors for the trickery and treachery that Shonibare replayed so successfully as a game of cultural contestation against the First World art system that he became one of its biggest stars. Wickedly clever, superbly eye-catching, and politically astute, Shonibare's installations have continued to deliver his signature ironic message in a variety of forms over the years, nearly always involving Dutch/Indonesian/African wax-print fabric designs. Fifteen years after his debut, *Nelson's Ship in a Bottle* alludes to the terms that made the British Empire's global network of trade possible: superior technology combined with innovative military strategy to achieve control of the international seas at the Battle of Trafalgar (1805).

But a peculiar transformation has unfolded since Shonibare initially burst onto the art scene: although he styles himself as bicultural, his work is now hailed as putting African art in the mainstream, and his use of fabrics is considered symbolic of African identity and independence, despite acknowledgment of the rather different history of its use. What may seem even more curious is that what began as an important critique of identity politics delivered by a postcolonial outsider who wished to avoid being typecast in the role of "ethnic artist" is now taking a turn to celebrate the fiftieth anniversary of Nigerian independence and the twentieth anniversary of its sponsoring bank, proud to be showcasing "Black Art."[3]

But in fact there's nothing curious about this if you consider the essential fragility of the relationship between the construction and the construal of an artwork: that how a work is read or interpreted is not necessarily controllable in ways that the maker or others might wish. Because significance is always subject to change, transformation, and even reversal over time and space, it invariably evokes problems of control and social discipline, of who gets to write a history and for whom. The most radical gesture never exists in a power vacuum, and its dangers to established order can be effectively contained by according the artist hegemonic institutional status. As the anger of Britain's postwar "angry young men" was blunted by their being canonized as members of the literary establishment, so too Shonibare's complicit self-canonization comes as no surprise. The paradigmatic loom

of today's global art system uncannily weaves art, capital, gender, and national identity back together after the occasional critical rip.

The very palpable danger of art, and especially art that imitates nature, as documented from Plato up to Early Modern writers engaged in church reform, as the preceding incursion already mentioned, lay in its tendency to jeopardize the stability of institutionally imposed values, thus endangering the health of society. What is important is the understanding of *artifice as a form of truth*. As writers allied with the Catholic Reformation re-emphasized in the sixteenth century, the more closely the artist is allied with God, the "truer" his artistic representation of sacred subject matter. For the same reason, Protestant theologians such as Ulrich Zwingli identified the *Abgott* in the patron's soul as anything that displaces God, be it money, glory, or another deity: as one becomes reliant on those "strange gods," the source of idolatry finds its external and indeed very monstrous expression *in* and *as* works of art.[4]

In the mid-sixteenth century, the Catholic Church tried to redirect the increasing freedom recently accorded the artist, recognizing it as quite literally dangerous because it diverted the attention of worshipers away from their devotions and toward admiration for the artist and his magnificent artifice. In issuing its famous "Decree on Images" (1563), the ecclesiastical establishment attempted to impose an absolute *decorum* – an improved and proper fit between the subject of representation, the style in which it was presented, and the audience for whom the representation was intended – which was intended to focus on the artifice as an optimal instrument for enlivening the beholder by appealing to his imagination through his senses. The authorities were quite clear that what was needed was a clarification of the nature and functions of the entire aesthetic matrix.

The greatest challenge that ecclesiastical writers faced was defining the *proper limits* of artistic license. As just noted, they were concerned with ontological issues, but the discussion was conducted in terms of artifice (derived from literary theory) on the proper fit between subject matter, the final appearance of the work, and the audience. There was never any agreement on the rules, but there was in any case now thought to be no room in the tightly controlled topological matrix of relationships (between agent, object, and function, as defined by the Council of Trent) for *distracting* the worshiper with admiration for the artist's ingenuity or the marvels of his artifice. Such digressions from the sacred purpose of artifice would be idolatrous if admiration of the material work of artistry or artifice – instead of the holy figure or scene represented in it – were (thereby irresponsibly) foregrounded.[5]

The historical record suggests *both* resistance and creative accommodation to the new standards of religious decorum. The standard distinction that ecclesiastical writers such as Archbishop Gabriele Paleotti made (following ancient and modern authorities on the limits of artifice) was that capricious fantasies which have no counterpart in the real world were inadmissible.[6] But Paleotti, author of one of the mostly widely disseminated treatises to follow up on the church's famous decree of 1563, felt he had to justify his exclusions, which led him to seek universal rules. In the end, he constructed new boundaries to the debate, favoring painting in the scientific style of optical naturalism, because it was in accordance with the way the eye sees nature directly and so it was not thought to distract the worshiper from the religious purpose of art (to lead him toward a state of grace).

The reformed scientifically based naturalistic style that appeared in response to church authority at the end of the sixteenth century and the beginning of the seventeenth was interpreted as being *devoid* of seductive artifice, despite the fact that artists had to have a great command of perspective, anatomy, drawing skills based on the direct observation of nature, and the ability to combine individual elements into a coherent, idealized representation of nature defined according to certain rules to engage the viewer's senses. We don't usually think of Western styles of naturalism as ideologically freighted by the ontological concerns of Christianity, but it was precisely on this basis that academic instruction developed the teaching methods that came to be in common use throughout Europe and beyond. Scientific naturalism was deemed to conform to human ways of learning from sense experience. Not only ecclesiastical writers but artists and art theorists such as Gianpaolo Lomazzo and Federico Zuccaro, who regarded the artist's license to invent things out of his imagination as central to the very idea of artifice, came to stress the value of scientific naturalism in terms established to justify the devotional use of sacred images.

The legibility of scientific naturalism (assumed to be universal, though its colonial applications certainly proved otherwise) and the teachability of artifice rendered on these terms, made Western styles of naturalism an ideal vehicle to express other forms of institutional authority. Missionaries exported naturalism widely to aid in the conversion process, but European dynastic rulers, later the authoritarian regimes of some modern nation-states, also found it useful. What we are calling broadly "Western" styles of optical naturalism were capable of being inflected in numerous ways and for different purposes. What we still call the French, German, Spanish, English, Italian, and other national schools of art testify to this flexibility.

There is no doubt that Western styles of representation have functioned as powerful epistemological tools in many different contexts. Their contemporary offspring is the mass media, all too often perceived as a transparent vehicle connecting people in one place with events in another.

Western critical language for evaluating pictorial embellishment has been framed in optical metaphors since antiquity. Terms of praise and blame such as "brilliant," "vivid," and "obscure," were never a transparent code; rather they refer to a complex system of figuration based on the assumption that abstract content can be communicated in images presented to the senses.

The discourse motivated by Christian theories of images in its most severe form worked precisely against the contemporaneous humanist literary tradition – itself grounded in the same ancient sources – that granted priority to the artist's ingenuity or genius and skill. This literature put increasing emphasis on the artist's powers of invention, but it also supported the underlying Christian ontology of images by emphasizing that the artist's powers, his *ingegno*, imagination, inspiration – the language and terminology varied and gained in richness – were gifts bestowed upon the artist that he (or, rarely, she) developed through diligent study. *Arte* in this sense (the Latin translation of the Greek term *tekhne*) referred to a body of skills that could be learned, while *ingegno* (from the Latin *ingenium*) referred to the artist's inborn powers, a divine gift.

The possibility of understanding the product of the artist's labor as well as his mental conception as an index of his character – his ingenuity, his devoutness, his *grazia*, *terribilità*, and, even more fundamentally, his *humanness* – is at the root of the modern idea of art. The artist's powers of conceptualization embodied in his "scientific" process of fabrication from initial sketches to completed work of art became a way of assessing the epistemological status of the work as well as the moral character of its maker.

Carrying the Matrix Beyond Europe (and Back Again)

In highly schematic form, we have just sketched the possibilities developed in Early Modern European texts and artistic practices (ca. 1400–1700) for evaluating the role of the artisan as an agent in the art matrix. But similar discussions also emerged in the context of European colonization, based on the same inherited theories of human cognition. The capacity to recollect, that is, to draw a series of inferences, as Aristotle and his commentators

defined the distinction between the human faculty of memory and the
retentive memory of animals, was both directly cited and indirectly implied
throughout sixteenth-century discussions of the mental capacities of colo-
nial subjects converted or "needing" conversion to Christianity, as judged
through their various forms of behavior, social organization, and cultural
productions. Even the strongest defenders of the Amerindians like Fra
Bartolomé de las Casas helped to construct an inferior collective identity
for the indigenous peoples of the "New" World in arguing that the Indians
were in fact capable of assimilating European culture, but only under
European guidance.[7]

Modern European notions about art and artistry have in fact a hybrid
genealogy in a double reckoning with its own religious views on the nature
and functions of artistry *and* with its encounters with non-European
societies. While Protestant Reformation theologians denounced the lavish
religious displays and material aids of Christian worship as idolatrous, their
ecclesiastic counterparts in New Spain and elsewhere levied charges of
idolatry against their newly colonized subjects. What the Catholic mis-
sionaries called "idols," regarded in terms of their grotesque appearance,
were understood as signs of the moral corruption and demonological pos-
session of their potential converts. Upon entry into the Early Modern
European *Wunderkammer*, such "idols" continued to both attract and repel,
but only as phantasms of their former selves: in the context of collecting,
"idols" were experienced as exotic curiosities.

In other words, *the same neo-Aristotelian theory of human cognition that
justified certain forms of artifice also justified their condemnation.* The dif-
ferences lay in how value was to be attributed to the relative positions of
agent, object, and function in the art matrix.

An unprecedented relationship was being worked out in these Early
Modern texts and collecting practices between what we commonly distin-
guish as *subjects* and *objects*, and a complex discursive field about artistic
invention encouraged certain generalizations. The artifice of any work of
art was most often evaluated as part of a contest between nature and art
but, whatever the narrative framework, the artist's invention was always
conceptually conjoined with the needs of both the subject and the particu-
lar viewing audience. In the three-way relationship between subject, artist,
and audience, the intentions of the artificer were considered embodied and
manifest in the work of art.

The central point in these discussions was in fact precisely the old scho-
lastic distinction between the "delusions" of a dissolute person and the

"true visions" of a prophet. In the thirteenth century, Thomas Aquinas articulated the range of logical possibilities in his differentiation between the eternal *substance* of an object and its accidental, external *appearance*. Mutations in appearance were external to the visionary's eyes, but the imagination of the "dissolute person" caused him to mistake the image for the thing itself, and he was thereby captivated by demonic illusions (*Summa Theologica* 3.76.8). Writing in 1582, Paleotti had condemned the representation of monstrous races, infernal rites, demonic gods, and idol worship and human sacrifice for the same reasons: they are evidence of the imagination of a dissolute person. The significant difference in the later, sixteenth-century text is that the grotesque artifice now refers to the *maker* of the image.

In observing how old categories stretched to fit new situations, we can begin to understand how non-European objects and images contributed to theoretical and critical discussions of Western art, even when their existence was never directly mentioned. *Fantasie, grotteschi, capriccie,* and similar artistic inventions signified doubly. On the one hand, they stood for the artists' freedom and capacity to invent images out of their imaginations that nature alone could never create. On the other hand, and for the same reason, in the absence of knowledge of proportion, perspective, and other subjects involving rational thought, they were associated with irrational mental activity, the active imagination unrestrained by human reason.

We've largely forgotten that the institutionalized classicism taught in academies of art for over three centuries had its direct sources in treatises on art composed in response to fifteenth-, sixteenth-, and early seventeenth-century discussions about the *proper* relationship between the appearance of a work of art and its function. The issues played out in debates over the best use of the artist's powers of sensate judgment.

A striking example of these continuities is provided by Leonardo da Vinci's *Treatise on Painting*, posthumously complied from the artist's autograph writings by his student Francesco Melzi and abridged by an anonymous editor in conformity with Tridentine efforts to redirect artistic invention. The abridged version of this text circulated widely and was eventually published in Paris (1651), where it became central to debates about artistic training at the Académie Royale de Peinture et Sculpture, founded in 1648.[8] The text was translated into all the major European languages and widely disseminated in Europe and its colonies, where it influenced other theoretical writings and frequently figured in academic artistic instruction.

In the seventeenth and eighteenth centuries, descriptions of early peoples outside Europe focused on their presumed lack of reason as a fundamental difference from civilized peoples. Giambattista Vico, in his widely read *La Scienza nuova* (1725) set the terms of discussion for the Enlightenment era in the first systematic effort to reconstruct the origins of culture. The framework of ideas that he articulated drew directly on the preceding century's intellectual heritage, which had been dispersed in a variety of sources, including travel accounts, illustrated cultural geographies, art criticism, and other forms of popular literature.

For 300 years, the classicizing foundation established in sixteenth-century treatises of art came to be typical of art academies throughout Europe. Meanwhile, the analyses of Vico and many others who made the same distinctions were based on the hypothesis that early peoples lacked the power of reasoning (ratiocination) but possessed a robust and vigorous imagination. On these grounds, "primitive" humans, in contrast to Europeans, were deeply immersed in their immediate sensory experiences without the mediation of abstract reasoning.

Some writers, like Rousseau, ennobled early peoples precisely because they were thought to live in harmony with nature, but for most writers working with European ideas, these others were assumed to possess minimal cultural traditions and to live with little awareness of the past or future. Their inability to abstract from experience was thought to explain the absence of European artistic styles of representation based on techniques of chiaroscuro and linear perspective such as those associated with academic artistic instruction. Ironically, the first major influx of artistry from the South Pacific and the North American Pacific northwest entered Europe at the very moment when the classical tradition was reasserting its dominance during the last quarter of the eighteenth century.

As Frances Connelly has shown, classicism, with its rational principles of composition and design, provided the standard or norm for assessing the (anti-rational) extra-European culture of "primitive people," emblematized as the "arabesque" or "grotesque ornament." The anti-rational grotesque provided a systemically necessary periphery to the classical for some three centuries, although the antithesis can be traced to ancient Roman rhetorical theory, where the analogous pairing of literary style was the Attic and the Asiatic, the former configured as natural speech and the latter as the obviously artificial, suave, or florid style of speaking. In some cases, the Romantic fascination with the grotesque and the monstrous led artists to study and directly incorporate elements of non-Western design directly

into their work. By the time Picasso incorporated direct references to African masks in *Les Demoiselles d'Avignon* (1907), setting off a (newer) modernist romance with "primitive art," the dyad of grotesque versus classical beauty had underpinned the Western discourse for more than three centuries.

Evidence for the role of extra-European artifice in not simply impacting upon but in fact co-constructing modern European ideas of art is extensive, and even an abbreviated account would take us far beyond the space and purpose of this volume. Our aim here is not to write a history of the idea of art, but to suggest in this incursion that in the Western tradition, from early to late to *post*modernity, the *structure of relations within the art matrix appears to maintain earlier religious notions under changing social circumstances as essential components in the modern discourse on the arts.* The next two incursions raise the question of what has changed and what hasn't (structurally, systemically) in contemporary ideas of art.

The Romantic Hero-Artist

The significance of what is taken to be the cause of the artifice (its truth or falsehood) was central to discussions of the emerging modern idea of art from the sober religious climate of the latter part of the sixteenth century to the contemporary (quasi-positive) evaluation of "primitive art" that is the subject of our third foray below. It's not the case that the arguments were new, or that the truth and falsehood of artifice had not been debated for a very long time in the Western philosophical tradition, but marshaling the arguments to establish an absolute sense of decorum controlled by institutional authority – and imposed on the cultural production of extra-European peoples – is a feature of modernity. Transformations in a neo-Aristotelian theory of the imagination that granted increasingly independent powers to the artist's mental deliberations, together with the classification of human knowledge in a hierarchical scheme that had always subordinated fiction and fantasy to rational thought and divine revelation (not without its gendered markings, moreover, as we'll see later) were two crucial historical factors in the modern Western idea of art. Renaissance painting, sculpture, and architecture – defined as theoretically grounded pursuits associated with poetry and perspective, and based on experience defined in terms of the direct observation of nature – provided the

standards against which non-Western cultural products continued to be measured by Europeans for hundreds of years.

By the late eighteenth century, with the rise of the European nation-state, the industrial revolution and early capitalism, and the elaboration beginning around 1750 of a philosophy of art (*aesthetics*), the Romantic notion of the artist (as a unique poet-genius standing in an oblique relationship to other citizens of the state or community) offered a different account than that of the Renaissance artist because it combined both readings of the pre-Enlightenment evaluation of an artist's mental capacities. The Romantic artist-genius, sometimes simplistically conflated with his Renaissance predecessor, occupied a very different, liminal position, both within and outside society. This was a position akin to that of the seer or sibyl, whose distance from the daily life of the people accorded him or her uniquely powerful insights into fundamental problems, conflicts, or conundrums. The artist functioned socially as both problematizing the world of daily life and curing its ills. Prophet and pariah, the artist was seen as both deeply embodying *and* radically endangering what were (presumably obscured or forgotten) conservative social values.

Modern scholarship dealing with the history of the comparison of the arts has focused on eighteenth-century themes like the unity of the visual arts. It is often assumed that the initiating argument for formalism is expressed in Kant's remarks on the beautiful, and indebted to his immediate predecessors like Alexander Baumgarten or G. E. Lessing who also focused on the general conceptions and principles of the arts. Actually the issues have a much deeper history: what began as polemical arguments about the relative merits of painting and sculpture in the sixteenth century had by the later eighteenth century attained a new level of philosophical credibility. Lessing and Kant, for all their differences, were both strongly suspicious of excessive pictorial ornament (which Kant associated with the imagination unguided by reason). Although the primacy of vision has a long history in Western philosophy, the commonplace term "visual art" – which might seem too neutral even to even *have* a history – actually made its earliest appearance in the first formalist theories of art at the end of the nineteenth century that expanded Kant's hierarchical distinction between rational and irrational representations.

In recent decades an increasing number of critics have claimed that the autonomous histories of the "visual arts" (as "histories of vision") first proposed in the late nineteenth century are for a variety of reasons no longer tenable. Art, defined on a Western model of optical painting, was

viewed as a "natural" sign, because it seemed compatible with our actual (biological) visual experience of the world. But is this not a culturally specific perspective on what art *is*? At the same time, a notion has also taken root that the visual (or the idea of visuality) had its own history, as preserved in works of human material culture broadly defined to include print, photography, digital imaging, film, video, multimedia, even performance. "Visual culture studies," and corresponding journals, university departments, and websites have given the category a material presence far beyond the unresolved disciplinary debates that generated such terminology. In other words, *visual culture* is staged as the cure for a condition of which it is itself symptomatic.

The Discontents of Art

So what does all this mean for us today? Are we stuck with the problematic category "visual art"? Is there some pressing reason to retain it in a manifesto on the idea of art that might promise an alternative perspective on these enduring conundrums? In 1958, when the Marxist literary and cultural historian Raymond Williams described culture as "one of the two or three most complicated" words in the English language, he argued that as culture came to mean a mode of interpreting common experience in terms of personal experience, it necessarily affected the meaning and practice of art.[9] Theories of cultural relativism, for example, coincided with the Romantic rejection of "all dogmas of method," especially those associated with representational art in the academic tradition of naturalism. As art became a key "center of defense against the disintegrating tendencies of industrialism" it became an object meant for individual, secular, "aesthetic" contemplation.

This nesting together of art, culture, and social modernity foregrounds the precise predicament we find ourselves in today, which might be quickly sketched as a double imperative informing disciplinary knowledge. On the one hand, we remain deeply invested in the Enlightenment project of accounting for the particular qualities of national cultures and ethnicities, while on the other hand we also seem committed to a project of defining art as that which is universally human at the "highest" spiritual level.

What makes current understandings of art still indebted to Enlightenment thought is precisely the historical *conjunction* of these two different ways of defining art. It has not proven feasible to divorce one way of defining

art from the other. *Art* (the essentialist argument) and *culture* (the material-ist argument) express two extremes of the central anthropological problem of defining humanness itself through art. Like an alternating electrical current, the alternation between *art as universally spiritual* and *art as the product of a particular culture* keeps the discursive field in place by its very oscillatory power, its enduring unresolvability.

We should rather begin with an acknowledgment of the dialogical rela-tionship as such: where did the oscillation itself come from and how does it endure? What drives the mechanisms of its many iterations over time, place, situation, as well as at different scales? And, especially, who benefits from this perpetual displacement of critical and historical attention? Is it another echo at a different scale of the theological conundrum signaled by the juxtaposition of the spiritual (immaterial) and the material?

Historical representations themselves, as Michel de Certeau argued, bring into play past or distant regions from beyond a boundary line sepa-rating the present institution from those regions. History writing (what he termed historiography) and psychoanalysis contrast with each other as two modes of structuring or distributing the space of memory. They comprise two strategies of time; two methods of formatting the relation between past and present. For history writing, this relationship is one of succession (one thing after another), cause and effect (one thing following from another), and separation (the past as distinct from the present). But psychoanalysis treats relations between past and present differently, as that of *imbrication* (one thing in the place of or covering the other) and *repetition* (one thing reproducing the other but in another form). Both, de Certeau argued, developed to address analogous problems: "to understand the differences, or guarantee the continuities, between the organization of the actual and the formations of the past; *to give the past explanatory value* and/or make the present capable of *explaining* the past; to relate the representations of the past or present to the conditions which determined their production."[10]

The argument has important implications for our understanding of historical ideas of art not only as phenomena that in varying ways incorporate what are distinguished as historiographic *and* psychoanalytic "strategies of time" or ways of "distributing the space of memory," but also as practices that provide the past with explanatory value in the present.

The issues raised by de Certeau about the spatial topographies of memory distribution and the shifting and multiply legible subject positions entailed by different strategies of time are powerfully foregrounded in the

work of a number of exiled artists calling attention to the plight of women by using the tools of their marginalization in the art system in an inverted manner to problematize the Western exoticization of its others. Exiled Iranian film-maker and photographer Shirin Neshat, for example, depicts writing in Farsi on women's bodies that calls attention to the silencing of women's voices and their subaltern positions in patriarchal theocratic regimes (as in the Iran she fled) and by implication in patriarchy in general (Figure 2.2). Especially evocative are Neshat's works incorporating texts written on mirrors or bodies so that spectators see themselves first exoticized with the unfamiliar writing appearing on their own bodies' reflected images, which in turn calls attention to the artist's own exoticized position in Western society, made manifest by directly implicating the spectator in the activities of marginalization and exoticization.

In a not dissimilar vein, Mona Hatoum, an artist born in Beirut of Palestinian parents, uses the physical activity and movement of the

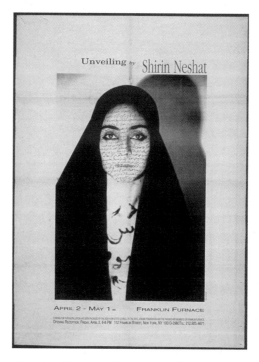

Figure 2.2 *Unveiling* by Shirin Neshat. Poster of exhibition, Franklin Furnace, Brooklyn, NY, Apr. 2–May 1, 1993. Photo courtesy of Franklin Furnace Archive, Inc.

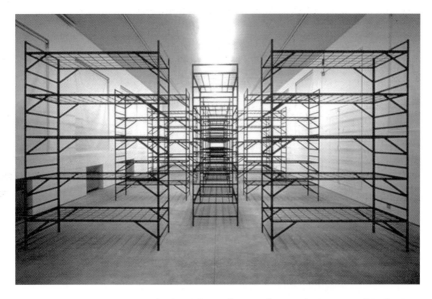

Figure 2.3 Mona Hatoum (Palestinian-Lebanese, b. 1952). *Quarters (Twelve Iron Structures)*, 1996. Iron. Installation view, Viafarini Gallery, Milan, Oct. 16– Nov. 21, 1996. Photo courtesy of the gallery.

spectator to evoke what was hidden or imbricated. Her 1996 installation *Quarters* (Figure 2.3) was literally animated by the viewer's movement through it.[11] While walking through a three-dimensional array of upright stacked metal bedframes, the spectator is suddenly surprised when reaching a position from which the arrangements dramatically fall into place as an axis of symmetrically aligned structures. At precisely that "Aha!" (*nunc stans*) point, the spectator's perception is suddenly altered by an awareness of being the focus of surveillance; of being in prison amidst prison bedframes. The spectator's position is precisely where everything makes sense geometrically. But the privileged view or gaze is a trap, for it makes it clear that one's clarity of vision is itself a trap: one is imprisoned by one's own gaze. It is as if a view such as we saw in the illustration of an ideal fifteenth-century city painting (Figure I.2) was a mirror of the spectator's viewpoint. A double manifestation: when you can finally and clearly see your environment, you can see clearly that you are in prison. That clarity and straight-forwardness of vision and centrality of position masks one's own marginalization. In an action that simultaneously evokes and problematizes historical and psychoanalytic methodologies, Hatoum interrogates the

distribution of the spaces of memory and identity by troubling the distinction between placement and displacement, order and disorder, past and present. The themes of cultural displacement and exile are staged as an endless oscillation between coherence and chaos, centrality and marginality, freedom and imprisonment. In short, an inverted and displaced Western discourse about the other is turned into a critical tool for troubling that discourse.

Hatoum and Neshat deal with what de Certeau referred to as "mnemic traces," where what is forgotten (an action against the past) returns in disguise, hidden, covered over by what appears as real or truly seen or known. Both artists deliberately perform the impossibilities of any direct and unambiguous seeing, and problematize neat oppositions between the viewer and what is seen, the gaze and its object. Such complications have a long history in artistic practice, but what Neshat and Hatoum make very apparent is that both terms are not fixed or static but relational and dynamically changing phenomena – as indeed we have begun to explore here with the notion of the art matrix and its topologies.

Which raises the question of *visuality* itself as a distinct phenomenon, a concept with a complex modern history. In the 1980s visuality came to mean something akin to Michel Foucault's discussion of "visual field," or film critic Christian Metz's discussion of "scopic regimes," or other terms in use at a time when writing histories of art as if all art were the object of perception began to be seen as problematic. "Ocularcentrism" and "perspectivalism" are two more closely related coinages to designate the hegemony of vision in modern life. And we are still talking about the dynamics of gazing, the proliferation of surveillance, the production of spectacle, and other ways of exerting institutional, social, and political control that extend the province of seeing far beyond images. There is at present a disturbing lack of clarity about the relationships between the critical discourse on "visuality" and the historical term "visuality" leading up to Kant in the latter part of the eighteenth century, and its recent reification as "visual culture" or "visual art," frequently applied (naively and ahistorically) to all kinds of cultural production as if they denoted a neutral, inclusive discursive framework, marking a fitting sequel (as an "expanded field") to the more restrictive Western category of "art."

The imposition of European values on extra-European cultural objects was the subject of Edward Said's groundbreaking book *Orientalism* (1978). It is not idle to ask in a volume devoted to the idea of art whether the category visuality can avoid falling into the Eurocentric trap as long as the signifiers

"art" and "visual" remain intact. Addressing the ways in which old sets of relationships continue to be reproduced structurally in displaced form – leaving "mnemic traces" in the historical record – requires a historical vision of sufficient scope and analytical commitment to understand how our inherited categories came into being and why they don't serve us well today.

For memory is never innocent. The co-construction of the categories of "art" and "culture" witnessed in the latter part of the eighteenth century was replayed at the end of the nineteenth century when the modern disciplines of art history and anthropology divided the world's cultural productions into two basic categories of "art" and "artifact." Despite the breadth promised by the term "visual art" (problematic though it might be on other grounds, as we have seen), these two disciplinary formations, as well as the discourse on art that we have sketched in this second incursion, continue to exert powerful, largely unrecognized effects on our contemporary understanding of art as our next Incursions take up.

At the end of the nineteenth century, cultural anthropologist Franz Boas was among the first to use the word "culture" in the modern plural sense, when he shifted the grounds of inquiry from a search for signs of inherited difference to an investigation of how foreign material is taken up by a people and modified by pre-existing ideas and customs. The challenge to understand such complex negotiations and modifications as not incidental but central to cultural life still impels us to understand the idea of art as an essential facet of that life.

Notes

1 Ariella Azoulay, *Death's Showcase: The Power of Image in Contemporary Democracy*, trans. Ruvik Danieli (Cambridge, MA: MIT Press, 2001), 4.

2 Olu Oguibe, "*Double Dutch* and the Culture Game," in *The Culture Game* (Minneapolis: University of Minnesota Press, 2004), 33–47, an essay as rich and sophisticated as the art it explains, on which our own discussion draws substantially.

3 Citing Guaranty Bank representative Tay Adennokun, at http:www.youtube. com/watch?v=OowSsEh7H4o, accessed Aug. 20, 2010. In the same clip, Shonibare himself describes his *Ship* as celebrating the diverse, global city of London, and its continuing economic success (on the model of Lagos, though he doesn't say so).

4 Carlos M. N. Eire, *War against the Idols: The Reformation of Worship from Erasmus to Calvin* (Cambridge: Cambridge University Press, 1986), 84, citing

Huldreich Zwinglis Sämtliche Werke, vol. 4, 133. The clearest, most detailed exposition appears in Zwingli's *Commentary on True and False Religion*, 1525 (Eire, *War against the Idols*, 85). Calvin also located the root of idolatry in man himself – in his efforts to domesticate God, man transferred the honor due to God to material objects. Calvin's most popular published work against idolatry, *The Inventory of Relics* (1543), compares idolators to unreasoning beasts and considers idolatry an ever present danger because men are by nature metaphysically deranged. See further discussion in Eire, *War against the Idols*, 211–220.

5 Canons and Decrees of the Council of Trent, issued Dec. 5, 1563, ratified by Pope Pius IV in 1564.

6 Gabriele Paleotti, *Discorso intorno alle imagini sacre e profano* (Bologna, 1582), in Paola Barocchi (ed.), *Trattati d'arte del cinquecento fra manierismo e controriforma* (Bari: G. Laterza, 1960), vol. 2, 177–509; on *grotteschi*, see vol. 2, 421 (bk. 2, ch. 36).

7 Las Casas writes that the Indians possessed skill in the mechanical arts, which were a function of the rational soul ("habitus est intellectus operativus"). Bartolomé de las Casas, *Apologética historia sumaria* (1551–), ed. Edmundo O'Gorman (Mexico City: Universidad Nacional Autónoma de México e Instituto de Investigaciones Históricas, 1967), chs. 61–65, comparing the arts of the Old and New Worlds to prove the rationality of Amerindian peoples.

8 A modern critical edition and English translation of Leonardo da Vinci's *Trattato della pittura*, ed. Raffaelle du Fresne (Paris: Langlois, 1651), is being prepared by Claire Farago with Carlo Vecce, Anna Sconza, Janis Bell, and Pauline Maguire (Leiden: forthcoming).

9 Raymond Williams, *Culture and Society, 1780–1950* (New York: Columbia University Press, 1958), xv–48; for his remarks on the difficulty of defining culture, see Raymond Williams, *Keywords: A Vocabulary of Culture and Society* (London: Fontana, 1976), 76–82.

10 Michel de Certeau. "Psychoanalysis and its History," in *Heterologies: Discourse on the Other*, trans. Brian Massumi, foreword by Wlad Godzich, Theory and History of Literature, vol. 17 (Minneapolis: University of Minnesota Press, 1986), 3–16 (emphases added).

11 Originally exhibited in 1996 at Via Farini, Milan, subsequently at the New Museum, New York, Dec. 1997–Feb. 1998. On Hatoum, see Ursula Panhans-Buehler, "Being Involved," in *Mona Hatoum*, Hamburger Kunstalle, Mar.–May 2004, exh. cat., 20–21.

Further Reading

Theodor Adorno, *Aesthetic Theory*, trans. Robert Hullot-Kentor, ed. Greta Adorno and Rolf Tiedemann (Minneapolis: University of Minnesota Press, 1997).

Frances Connelly, *The Sleep of Reason: Primitivism in Modern European Art and Aesthetics, 1725–1907* (University Park: Penn State University Press, 1995).

Jonathan Crary, *Techniques of the Observer: On Vision and Modernity in the Nineteenth Century* (Cambridge, MA: MIT Press, 1990).

Claire Farago (ed.), *Re-reading Leonardo: The Treatise on Painting across Europe 1550–1900* (Aldershot: Ashgate, 2009).

Claire Farago, " 'Vision Itself has its History': 'Race,' Nation, and Renaissance Art History," in Farago (ed.), *Reframing the Renaissance: Visual Culture in Europe and Latin America 1450–1650* (New Haven, CT: Yale University Press, 1995).

Frances Ferguson, *Solitude and the Sublime: Romanticism and the Aesthetics of Individuation* (New York: Routledge, 1992).

Hal Foster (ed.), *The Anti-Aesthetic: Essays on Postmodern Culture* (Port Townsend, WA: Bay Press, 1983).

Martin Jay, *Downcast Eyes: The Denigration of Vision in Twentieth-Century French Thought* (Berkeley and Los Angeles: University of California Press, 1993).

Amelia Jones, "The Contemporary Artist as Commodity Fetish," in Henry Rogers and Aaron Williamson (eds.), *Art Becomes You! Parody, Pastiche and the Politics of Art. Materiality in a Post-Material Paradigm* (London: Article Press, 2006).

Anthony Pagden, *The Fall of Natural Man: The Amerindian and the Origins of Comparative Ethnology*, 2nd edn. (Cambridge: Cambridge University Press, 1986).

Roy Porter (ed.), *Rewriting the Self: Histories from the Renaissance to the Present* (London: Routledge, 1997).

Jacques Rancière, *The Future of the Image* (London: Verso, 2007).

Edward Said, *Orientalism* (New York: Vintage, 1979).

Raymond Williams, *Keywords: A Vocabulary of Culture and Society*, rev. edn. (New York: Oxford University Press, 1983).

THIRD INCURSION
TO SEE THE FRAME THAT BLINDS US

To learn to see the frame that blinds us to what we see is no easy matter.
Judith Butler, "Photography, War, Outrage"[1]

> If ideas about art never exist in a vacuum, as the previous incursions claim, but are always everywhere connected to a topological web of relations between maker, artwork, and artistic function (the art matrix), then taking up a perspective askew from the well-trodden toll-roads of Euro-American art criticism, historicism, and theory will inevitably yield quite different geometries.

We began a fieldwork project in Australia that paused many months later in Paris. Our ex-centric route from what has historically been the periphery to a center of the contemporary art world played with, upon, and against the center–periphery model of artistic and cultural development. Center–periphery explanations of cultural interaction, which have inevitably placed Europe in relation to artistic peripheries elsewhere, represent a colonialist, ethnocentric worldview. The scale of explanation varies – the center could be Rome, the periphery Florence, or England, the Americas, Australia, and so on – but the systemic or structural principle would remain the same if the center were Botswana, Bogota, or Beijing.

 If we were writing a book about global histories of art, we might have begun by taking contemporary applications of the center–periphery model to task for not sufficiently recognizing the dynamically active conditions of reception. By contrast, a network of distributed knowledge practices might

Art Is Not What You Think It Is, First Edition. Donald Preziosi, Claire Farago.
© 2012 Blackwell Publishing Ltd. Published 2012 by Blackwell Publishing Ltd.

offer a less Eurocentric (or Sino- or Afro-centric) way to write such a global history of art. But first there would still have to be general agreement that the problematic notion *art* is a universal, pan-human phenomenon and activity. And that raises other troubling questions – such as, who is at the table to draw up the agreement? Many first nations and indigenous peoples in numerous locations around the globe refuse the label "art" for their cultural productions and object to public cultural institutions such as museums collecting, preserving, or displaying their esoteric cultural artifacts because they are not meant to be viewed in this manner or seen by the uninitiated or even preserved. Our task here is different, in attempting to articulate *how* the Western ideal of (fine) art came to be applied to cultural productions of any origin whatsoever – and, specifically, how that now contested but no less globally disseminated product of European thought operates in the world today.

To understand the art system as a topological matrix, we looked at it obliquely from the more expected and heavily rutted critical and historiographic orbits of contemporary Euro-American art-making, art history, art criticism, and aesthetics. We investigated the origins and evolution of the Aboriginal art movement that began in the 1970s and rapidly assumed international artistic and commercial prestige. How did indigenous Australians without formal artistic training in any conventional sense or even knowledge of art-making practices and their history elsewhere, come to be inserted into the canon of High Modernism? The systemic fabrication of artistic identity is clearly compatible with the prerequisites of the contemporary globalized economy and its need for celebrity artists. The creation of Aboriginal art (the term itself is deeply fraught – initially derived from accounts of cultural "primitivism") is poignantly paradigmatic of the modernist invention and commodification of (fine) art. This specifically entailed the abstraction and extraction – the reification, in fact – of particular formal visual or optical properties and facets as simulacra of actual multimodal, multidimensional, and multifunctional indigenous practices, with the effect of making such abstractions consonant with late modernist (Western) artistic formalism in its contemporary globalized manifestations.

This incursion is twofold. First, it investigates the ramified effects of integrating certain formal aspects of indigenous cultural production into the global system of the visual arts, *both* from the standpoint of the global art system (Aboriginal art as the Next New Thing) *and* from the standpoint of the communities where cultural production takes place. The second aim is to understand how indigenous artistic and/or cultural production and

practice more generally clarify our own presumptions about the nature of (Western) ideas about (fine) art in the contemporary world. Although their visual appeal is primary to their aesthetic and commercial success, the Western Desert acrylic paintings at the center of our fieldwork and discussion here are also widely valued by collectors for the cosmological significance of designs that are very rarely understood at all by those outside the secret and sacred traditions from which the designs are partly derived. Over time, marketing strategies for these acrylic paintings – the issues of origin and nomenclature are complex and fraught, as we will discuss more fully below – have come to incorporate reference to their content in ways that simulate copyright. By including the artist's "dreaming" – told in simple terms that do not violate the community's integrity to control the dissemination of knowledge – the noumenal content of the work is verified, its enigma authenticated along with more prosaic signs of authorship, such as the artist's "skin name," place of origin, the work's exhibition history, and so on.

At the art centers we visited in the desert regions of the central parts of the Northern Territory and the eastern edges of Western Australia, art production potentially offers economic relief from impoverished and in many respects severely dysfunctional community life. The mostly government-run operations function in settings without adequate health care, educational opportunities, and with little or no economic infrastructure such as retail businesses. Yet for all the hope that the production and sale of Aboriginal art in an international market represents for these art centers – it is the reason for their existence, even when they are unprofitable – the artworks themselves have no other intrinsic functions in the communities. They might be a point of pride, but they are also a mark of indentured servitude to a global market; in any case, paintings made by indigenous Australians for the global art market do not *furnish* indigenous houses with objects of individual contemplation or family decor and acrylic paintings as such serve no function in indigenous ceremonies or other tradition-based collective practices. On the other hand, objects initially made for sale, such as dancing boards and clapsticks used in. In other words,there is nothing that intrinsically prevents objects made as art from having a functional value in their indigenous context. Aboriginal communities use their livelihood to negotiate their individual identities between two worlds in subtle and profound ways, coping strategically in ways that neither assimilate nor reflect the dominant culture.[2]

To appreciate the conundrums that contemporary Aboriginal art present for consideration of the art system, it is important to bear in mind how

sudden the transition from the traditional itinerant camping lifestyle of hunting and gathering to a sedentary way of life has been in some cases. As recently as 1984, a group of nine Pintupi people who had never seen white outsiders emerged from the Western Desert. Within three years of first contact, some of them produced museum-quality acrylic paintings for the commercial market.[3] Acrylic paintings mark the arrival of the "genius artist" model of individual artistic production and its attendant manifestation, the celebrity artist.

The jarring effects of a changed lifestyle are furthermore due to the change of federal policy from assimilation to self-determination. Initiated by the Whitlam government in 1972, such programs enabled a greater degree of self-governance and allowed some to return to traditional lands, but did not eliminate the social problems they were intended to address. On the contrary, domestic violence and alcoholism worsened conditions for many indigenous settlements and communities once the government refused to be involved at the local level.

Disjunctions between communities of collecting and communities of production – an effect of this recent "art historicization" of Aboriginal cultural praxis – foreground aspects of what was forgotten, erased or occluded in early European modernity's own invention of what subsequently became the idea of (fine) art as itself an abstraction of certain (visual or optical) properties out of cultural behavior: the abstraction of visuality as such in the service of that modernity. In the next part of this incursion, we journey from these preliminary considerations of contemporary artistic practices originating in the Australian desert to one of its most celebrated points of reception, located in urban Paris.

Twilight of the Gods

We bought our tickets, showed them to a huddle of uniformed attendants, started toward the exhibition entrance, all anticipation. Finally, we were at the Musée du Quai Branly, the recently opened centerpiece of Parisian museology. As we made our way up a broad winding ramp in the increasingly darkened space, a flood of words projected onto the floor silently rushed under us – dancing bright lights weaving hypnotically, beckoning, enticing, teasing. A seductive roadway of words, creating a moving walkway spilling from an unknown source, piling up, moving fast, too fast to read, marking deliriously spiraling trajectories that dissolved, bounced, jostled,

and ricocheted in a virtual jitterbug of disco lights under our advancing footsteps, drawing us upward.

While we immediately recognized the signature style of Scottish-born artist Charles Sandison, there were no obvious labels of any kind. So this was not meant as Art with a capital A, but as *stagecraft*, a literally moving entrance. And what a mystifying space we found at the top of the ramp! An even darker space, with high ceilings hung with bright spotlights trained on amazing, even unimaginable, objects, suspended in enormous glass cases without frames so that everything appeared to be floating in a liquid glittering darkness above the glowing, seamless red vinyl floor that wound through the long, deep space (Figure 3.1). The combination of darkness and reflected light on so much glass facing in many directions absorbed the spectator. We – spectators and displayed artifacts – all became ghostly. Instantly. The objects on display, looming material presences from a museological spirit world, were raffia and wood masks, long snaky totems, a spectacular gigantic wooden drum with animated details, abstract figures intricately carved or dramatically painted with geometric patterns, grinning and grimacing faces assembled in groups for no apparent reason other than theatrical effect. Enormous creatures in lively poses gestured in some

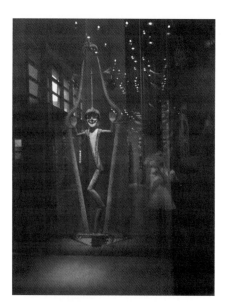

Figure 3.1 Installation view, first gallery. Musée du Quai Branly, Paris, July 2010. Photo Claire Farago.

universal but not quite comprehensible sign language, palpable and mute. Truly stunning. Deeply moving. Absolutely gorgeous. Yet the initial euphoria gave way to museological sobriety, soon dampening delight. What does "Oceania" mean? Or "funeral mask"? There was little to learn (where were the extended labels? the informative text panels?). Virtually nothing to *read*, only beautifully staged things to *see*. Here was the most lavish, most unapologetically formalistic display of ethnographic objects as art we had ever witnessed.

Well into the display space were two sections of Australian indigenous art. After studying hundreds of historical objects from a wide variety of Oceanic and African cultures, without a blink we came to contemporary bark paintings from Arnhem Land and contemporary acrylic paintings from the Western Desert. Another day, in another place, they would have been displayed as "contemporary art" in a canonical white cubed gallery, but here they were being offered in direct juxtaposition and thus comparison to funerary masks and sacrificial offerings. Enveloped by the darkness, they glowed with the same eerie warm light as everything else on display: the old familiar commensurability of modernist museology and marketing (Figure 3.2).

Figure 3.2 Installation view, Western Desert paintings from Australia. Musée du Quai Branly, Paris, July 2010. Photo Claire Farago.

One of the only educational panels in the display focused on the Swiss surrealist artist-ethnographer Karel Kupka, highlighting his prescient interest in the indigenous material beginning in the late 1950s, thus confirming that the objects on display might be considered art of an unorthodox modernist variety. Kupka went on a series of expeditions to Arnhem Land in northern Australia in the 1950s and 1960s collecting for the Ethnographic Museum in Basel and the Musée National des Arts d'Afrique et d'Oceanie in Paris, the predecessor to the Quai Branly along with the Musée du l'Homme. There was nothing in the museum wall-text about the Romanticist labeling in Kupka's *Dawn of Art* (1965) book, certainly no discussion of the way that his late-blooming evolutionist paradigm had deeply offended and antagonized Australian anthropologists. Nor was there discussion of other key individuals, such as the orthopedic surgeon turned collector Stuart Scougall, or Tony Tuckson, Deputy Director of the Art Gallery of New South Wales, or the Melbourne-based businessman Jim Davidson, whose efforts had inserted Aboriginal material culture into the institutional framework of fine art during the same period. Nor was there discussion of the continuous contact of Australians with Europeans, documented since 1803 in the case of the Yolngu of Arnhem Land whose recent and historical objects were on display in the immediate vicinity.[4]

The uncanny assemblages of contemporary paintings and sculpted objects – some of which had been made purely for the art market, others of which were more traditional objects – such as hollow log coffins that had had actual funerary functions – were set next to a bank of stained glass windows suggesting a rainforest. What we saw was a fake painted forest serving as the setting for functionally fake ethnographic objects that had been made within the last two decades for the commercial art market by contemporary artists, many of whom were well-known names to collectors of Aboriginal art.

When the museum – the MQB for short – first opened in 2006, at least one Australian curator had called the display a stunning example of "regressive museology."[5] Yet what we experienced was much more complex than mere museological regression, though it certainly was that too. These contemporary Australian paintings and other objects were made to be regarded as art, whereas the rest of the museum's exhibited collection that we saw consisted of more or less historical objects that were not made as art in the Western sense.[6] Yet everything was on display for its formal qualities, and therefore treated as *artful* – valued for its timeless artistry. The theatrical display – the spectacle that had captured us in the entry hall – was quite

unlike any art museum display of contemporary art. That is, unless it was an installation by an artist, or by a curator working in conjunction with an artist, to interrogate conventional museum practices. The exhibition at the MQB was neither: what we had been witnessing was the presentation of objects as if they were imbued with embodied spiritual presence according to a Western taxonomy that had traditionally classified such objects as artifacts. Many of these objects were once considered as idols or fetishes. The contemporary process of exoticization consisted in manipulating the dichotomy between art and ethnographic object/idol in a mode of presentation that oscillated between art and artifact, the central term of which was "the spiritual." By including contemporary Aboriginal art, the museum not only framed its holdings in this area as if they were still imbued with spiritual presence; it also gave voice to what we had observed about the framing of contemporary indigenous Aboriginal art in art gallery settings – namely, the claim that these abstract designs have an enigmatic but indisputably "spiritual" dimension.

Staging the Spiritual

By focusing on the formal qualities of its vast collection, did the Musée du Quai Branly overcome the oppressive weight of historical taxonomies that divided the world's cultural productions into discrete categories of art and artifact? Hardly. The MQB is an exceptional place, but it is the exception that proves a rule. Allying the primitive with modern abstraction has been a ubiquitous modern trope, one that is also replayed from the other side of the equation, in exhibitions of contemporary Aboriginal art. Recounting his first encounter with Western Desert painting in the early days before it became a commercial success, Philip Batty, a former teacher at Papunya, the desolate government relocation center where the painting movement officially began in 1971, and now Senior Curator of Central Australian Collections at the Museum Victoria in Melbourne, poses one-half of the question we want to pursue:

> Certainly, the detached kind of art I had studied at the National Art School stood in stark contrast to the work of the painters. In depicting their dreamings, they were depicting their personal ancestors and therefore, supernatural beings to whom they owed their physical existence and identity. This was made particularly apparent when I attended the men's secret-sacred rituals

in which the recreation of the dreaming – encompassing similar icono-graphic symbolism seen in their paintings – was, for the Aboriginal partici-pants, a serious and potentially dangerous business. How then was this serious religious business converted into a saleable commodity called "art"?[7]

The other half of the question is equally important: how is it still pos-sible in 2010 for this saleable commodity called "art" to be reinserted into a context of "spiritual" expression? The questions are actually two sides of the same coin. The link between "the primitive" and "high modern abstrac-tion" construed as a positive value is the issue around which the cultural construction of the indigenous Australian artist as a high modernist genius takes place. Framing Aboriginal art as the product of individual genius is only superficially different from suppressing the individual intentionality of the artist in a collective display when it comes to staging "spiritual pres-ence." In 2008, when the National Museum in Canberra opened its retro-spective exhibition of Emily Kame Kngwarreye, indisputably the most famous Australian woman of any ethnicity who has ever painted, the show extolled her originality as on a par with Kandinsky, Klee, and de Kooning, despite her humble origins and subsequent life at a remote cattle station named Utopia in the Australian outback. Kngwarreye had neither formal artistic training as a painter nor any familiarity with European Modernism. Yet her brief and unbelievably prolific career (she is estimated to have painted an average of one canvas per day amounting to some 3,000 works in an eight-year span), was described in the catalogue and on the exhibition walls as unfolding in developmental stages comparable to the careers of equally long-living European artists such as Rembrandt, Titian, and Michelangelo (Figure 3.3).[8] "Emily," the catalogue claims, worked through the issues of Modernism entirely on her own.

Aboriginal art succeeded commercially in the 1990s, when High Modernism was critically waning, although it was, as it still is, a profitable share of the art market. From the standpoint of art as a high-end commodity form, Kngwarreye's paintings became a new product on an old shelf as her career skyrocketed – her work offered a novel variant of an existing genre that invigorated a tired market. This is not to underestimate the local context of viewing. Her paintings were an enormous success when the recent ret-rospective of her career, subtitled "The Genius of Emily Kame Kngwarreye," opened in Japan, where longevity is highly respected, so much so that attain-ing the age of 88 – the age at which Kngwarreye in fact passed away – is considered a lifetime achievement marked by celebrations.

Figure 3.3 Emily Kame Kngwarreye (Australian, 1910–1996). *My Country #20*, 1996. Synthetic polymer paint on canvas. Collection Fred Torres and Dacou Aboriginal Gallery, Melbourne. Photo courtesy Artists Rights Society, New York/ VISCOPY, Australia.

The same move that elevated the Aboriginal artist to the status of European modernists of an earlier generation reinscribes the hegemonic Eurocentric discourse in which the Aboriginal artist, no doubt unintentionally, still occupies the lower rung of the traditional hierarchy between civilized and primitive, European and other. At its Australian venue in Canberra, the exhibition took place not at the National *Gallery* of Australia, where one would expect to see exhibitions of contemporary art, but across town at the National *Museum* of Australia, which otherwise collects and displays ethnographic objects. To display the "high art" of a leading Aboriginal artist in this venue resonates on several registers. Ostensibly, the exhibition transgresses the existing barriers between art and anthropology. However, the presentation of Kngwarreye as a modernist "genius" would not have the same cachet at the National Gallery in 2008, a date by which many cutting-edge artists considered the paradigm of the solitary artistic genius to be a patriarchal, hegemonic strategy to exclude or marginalize difference as well as exclude other forms of artistic practice.

From an institutional standpoint, Kngwarreye was held hostage by an art system colonized by the interests of the elite collectors who craved her work for its unadulterated, uncanny recapitulation of formal Modernism

– and painted seemingly straight from the desert inhabited by Aboriginal people still in touch with their ancestral way of life.[9] Kngwarreye was never in a position to mount a sophisticated, self-aware resistance to the cultural status quo that Richard Bell or other Australian "liberation artists" have articulated. Her paintings were the product of an unacknowledged collaboration with the curators and collectors who packaged her as a modernist – to the extent of providing her with preformatted, stretched canvases like the ones lined up to create serial paintings in the Japanese installation of her *Utopia Panels*, originally commissioned by the Queensland Art Gallery in 1996 (Figure 3.4).[10] The artist's agency is not negligible, but distinctions between anthropological or curatorial intention and the artist's intentionality and agency are enduringly indeterminate.

It is the dynamic structure of the matrix of the art system that needs explicating: What creates the celebrity artist? What keeps once seemingly outmoded notions of the individual genius in play if not profitability – as is the case with the small cadre of Aboriginal artists in the highest echelons of collectability, such as Kngwarreye and Clifford Possum Tjapaltjarri. Some of their signed paintings were actually collaboratively produced,

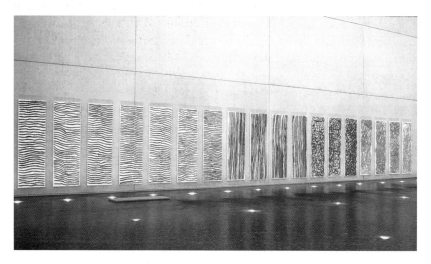

Figure 3.4 Emily Kame Kngwarreye (Australian, 1910–1996). *Utopia Panels*, 1996. Synthetic polymer paint on canvas, 18 panels. © Estate of Emily Kame Kngwarreye. Installation view of the artist's retrospective exhibition, Queensland Art Gallery, Brisbane, 1998. Photo Margo Neale.

while others have been disowned altogether by the artist.[11] Auction houses incur considerable expense in establishing the provenance and authorship of works of art that are otherwise difficult to attribute. Sotheby's allegedly offers only one in 20 "Emilys" of the five percent that are accepted for sale based on their established provenance. If an authenticated painting deemed to be of sufficient quality to offer at auction does not sell at the anticipated price level, however, the auction house withdraws it or "buys it in." Unscrupulous dealers and collectors also benefit from this system by withdrawing the work after its appearance in a catalogue but before the auction takes place. At someone else's expense, the authentication process enhances the value of the work, which they then sell privately at an undisclosed price.

In the resale market, profits are exponentially higher and, until very recently, did not benefit the artists and their estates at all. Although legislation to correct these injustices went into effect on June 9, 2010, unless the work is registered, the artist does not receive any share of the profits accrued in the resale market in Australia.[12] The actual costs entailed in the administrative process transfer not only to the buyer but also to the artists and their remote art communities, who suffer perhaps the greatest loss when celebrity artists (driven by the constant need for cash) act as free agents. Unscrupulous dealers take advantage of their situation, calling into question the authenticity of works circulating in an unregulated manner. Without documentation, it is very difficult to ascertain the authorship of any work. At a more fundamental level, the real problem is that, as long as the question of single authorship and high art media determine the values of the art industry, revenue is lost to art cooperatives like CAAMA, where Kngwarreye's work was on display when it was first "discovered" in 1988 by James Mollison, then Director of the National Gallery of Australia. At the same time, artists working within the system can be turned into celebrity artists overnight. Two years after she was "discovered" by Mollison, Kngwarreye had her first solo exhibitions in the state capitals of Sydney, Melbourne, and Brisbane. In 1997 Emily Kame Kngwarreye posthumously represented Australia in the 47th Venice Biennale. Not bad for an artist (and a woman) without formal artistic training who started painting at the age of 80. Yet despite the unparalleled success of a very few, artists acting as free agents can adversely affect the well-being of entire communities that depend on the economic success of their artistic enterprises. In the final analysis, when indigenous Australian artists making art for the market adapt their work to suit the expectations and tastes of their buyers, what goes by the label of "Aboriginal art" is quite literally a mirror image of European desires.[13]

This *compromised agency* of Aboriginal artists in the art system is thus itself emblematic of the complexities that the idea of art entails in the twenty-first century. Once they enter the art system, objects in which the artists adapt imagery from actual ceremonial practices of their own culture may *signify* no differently from art that imitates the ceremonial objects of other cultures – or abstract art in general for that matter. The "spiritual value" attributed to the object depends greatly on the collector or other spectator who, in the paradigmatic case of Aboriginal art, does not have easy access to much of that meaning. The enigmatic nature of the abstraction enhances its noumenal value in the marketplace, and the marketplace is where its actual economic value is determined and maintained according to a system far removed from the artist's actual intentions. And even farther removed from the abject poverty of the desert art centers, where Kngwarreye, her many needy relatives, and the majority of artists dependent upon and feeding the thriving market in Aboriginal art live out their lives – lives which are often cut short by health problems due to poor nutrition and lack of adequate access to the health care system, and by poor coping skills most commonly manifest as alcoholism, lifestyle diseases such as diabetes, and domestic violence.

The situation in which artists are adapting their own ceremonial designs to a Western context of art-making does not quite fit the pre-existing institutionalized practice in which ritual and ceremonial objects are recuperated in hindsight *as* modern art. Their agency is of a different order. Yet the artists still run the risk of being perceived as occupying the position of the "primitive" in an evolutionary trajectory of cultural progress because their appearance as Abstract Expressionists at the cutting edge of the avantgarde is a *belated Modernism*. That is arguably the situation of Kngwarreye framed as a high modernist artist at a time when cutting-edge artists in an international arena have distanced themselves from the modernist paradigm of the individual genius. The cutting edge is always moving on. The systemic challenge, then, is to make art that is perceived to be at the front line of this movement. This is a questionable requirement, however, because what constitutes originality and for whom is neither stable nor independent of social context – a conundrum that "liberation artist" Richard Bell clearly articulates:

> I am an Aboriginal man living and working in Brisbane, Queensland, Australia. I make a living from painting pictures. Because I am from the closely settled east coast of Australia I am not allowed to paint what is

popularly called "Aboriginal art." Nor can I use the symbols and styles of Aboriginal people from the remote, sparsely settled areas of northern Australia. Apparently, this would make my work derivative and hence diminished in importance, relevance and quality. However, in western art, which appears to be almost entirely and increasingly derivative, no such restrictions apply. Quoting, citing, sampling or appropriating pre-existing works even has its own movement: appropriationism. There is even a belief that "everything has been done before" (which makes it cool to appropriate).

Consequently, I have chosen to quote, cite and sample the works of many artists from around the world.[14]

Bell's ironic appropriation of Roy Lichtenstein's art makes its strongest point within another system of reference than that of 1960s Pop Art (Figure 3.5): the dots are no longer just references to the reproduction process of cheap newspaper print (Ben-day dots), hence to discourses on the originality of the artist; they are now, primarily, considered in the social context of Australian art marketing, references to the so-called "dot style" distinctive of Western Desert acrylic painting. The ricochets playing out in Richard Bell's laconic text are deeply and almost deliciously ironic. With this irony, he situates himself along the moving front line of conceptual art; at least, that is the strategy.

Figure 3.5 Richard Bell (Australian, b. 1953). *Big Brush Stroke*, 2005. Synthetic polymer paint on canvas. Photo courtesy of the artist and Milani Gallery, Brisbane.

In all fairness, not all artists are as cool on the market as Richard Bell and not all art centers are as deeply beholden to the vagaries of the market and the art system as the posthumous fate of Kngwarreye's and Clifford Possum's paintings would suggest, Howard Morphy notes regarding indigenous communities in Northern Arnhem Land and elsewhere. Morphy stresses factors of social cohesion at the local level, citing how feelings of social inclusion are affected by the extent to which indigenous rights are recognized, social disadvantage alleviated by governmental policies, and Aboriginal art practice used as a resource. He offers two main case studies: the ways in which Yolngu people of East Arnhem Land have successfully used art to mediate the impact of colonization since the 1930s and the effectiveness of Boomalli Cooperative, a network of diverse indigenous artists who were able to create opportunities otherwise denied them by organizing around common objectives in the urban environment of Sydney. The Yolngu are able to use art as a means of action because it is an integral part of their system of knowledge and way of life.[15] And indigenous Australian art has changed the ways in which the world views art and values indigenous Australian culture. White Australians are surprised to learn that, overseas, "Australian art" often connotes just these types of artistic production.

Overall, the commercial success of Aboriginal art has been a good thing for the self-worth of indigenous artists and their communities, and for the perception of First Australians in the white settler culture. More and more, critically aware indigenous voices are also establishing positions of authority within the art system, as the career trajectories of curators Hetti Perkins and Djon Mundine attest.[16] Even so, the socio-economic situation of the Aboriginal population continues at a level far below that of their white counterparts and even shows signs of worsening, despite the heightened awareness of their plight and new appreciation for indigenous traditions as a rich, complex cultural heritage. It appears that such recognitions collapse in upon themselves in the face of an unregulated art market, but the more general problem is coming to terms with what self-determination for a formerly colonized indigenous minority entails: even when money and social services are not in short supply, effective communication with and understanding of people who may not want to join the neo-liberal middle class are.[17]

Contemporary Aboriginal art in its diverse manifestations is in many (but not all) ways paradigmatic of the situation of art and of the generally marginalized and exceptionally celebratory status of artists in contempo-

rary Euro-American society. The art system, in Australia as elsewhere, rewards highly only a very few artists who thereby come to occupy the top of the hierarchy, while the vast majority of artists remain outsiders, marginal members of society who age without adequate pensions and health care even in the most sophisticated urban "centers." A very few contemporary artists, such as Damien Hirst and Jeff Koons, have dealt with the complex financial structure of the contemporary art system to their own advantage while also offering a substantial critique of art as a commodity form. That is, they make objects that refer ironically to the celebrity status of the artist due to the profitability of his art, while also personally profiting from the situation by commanding extraordinary prices for their work. The fact of the matter is that such practice in no way interrupts the cycle of profitability that it critiques, and actually feeds it.

A Third Space

By the time Western Desert acrylic painting became an artistic sensation and economic goldmine in the Australian and international art industry in the late 1980s, the symbolic markings characteristic of the "style" were viewed reductively within the framework of high modernist abstraction. We would be undercutting our own argument if we did not deal with the question of art as a *what* and a *when* – a thing and a way of using things – from a perspective that is not tied to specifically European understandings of artistic significance. Can we locate a place in between notions of artistry in the modern Western sense and those of other traditions? Let's briefly reconsider the initial art-making site of Western Desert painting as a place of *enunciation, identification, and negotiation* where "whitefella" was *not* in charge of "blackfella," to use the Australian racial terms still characteristic of popular culture.[18]

Kngwarreye and many other Aboriginal artists whose styles developed on the model of Western Desert painting and whose careers were shaped and steered by government art advisers and powerful institutions such as the National Museum and the National Gallery of Australia, found themselves promoted in the self-defeating position of disavowing their own working practices and material craft traditions. In reframing "Emily" as a (belated) Abstract Expressionist, institutional authority denied her both the possibility of participating in the deconstructive discourse about the Western idea of art and the possibility of acknowledging communal working methods

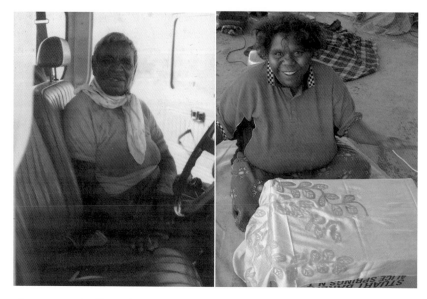

Figure 3.6 (*Left*) Emily Kame Kngwarreye seated in the "batik truck," Utopia, Northern Territory, Australia, 1981. Photo Julia Murray. (*Right*) April Haines Nangala making a batik at Arlparra, Utopia, Northern Territory, Australia, 2007. Photo Julia Murray.

even where they continued to exist. A collaborative practice of art-making is typical of batik production as well as ceremonial body painting where her artistic training began.[19] The Utopia women's group that Emily helped to establish is still active, incorporating younger women whose innovative compositions continue to negotiate between their own land-based design vocabulary and a dynamic market for Aboriginal art (Figure 3.6).

Thinking about the idea of art beyond the commodity form and identity politics, intercultural collaboration between white art teachers, white art advisers, and their black indigenous charges mobilized the desire for transporting cultural meanings across differences.[20] In this revisionist account of the birth of the Western Desert painting movement, the incommensurability between two worlds provided Geoff Bardon, the art teacher-adviser, with a fundamental challenge in cultural translation. Yet we could equally say that the recognition of incommensurability that motivated the transportation of cultural meanings across boundaries originated in the agency of the First Australians, with Kaapa Mbitjana Tjampitjinpa when he

approached Bardon with a plan to paint the walls of their art-making space, which led directly to the movement, and with Obed Raggett, Bardon's trilingual interpreter and assistant who greatly facilitated communication. Or earlier, with the orginal Hermannsburg artist Albert Namatjira (1902–1959), as discussed in the next incursion.

Some cultural theorists have called attention to the body of work produced by Western Desert painters as "rais[ing] questions of authorship, community involvement, historical retrieval, and political affirmation . . . [by] allow[ing] for a horizontal model of storytelling to emerge through the collaborative practice of a community."[21] As Australian cultural theorist Paul Carter puts it, "another space was opened in and round the painting room, another ground of exchange. To look at the paintings made there . . . is also to ponder the terms of a non-assimilationist political future"[22] (Figure 3.7). That is to say, the communal art-making situation that Bardon, Kaapa, Clifford Possum, and many others utilized – a mode

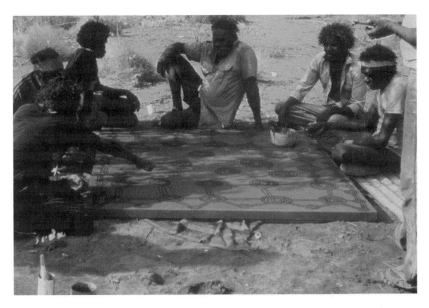

Figure 3.7 *Left to right*: Barney Tjapaltjarri, Charlie Tarawa Tjungurrayi, Tjampu Tjakamarra, Jimmy Tjungurrayi, Morris Gibson Tjapaltjarri, and Willy Tjungurrayi at Piggery Camp, west of Papunya, Northern Territory, Australia, 1978. Reproduced from Vivien Johnson, *Lives of the Papunya Tula Artists* (Alice Springs: IAD Press, 2008), 77. Photo Diana Calder; courtesy IAD Press.

of practice that was and often still is marginalized in accounts of Aboriginal art-making because it does not conform to the genius-artist model of the art industry – encouraged an individualistic art practice, but it also generated other, incommensurate perspectives. Together, Aboriginal artists and their white teacher-advisers set out to create a third space in which some level of exchange could flow.[23]

An object-lesson about the dynamic nature of relationships within any art matrix, and about the possibilities of change, for better or worse, taken from the center of Australia to the periphery of Paris, was not without enormous repercussions. Within the indigenous communities, this cross-cultural collaboration initiated intense disagreements over the proper use of "secret-sacred" symbols, resulting in a hiatus in painting that lasted nearly 15 years in some areas[24] – as we shall take up in the next incursion which looks more broadly at accounts of artistic agency.

Notes

1 Judith Butler, "Photography, War, Outrage," *Modern Language Association of America* 120 (May 2005): 826.

2 As observed in both West and East Arnhem Land, by anthropologist Howard Morphy and art historian Susan Lowish. Personal communication with Susan Lowish, Feb. 10, 2011.

3 For example, Warlimpirrnga Tjapaltjarri, *Two Boys Dreaming at Marruwa* (1987), now in the collection of the National Gallery of Victoria, Melbourne; see Dick Kimber, "Kapi! Contact Experiences in the Western Desert 1873–1984," in *Colliding Worlds: First Contact in the Western Desert 1932–1984*, exh. cat. ed. Philip Batty (Melbourne: Museum Victoria, 2006), 4–28, p. 28, for a reproduction of this painting.

4 See Howard Morphy, *Becoming Art: Exploring Cross-Cultural Categories* (Sydney: University of New South Wales Press, 2008), 56. Swiss artist Kupka presented his research for a doctorate in anthropology at the University of Paris – essentially a documented catalogue and ethnographic contextualization of Yolngu works. Anthropologists who objected to his book positioning Aboriginal art at the dawn of human history include Ronald Brendt, W. E. H. Stanner, and A. P. Elkin. Morphy writes that all of these believed in the visual power of Aboriginal art, were interested in the role of the individual artist, and were concerned to attribute works to particular artists. This was (and still is) the revisionist antidote to treating ethnographic objects as the (timeless) production of collectivities.

5 Bernice Murphy, co-founder of the Sydney Museum of Contemporary Art and currently National Director of the Museums of Australia, cited by Jeremy Eccles, *Australian Market Report* 23 (Autumn 2007): 32–34, at http://en.wikipedia.org/wiki/Musée_du_quai_Branly (accessed July 24, 2010).

6 With the notable exception of a display of European and similar slippages between traditional cultural practices and those made for the market in the displays of Native American art.

7 Philip Batty, "Selling Emily: Confessions of a White Art Advisor," *Artlink* 27(2) (2007), summary at http://www.artlink.com.au/articles/2966/selling-emily-confessions-of-a-white-advisor/ (accessed July 9, 2011; full article available by subscription). For one American writer, looking at Central Desert Aboriginal painting is like watching American basketball: "an immemorial vocabulary of forms, all highly ambiguous in significance, that can be pursued in an infinite variety of modulations and innovations – sometimes subtle, sometimes startling and dramatic." W. J. T. Mitchell, "Abstraction and Intimacy," written originally in the 1990s and published in 2003 in Mitchell, *What Do Pictures Want?* (Chicago: University of Chicago Press), esp. 241–242.

8 Margo Neale, "Marks of Meaning: The Genius of Emily Kame Kngwarreye," in *Utopia: The Genius of Emily Kame Kngwarreye* (Canberra: National Museum of Australia, 2008), 33–47.

9 And indeed apart from Aboriginal curator Margo Neale's apparent passion for Kngwarreye's art.

10 *Emily Kngwarraye-Alhalkere: Paintings from Utopia*, ed. Margo Neale, exh. cat. (Brisbane: Queensland Art Gallery, 1998). The retrospective at the National Gallery of Australia in Canberra was based partly on research conducted for this earlier exhibition, organized immediately after the artist's death (much to the consternation of many who hold to traditional views for respecting the spirit of the deceased).

11 Meaghan Wilson-Anastasios and Neil De Marchi, "The Impact of Opportunistic Dealers on Sustainability in the Australian Aboriginal Desert Paintings Market," in *Crossing Cultures: Conflict, Migration, and Convergence: Proceedings of the 32nd International Congress in the History of Art, The University of Melbourne, 13–18 January 2008*, ed. Jaynie Anderson (Melbourne: Miegunyah Press, 2009), 986–990. We thank the authors for discussing the issues with us.

12 The resale royalty scheme, established under the Resale Royalty Right for Visual Artists Act 2009, went into effect on June 2, 2010. Under the scheme, artists are eligible to receive 5 percent of the sale price when their original works are resold through the art market for AU$1000 or more. The resale royalty right applies to works by living artists and for a period of 70 years after an artist's death. http://www.arts.gov.au/funding-support/royalty-scheme/visual-arts-resale-royalty-scheme. Our thanks to Susan Lowish for this information.

13 Batty, "Selling Emily," 6.

14 Richard Bell in *Culture Warriors: National Indigenous Art Triennial*, curated by Brenda Croft et al., exh. cat. (Canberra: National Gallery of Australia, 2007), 59. Bell won the 2003 Telstra National Aboriginal Art Award with a work entitled *Scienta e Metaphysica (Bell's Theorem), or, Aboriginal Art – It's a White Thing*.

15 Howard Morphy, "Acting in a Community: Art and Social Cohesion in Indigenous Australia," *Humanities Research* 15(2) (2009): 115–132. The Yolngu at Yirrkala worked with anthropologists and others (Tuckson, Scougall, Kupka) to present the value of their work to the outside world, and to lay the basis for the premier collection of indigenous art at the Art Gallery of South Wales. Collaborative art action is the subject of the next Incursion.

16 The daughter of political activist Charlie Perkins, who was a leader of the Australian civil rights movement of the 1970s, Perkins is a curator at the Art Gallery of New South Wales. Mundine is currently a freelance curator.

17 See Peter Sutton, *The Politics of Suffering: Indigenous Australia and the End of the Liberal Consensus* (Melbourne: Melbourne University Press, 2009) for a sensitive articulation of the problems and an introduction to the extensive literature.

18 The three terms are used by Nikos Papastergiadis in his manuscript "Cultural Translation and Cosmopolitanism" (2008). We thank the author for sharing his work in typescript with us. His "Cultural translation, cosmopolitanism, and the void" appears in abridged form in *Translation Studies* 4(1) (2011), 1–20.

19 See the revisionist account in Judith Ryan et al., *Across the Desert: Aboriginal Batik from Central Australia*, exh. cat. (Melbourne: National Gallery of Victoria, 2009).

20 Paul Carter, *The Lie of the Land* (London: Faber & Faber, 1996), 356.

21 According to Nikos Papastergiadis, "The Global Need for Collaboration," at http://collabarts.org/?p=201 (accessed June 29, 2011).

22 Carter, *The Lie of the Land*, 356.

23 Communication with Judith Ryan, Nov. 23, 2008.

24 As of this writing, the reasons for incorporating secret-sacred imagery in the early acrylic paintings, which may not have been intended for sale, and later, less sensitive imagery in paintings made for the market is unresolved. The main arguments are reviewed by Tim Bonyhandy, "Papunya Aboriginal Art and Artists: Papunya Stories," originally appearing as "Sacred Sights" in the *Sydney Morning Herald* (Dec. 9, 2000), "Spectrum," 4–5, at http://www.aboriginalartonline.com/resources/articles4.php (accessed Feb. 1, 2011). A forthcoming exhibition co-curated by an anthropologist and an art historian, Philip Batty and Judith Ryan, promises to add a great deal to our knowl-

edge of the transition from ceremonial art-making practices to art made for the market, *Origins: Old Masters of the Central Desert*, which opens at the National Gallery of Victoria, Melbourne, Sept. 30, 2011–Feb. 12, 2012, and subsequently travels to the Musée du Quai Branly. The exhibition will feature approximately 200 of the first paintings produced at Papunya in 1971–1972 by the founding artists of the Western Desert art movement. The exhibition will establish a connection between these paintings and their sources in designs made for use in ceremony. It will begin with a massing of shields, spear throwers, stone knives, headbands and body ornaments, early drawings collected by anthropologists, historical photographs, and a ground painting. Our thanks to Philip Batty for this advance information.

Further Reading

Inga Clendinnen, *Dancing with Strangers* (Melbourne: Text Publishing, 2003).

Chris Healy, *Forgetting Aborigines* (Sydney: University of New South Wales Press, 2008).

Vivien Johnson, *Lives of the Papunya Tula Artists* (Alice Springs: IAD Press, 2008).

Philip Jones, *Ochre and Rust: Artifacts and Encounters on Australian Frontiers* (Kent Town, SA: Wakefield Press, 2007).

Sylvia Kleinert and Margo Neale (gen. eds.), *The Oxford Companion to Aboriginal Art and Culture* (Oxford: Oxford University Press, 2000).

Marcia Langton et al. (eds.), *Settling with Indigenous People: Modern Treaty and Agreement-Making* (Sydney: Federation Press, 2006).

Howard Morphy, *Aboriginal Art* (London: Phaidon, 1998).

Howard Morphy, *Becoming Art: Exploring Cross-Cultural Categories* (Sydney: University of New South Wales Press, 2008).

Fred Myers, *Painting Culture: The Making of an Aboriginal High Art* (Durham, NC: Duke University Press, 2007).

Fred Myers (ed.), *The Empire of Things: Regimes of Value and Material Culture* (Santa Fe, NM: School of American Research Press, 2001).

Nikos Papastergiadis, *Dialogues on the Diasporas: Essays and Conversations on Cultural Identity* (London: Rivers Oram Press, 1998).

Nikos Papastergiadis, *The Turbulence of Migration: Globalization, Deterritorialization, and Hybrdity* (Cambridge: Polity Press, 2000).

Sally Price, *Paris Primitive: Jacques Chirac's Museum on the Quai Branly* (Chicago: University of Chicago Press, 2007).

Irit Rogoff, *Terra Infirma: Geography's Visual Culture* (London: Routledge, 2000).

Judith Ryan et al., *Across the Desert*, exh. cat. (Melbourne: National Gallery of Victoria, 2008).

FOURTH INCURSION
DECONSTRUCTING THE AGENCIES OF ART

Painting is not done to decorate apartments. It's an instrument of war for attack and defense against the enemy.

Pablo Picasso (1945)

> Any idea of art incorporates ideas about agency and causality; about who or what is responsible for an artwork's material form. Different ideas about agency and effective causality also impact on what is considered a work of art – as when agency is understood as not necessarily linked to a single individual but to a community at large, and when the effects are not necessarily taken as "works of art."

Must an artist be imagined as an autonomous, unique creative genius, a leader or exemplar or embodiment of preferred social and political values? Or is an artist more like a colleague and skilled worker or comrade among other workers – someone to have a beer with, perhaps? Or both, or neither? And must an artwork be understood as a unique, complete, balanced, organic whole, perhaps imagined as reflecting or echoing an assumed natural or biological order of things, as is thought to be the case with classical architecture, whose internal proportions appear to simulate the geometric ratios of organic body parts? In viewing or using a work, am I a passive or silent reader or consumer, or a co-interpreter and performer and *completer* of the work? Is a work finished in its viewing or use, or is it always open to reviewing and rethinking? Does the gap between artistic intention and the reception of a work's stated or presumed intentions leave open the possibility of discovering new meanings and uses for a work?

Art Is Not What You Think It Is, First Edition. Donald Preziosi, Claire Farago.
© 2012 Blackwell Publishing Ltd. Published 2012 by Blackwell Publishing Ltd.

And what about the actual *staging* of these relationships: What constitutes a proper or effective site for fielding together these components of artistic production and reception, for thinking about those relationships as they might be at present, or how we might imagine them existing at the time the work was made and used? Do we ever really *see* a work from another time and place without having *some* sense that the relationships mentioned above might have been configured differently? Do museum or gallery stagings of works not only encourage but make possible in the first place an idea that an artwork is meaningful apart from that historical knowledge, as a seemingly purely visual and timelessly significant artifact?

In general, of course, and in the abstract, all of these ideas about artist, artwork, user, and use are possible and likely, but in the concrete, the relationships between how these notions are taken have varied enormously. The history of the idea of art is a series of transformations or distortions of what might be imagined explicitly or implicitly to be an ideal matrix of relationships between producers, products, and their meanings or functions for users – who may also at times be producers. The identity, nature, and actual histories of these aspects or dimensions of the art system – their topological shape and the fittingness or decorum of that set of relations – are consistent only when embodied locally at given times and in particular places or given communities, and then they are fixed only for a time.

A significant amount of critical attention has in recent years been given to ideas about what might constitute proper, or properly effective, or socially empowering, or challenging relationships amongst these aspects of artistry. But that in itself is neither new nor unique. If art is understood not simply or only as a *kind of thing* but as a *way of using* a (potentially very wide) variety of things, a of way acting in and on the world so as to affect it (and ourselves) in any number of simple and complex ways, then the question of the nature of *agency* becomes central to any understanding of the idea of art. This incursion takes up where the previous one paused, where the question of individual and collaborative group agency in cultural production was raised in the context of the emergence of Aboriginal art.

On Other Art-Making Practices Becoming Art

Artworks or objects defined as such from particular perspectives are an integral part of the processes that socialize people into ways of seeing things that create understandings about the world. Those processes may vary

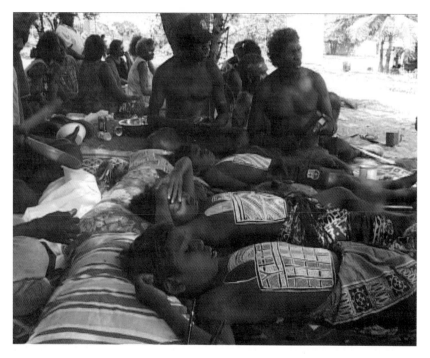

Figure 4.1 Circumcision ceremony at Yilpara, Northern Territory, Australia, 2003. Photo Howard Morphy.

enormously in form and circumstance: museums are one manifestation of such processes; the image shown in Figure 4.1 is another.

The photograph shows a group of young boys lying on the ground in a circumcision ceremony at the Yolngu Aboriginal site of Yilpara. The boys lay still for about four hours while their chests were painted by the men shown behind them with images referring to the journeys of ancestral beings manifested in the designs. Female relatives sit behind the men, attending to the events and performing tasks of their own. As the body of each boy is painted with designs belonging to his own clan group, the men sing tales of the beings whose journeys are depicted. The paintings may only be glimpsed for a few minutes by a small segment of the society, yet their significance is connected to community knowledge of the group's histories, the group's relation to their ancestral beings, the configuration of the landscape, and the technical skills of the artist – the latter being attributed by the community to the creative genius of ancestral beings. The actual genital alterations take place after the scene shown here, toward sunset.

The body paintings effectively embody or encode the relationships between individuals in the group, links to ancestral beings, and connections of both to place, and are an important component of the boy's social position as well as the ways in which he is linked to sources of ancestral spiritual power. The significance of visual images such as these exists in multiple dimensions and is not permanently fixed upon a single factor within the artistic performance being portrayed. In fact, the artistic performance exists only insofar as it is a component in a multidimensional, multimodal orchestration of materials, individuals (material and immaterial, in familiar Western terms), as well as places, times, generations, and genders. Everything about a performance such as that depicted here is meaningful, but not everything is meaningful in every way, nor is everything meaningful in the same way. The significance of any one facet is differential and semi-autonomous, and is an aspect of its relations to other features of the orchestration.

The skill of the men painting these circumcision images has a partial life of its own, in two senses. First, it is admired on its own – by those members of the community who may be permitted at certain times to actually see it. Its reputation may live on in the memories of the community at large, as an image's meaning is referred to in songs, in landscape features, and in the names of individuals that refer to those topographical features. Second, the *agency* of the painter is not sharply individuated but is seen as collaborative in being linked to the creativity of ancestral beings: a shared causality or distributed responsibility for the form of a thing.

Multiple Agencies in a Multifaceted Network

One way to think about the *idea* of art is as a process of memorialization that involves multiple agencies in a multifaceted network of relationships. The process of cultural production is always dynamic and, today, the shared causality or distributed responsibility is even more open-ended when we take into account our own position as observers (writers and readers of this book). How have *we* who are not the men or boys of the Yolngu community come to see their circumcision ceremony? What is our own agency in all of this? Cultural memories tie the immediate community to the outside world in multifaceted ways. Consider how museum collections become auxiliary sites of memory enabling access to a wide variety of cultural practices.

Consider also how, in many communities, the word "museum" is a reminder of what has been lost to Aboriginal people, not what has been preserved, an issue that we discuss in the sixth incursion.[1] Collaboration with museums may enable a process of repatriation for communities whose material cultural objects have been removed and whose ties to the knowledge surrounding these objects severed in the colonizing process and its aftermath, assimilation. Through such contemporary efforts to reverse, heal, or otherwise come to terms with the effects of dispossession, indigenous communities are regaining access to their heritage through visits to museums and by studying photographs and artifacts collected by anthropologists. For example, the Lamalama people of east Cape York (also in Arnhem Land) have utilized the Donald Thomson Collection at the Melbourne Museum based on fieldwork conducted from 1928 to 1932, which is still within living memory of the oldest community members.[2] The younger generations are taught about their collective social memory by elders to ensure the continuance of knowledge that links places, people, song, performance, stories, artifacts, and so forth. Sometimes the objects and photographs provoke recollections, including memories of traumatic encounters with former colonizers and other outsiders; and sometimes the connections enabled through these museum encounters have been used in court as evidence to establish land claims. Such collaborations can also document museum collections through indigenous oral histories.

Beyond the human, material, and institutional factors per se are those of time and change: each ceremonial performance is both uniquely linked to its particular manifestation at a given time and place, and also innovative in representing a unique alteration of habitual practices. Each situation is a dynamic and innovative one, a realization of a virtual archive of the memories of images and practices which may nonetheless be held by the community as unchanging even in the context of the introduction of obviously new media, motifs, and forms. In the case of this community, changes in design form occur across contexts allowing for the group to negotiate social changes with outsider (white settler) communities, and to adapt to or affect changes in other communities, including federal and state government agencies.

What has just been described reflects upon issues raised from the beginning of this book, specifically the questioning of our notion of the *art matrix*: the topological *system of relations* connecting (while separating) artist, artwork, and social function which we have taken as our primary object of attention by charting some of its key historical permutations in

the West. The kinds of changes we've outlined could be seen as if they were distensions or metamorphoses of an assumed ideal grid (matrix) of relations between facets of artistry.

But we will now go further and claim that, in addition to being a temporarily useful analytic device to highlight and articulate the shifting historical relationships between art and artist, the model of the matrix also suggests a methodology and a strategy of fundamentally transforming the entire contemporary discourse on art and artistry. It does so by problematizing and rendering that discourse circumstantial rather than natural, universal, or global. In other words, it clarifies our function here to outline an alternative vision of a mode of practice that would be structurally, thematically, ethically, and politically different from what currently constitutes that discourse in academic fields such as anthropology, art history, and museology.

The example given here of the *place* of artwork, artistry, and the functions and agency or agencies accorded responsibility for what may be considered an artwork challenges conventional Western ideas about art in very specific ways, sharply calling into question what has come to seem natural or inevitable about those ideas. The Yilpara circumcision ceremony constitutes an orchestration of a variety of forms and materials over time, space, and memory in relation to the land, the people, and guiding ancestral beings. Its enactment is always an orchestration of diverse elements, resources, and skills for the specific purpose of *socializing people into ways of seeing things that create understandings about the world*, to borrow a phrase we used earlier in relation to the Yilpara ceremony. The ceremony is both *product* and *producer* of individual and collective knowledge, and its components are neither entirely discrete nor fixed but are semi-autonomous and exist in relation to the other components of the performance.

The same mutual dependency holds for the ways that investigators have access to their subjects of study. The performance at Yilpara participates in an ever broadening network of relationships that come to encompass the anthropologist, the museum, the tourist – whatever outsiders might witness as this event at first or second hand. Structurally, the historian, the anthropologist, the museum curator, even the tourist face the same challenge of locating his or her agency in a (spatial and temporal, historical and political, vested and partial) continuum with the subject of study. The cultural anthropologist and other observers function as part of a relational network that includes their subjects of study – they are outsiders but they are also,

to varying extents, insiders. What responsibilities attend knowing about someone else's artistry in the case of esoteric knowledge? Pondering the agency of the observer in this case raises urgent ethical issues. The community's natural right to privacy and control often conflicts with Western assumptions that knowledge should be accessible to everyone.

These issues are not easily resolved. Configuring the study of artistry as a matrix or a network of distributed agencies necessarily places *everyone* within the matrix. Articulating the position from which the writing or observing takes place becomes an ethical responsibility when one considers that the art matrix connects everyone. For one's personal agency is never personal. It depends upon where one is located in the network of agencies. The historically and ideologically charged terrain requires careful negotiation. So far in this incursion we have been looking at case studies of artistic practices taken from the anthropological literature. In the next section, we will bring this discussion of agency around to practices more easily identifiable as "contemporary art."

Collaboration/Participation/One Thing After Another

The question of who or what is (or should be) responsible for artistic production, and under what conditions and for whom, has a long, rich, varied, and well-documented history in diverse academic fields in the Western tradition such as anthropology, aesthetics, art history, archaeology, museology, philosophy, and theology. Aspects of this background were discussed in the First Incursion; here we briefly consider recent developments in rethinking artistry, and in particular the changing identities and functions of the artist and of the work itself.

Since the mid-1990s, artists, critics, and historians have drawn attention to forms of artistry that consciously emphasize dialogic, participatory, or interactive practices in marking a focus on socially engaged practices, as recently summarized in a useful collection of texts published by London's Whitechapel Gallery.[3] For some, emerging changes in artistic practice, exhibition, and marketing have resulted in "a shift from the production of images to the initiation of scenes for the replaying of social relations," as Nikos Papastergiadis very aptly put it recently.[4]

Some artists and collaborative groups have been concerned with articulating an alternative symbolic order for representing the viewpoint of the socially marginalized and dispossessed, for example, in giving voice to the

perspective of undocumented migrants where the mainstream media and government view characterizes them as a threat to social order. The most deeply invested projects are often those which come from the community itself, such as the Chicano Park murals in Los Angeles, San Diego, Denver, and elsewhere, that began in the 1960s era of the Civil Rights movement and continue today. Operating largely outside the art system as a form of community education and pride, Chicano outdoor murals receive little press or scholarly attention that would situate them as historically significant aspects of contemporary art.[5]

Papastergiadis offers another compelling example of the ways in which artists play roles in local communities to deal with universal issues of social justice and human needs. The project, entitled *Nine* (2003), was conceived by the Panamanian artist Brooke Alfaro, who worked with two rival street gangs from Panama City for over a year, gaining the trust of the gangs, their families, and friends. He then proposed to videotape each gang interpreting the same song by El Roockie, already a popular rap artist in the city. Alfaro arranged for a screening of the two videos, side by side, in the contested suburb of Barazza, where a street was closed off and darkened for the occasion, converting an apartment block into a giant public screening space. In the final scene of the video, as the two gangs march toward each other on adjacent screens, one guy tosses a basketball in the direction of the other gang. The ball momentarily disappears as it crosses the gap between the screens and then is caught by a member of the rival gang. Papastergiadis records his own response:

> Watching the video documentation of this event, I could see that the art was not just the content on the screen, but also the experience on the street that culminated with the uproar of spontaneous pleasure. At the end of the screening the crowd kept shouting "more"! This euphoric demand for "more" was not just a sign of ecstatic emotion, but also a declaration that the video had migrated from being an artwork made and owned by Alfaro, and headed towards becoming an anonymous and purely temporal experience that was co-produced by all the participants.[6]

Not only artists but curators, critics, and historians can also act as agents in a very similar manner, de-centering their own role and intensifying the process of interchange between members of a community. The art event serves as the mediator. Involved with these developments have been ways of creating dialogues with diverse communities motivated by two factors.

First is a desire to change the focus of art exhibitions from the display of artworks primarily for their aesthetic or purely visual content to works with more explicit social and political content. Second, there has been a desire to shift the very idea of the landscape of world art production from a center–periphery model where the former was sited in major urban centers in the northern hemisphere (New York, London, Berlin, etc.), the latter being everywhere else – usually the non-Euro-American world (or for some the southern hemisphere or the global South, especially Africa and Latin America) – to a diverse global network of art-producing communities whose relations to one another were not hierarchical.[7]

Central to many of the most recent debates was Nicolas Bourriaud's controversial 1998 text on *relational aesthetics*, which the author defined as "an art taking as its theoretical horizon the realm of human interactions and its social context, rather than the assertion of an independent and private symbolic space…an art form where the substrate is formed by inter-subjectivity, and which takes being-together as a central theme, the 'encounter' between beholder and picture, and the collective elaboration of meaning."[8] For some, this collaborative art practice has also been taken to task for representing little more than an "aestheticization of novel forms of capitalist exploitation."[9]

Others, however, such as philosopher and cultural critic Jacques Rancière, anthropologist George Marcus, and sociologist Zygmunt Bauman, have more nuanced takes on dialogic or collaborative art practices in relation to contemporary manifestations of power relations, arguing for their emancipatory potential in affording concrete possibilities for shaping social communication and the creative construction of meaning and knowledge. To paraphrase Marcus, artist and communities (like the ethnographer and his/her collaborator "informant") have the potential of becoming "epistemic partners" in these productions of social meanings.[10] By contrast, the older notion of the artistic producer is that of an autonomous, independent individual producing meanings with objects or artifacts *for* or on behalf of a community of individuals who are positioned to consume, decipher, or read the presumed "intentions" of that maker in what is produced. The complicity of such a paradigm with certain religious ideas about individual agency and responsibility, on the one hand, and the economic "free" agency of capitalist libertarianism, on the other, should be readily apparent, as we have sought to clarify in these pages.

Shifts or turns in aesthetic paradigms, then, involve the *entire* matrix of how relations between artist, artwork, and the function(s) of both are

staged. Change one component, and the others are affected either pro-
foundly or subtly. The social, political, economic, aesthetic, philosophical,
and religious implications of any such transformations of any component
may be much more profound or even deeply disturbing than might be
imagined in the abstract. An important recent shift has been in the organi-
zation of international exhibitions such as biennales that more explicitly
"address issues that arise from the specific cultural realities in their own
daily life."[11] Much has been said both for and against this internationalism
as well as the movement of some artists toward collaborative practices, in
both cases for a variety of reasons. Some, such as the former director of
Documenta XI in Kassel, Germany in 2002, Okwui Enwezor, saw the devel-
opment as a move toward creating a truly global art practice and as repre-
senting a "new social aesthetic."[12] Others such as Rustom Bharucha, have
taken a decidedly negative and critical view of these developments, seeing
them as a pseudo-democratic, neo-liberalist linkage of humanistic ideals
of sharing with economic outsourcing: *the synthesis of artistry and com-
modification.*[13] The latter critique essentially continues a long-standing
debate within modern art history and criticism.

The Johannesburg location of two international biennales offers a salient
example of the way in which disturbing colonial structures also continue
to surface in new configurations of the art matrix. The first biennale, held
in 1995, just one year after free elections were established in South Africa,
presented a "dubiously positive picture," as Julian Stallabrass put it, by
excluding local artists who had a troubled vision of the nation.[14] As a result,
most of the local black community boycotted the event, which primarily
courted the exclusive international art world. The second biennale, curated
by Enwezor in 1998, entitled *Trade Routes: History and Geography*,
responded to the earlier critique by dealing directly with issues of race,
colonization, and migration, and by stressing South-to-South links in the
international art community. Yet local artists and critics still complained
of being excluded, partly because few could participate in the "standard
forms of post-conceptual and lens-based art."[15] The event was further
compromised by financial crisis following the end of apartheid, induced
by brutal Keynesian measures that favored foreign investors.[16] Low attend-
ance closed the event a month early.

Old cultural hierarchies were reiterated in both Johannesburg biennales
in a displaced form. How did this take place? International visitors were
confined spectators who felt restricted at not being able to explore what
was considered a dangerous environment for them in and around

Johannesburg. The local population was unreceptive to the international, multicultural globalism on offer, from which they were largely excluded and which they perceived as having been imposed upon them in a colonial manner. Although the local conditions are always specific to the place and time, similar structural and politically charged problems have plagued many other large-scale international exhibitions. Carol Becker characterizes the internationally acclaimed curators on this art circuit as "nomadic specialists, creatures of the global art system" who move in the rarefied environment of what is ultimately a marketing event, promoting spectacular forms of art-making such as new media and installation art that appeal to elite, Euro-American-educated tastes.[17]

Whatever the critical position one adopts, these transformations in the components of the art matrix are a matter of opportunities on all fronts. In terms of the issues raised above about the relative merits of contrasted paradigms of artistic activity, it is necessary to take a rather more historical, holistic, and comparative perspective on these debates, in the following respect.

Historically speaking, doesn't what is currently being staged with hindsight as shifts in artistic practice, said to be marked by corresponding critical developments such as relational, collaborative, or dialogic aesthetics, consist largely in replaying old and unacknowledged or forgotten debates within twentieth-century Modernism? There have been critical attempts to distinguish between older and newer versions or visions of collective or collaborative artistic practice, but perhaps what has been taking place over the past decade is more a replaying of the contents of old utopian social-realist manifestos about the artist-worker as proletarian social worker and comrade. What did that or those pasts promise that differs (structurally, systemically, content-wise) from what is imagined or projected today? Utopian promises are always double-edged.

There is, however, a key difference between older avant-gardist movements of solidarity and current collaborative practices in that the former were *designed for* and *imposed upon* communities. (This holds true, even more so, for art-making practices directly sponsored by totalitarian regimes.) Those collaborative models of artistic production did not deviate systemically or structurally from the paradigm of the autonomous sovereign artist working on behalf of rather than with a community, in simulating a transitive (speaker–text–listener/reader/viewer) model of communication rather like a parliamentary "representative" in liberal democracies. A de-centered model by contrast allows meaning to circulate – everyone *is* an artist and the art is the material catalyst of the interaction.

And yet, this seems to be effective only until the innovation is absorbed into the art marketing system.

Embodied knowledge – the kind of knowledge necessary for making things – involves more than putting skills into practice: what makes improvisational thinking possible is a kind of consciously manipulated knowing that involves movement through the world.[18] It is important to be clear that both collaborative and individuated artistries have *coexisted* and have been co-determinative for much of the history of artistic Modernism (broadly defined here to include the past half millennium); it's not simply a matter of the one succeeding the other – even if it is the case that institutions and professions such as art history or art criticism have long been grounded in progressive visions or teleologies of the development of styles and genres.[19] Indeed, the continued adherence to a certain sequentialism or even a "period style" in artistic visions or fashions may well be yet another confirmation of an endemic historical *amnesia* seemingly hard-wired into modern(ist) art's own marketing strategies of keeping in play an ardent, implacable addiction to art's "history" as a *teleology* of the idea of art.

It is necessary to adopt a holistic perspective on the evolution of the artistic matrix or art system rather than continue to articulate historical changes in what might be called a two-dimensional manner – that is, construing changes in the form of objects over time and space as transitively reflective or "representative" of other phenomena. More fundamentally, such a manner of reading appears to naturalize a certain metaphysics of signification whereby a concordance between material objects is in some respects literally believed in (as claimed) and the mentality of subjects is regarded (for whatever ostensible reasons) as responsible for their appearance.

This has been and remains one of the most intractable ideological determinates of historical and critical thought in the Western tradition, and continues to be played out on countless levels of social experience and practice, notably with respect to how relationships between what are distinguished as "subjects" and "objects" are articulated. Entire professions and institutions are grounded in (and their historical developments founded upon) how this metaphorical juxtaposition is (stage-)managed; how things are (imagined to be) "read." This is the case irrespective of the particular geometry of relationships between object, event, and mentality (personality, identity, spirit, etc.); that is, whether the concordance is direct or indirect – whether it is imagined that one can directly read (indexically, so to speak) certain intentions in the form of an artifact, or whether the artifact is an indirect metaphor or symbol of the imputed mentality or identity.

It is precisely this intentionality that lies behind the disputes between differing versions of how artifacts (or behaviors more generally) signify or mean. Read any standard art history textbook and you will find a virtually unfailing adherence to this semiotic and epistemological paradigm: made (or appropriated) objects are invariably signs of what is imagined to exist prior to and (thus) be responsible as a cause for which what you see before you is the effect. A massively ramified and modernist-inflected institutionalization of making legible what is visible, as signifying what is thought to have been meant by an object or palpable behavior.

Certainly, disputes as to the positive or negative nature of "collaborative art practice" rest upon believing (or not believing) that such modes of practice are indices of community spirit or social cohesion, or that they indicate complicity with processes of mystification, subjugation, and social alienation. So the designation of (and deliberations about) what constitutes effective agency brings to the fore the specificities of the social and cultural tradition in which such beliefs are staged. Which suggests, further, that the efficacy of any paradigm of artistic agency is tied to images or projections of its individual and social *effects*: what it actually does or what it may do, what is imagined it may actually accomplish.

Distributed and Circumstantial Agencies

Let us return to the need for a *comparative* intelligence in pursuing effective perspectives on the art matrix or system. We are arguing for the importance of developing a perspective on artistry that, to mix metaphors for a moment, is more stereoscopic than monolingual. As someone once said, if the only tool our ancestors had was a hammer, they would have treated everything as if it were a nail, and neither you nor this sentence would be here now.

Collaborative cultural and artistic practices outside of the orbits of the Western tradition, or in premodern orbits of that same tradition, were in fact never so uniform or homogeneous as it might appear with hindsight, given that the histories we compose of it have been written for use in and by the present, including not least our ideas about art. We find a very wide variety of modes of collaboration in regards to building, maintaining, disseminating, and transforming social knowledge.

In other words, artistic agency is not a fixed or permanent characteristic of practice in the many communities and ethnic groups studied over the

past two centuries, but is *distributed* and *circumstantial*; being artistic (and being art) is related to time, space, gender, and generation no less than the purposes to which practices are put. It is clear that in many different Aboriginal communities, and not only in Australia, relationships of artistic practices to community life were and are complex and are rarely *not* dynamically evolving in the ongoing tasks of mediating between indigenous and settler polities. Social cohesion is produced, maintained, and transformed through practices that may be collaborative as well as individuated, and are also part of a larger social network.

Looking again at the origin of the Western Desert painting movement from the standpoint of the artists' ability to intervene in the existing art system with its dispersed field of agencies, the creation of "Aboriginal art" as an indigenous High Modernist artistic practice, entailed the abstraction of visual markings out of traditional multimodal, multidimensional, and multifunctional practices, a cross-cultural mediation of meanings by initially initiated male Aboriginal individuals as a way of bridging native and settler communities, of manifesting (some aspects of) traditional knowledge for outsiders. Given the existing forms of domination in the art marketing system, from the standpoint of the individual artist or group of artists, their interventions are pragmatic tactics implemented when opportunities arise rather than utopian strategies designed to change the entire system.

The story told also depends on the scholar's or critic's narrative strategies. Here follows another take on the same event described briefly in the Third Incursion. There would be many ways to narrate this story, yet the young art teacher Geoff Bardon remains the hero of the Western Desert painting movement in the current telling, portrayed as dating from the moment of his arrival at the government relocation center of Papunya. We are not suggesting that he deserves to be deposed so that someone else can be inserted into the same hagiographical template. Rather, we return to the pressing issue of how history is told: what sources are used, who tells it, who benefits, and who doesn't.

Western Desert Painting's Double Roots

Kaapa Mbitjana Tjampitjinpa (ca. 1926–1989), had been painting in a traditional manner as well as producing watercolor landscapes in the European-derived representational style associated with the Lutheran

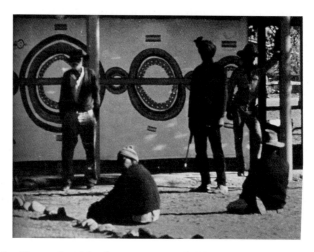

Figure 4.2 Honey Ant Mural at Papunya School, Papunya, Northern Territory, Australia, June– August 1971 (destroyed). Reproduced from Vivien Johnson, *Lives of the Papunya Tula Artists* (Alice Springs: IAD Press, 2008), 43. Photo Geoff Bardon; courtesy IAD Press.

mission at Hermannsburg when Geoff Bardon arrived at Papunya in 1971. Kaapa was chosen by the older men because of his painting skills to head the team of Aboriginal artists who approached Bardon with a plan to paint a mural in the traditional manner (see Figure 4.2). The founder of the Hermannsburg School was Albert Namatjira (1902–1959), a Western Arrernte man and the first Aboriginal person to achieve mainstream recognition as an artist, decades before Bardon and Kaapa met.[20] Namatjira's connections to Papunya are direct: he spent the last two years of his life there, arriving about the same year as Kaapa (1957). In other words, the Western painting movement was not the outcome of naive indigenous artists meeting a gifted white art teacher. The formal art-making skills of the Aboriginal men pre-existed Bardon's arrival and were connected both to their traditional responsibilities as initiated adult males and to an existing cottage industry of making "art" for tourists and the mainstream art market in which Namatjira himself participated by painting in a European representational style that he himself valued highly.

We emphasize that the structure of relationships that we have been describing as a matrix makes it possible or impossible for individuals to exercise their agency in certain ways and not in others. In the previous incursion, we discussed how the conventional story of Emily Kame

Kngwarreye's rise to stardom suppresses aspects of her personal history as a senior adult woman and as a batik artist. Not to mention her leading role in her people's land claim. Complex agencies were involved in her success as a painter and she herself continued to practice collaborative working methods during her entire career. A similar selective acknowledgment of agencies characterizes the birth of the Western Desert painting movement as a whole, and this is not due to the demands of the marketplace alone. The opportunity seized by Emily and by the Aboriginal men definitely raised their sense of self-worth and created an important new painting movement, among other things, but the retrospective narrative of these events is still subject to the biographical framework and the privileging of white agency associated with the most conventional garden variety of (implicitly or explicitly racist) art history. We still search for ways to tell the stories with the nuance and force that prolonged contact between the various agents in a field, split since the colonial era along ethnic lines demands, and such searching is itself a dynamically changing part of the matrix.

It is crucial to be conscious of the power of paradigmatic beliefs about aspects of artistry: if you begin with an idea of art from a point of view which takes as its foundation or ideal model that of a unique, autonomous individual maker whether real or imagined in a given, how art is construed will be radically different from that of a maker who creates meaningful interventions into those very conditions. Not everything is always available as meaningful, and agency may be distributed across objects and beings in ways not even remotely apparent to an outsider. But, as we have suggested, the distinction between outsider and insider is often a momentary condition, subject to transformation and metamorphosis in ways not always predictable in advance, if ever.

The next Incursion explores the manner in which agency has been distributed between objects and beings in existing accounts – and what to do about it.

Notes

1 Ruth Phillips, *Museum Pieces: Essays on the Indigenization of Canadian Museums* (Montreal: McGill-Queens University Press, 2011), 248, citing *Report of the Royal Commission on Aboriginal Peoples*, vol. 3: *Gathering Strength*; ch. 6: "Art and Heritage," at http://www.collectionscanada.gc.ca/

webarchives/20071211060616/http://www.ainc-inac.gc.ca/ch/rcap/sg/
si56_e.html#1.2%20Sacred%20and%20Secular%20Artifacts (accessed Jan.
27, 2010). We thank the author for sharing her manuscript with us before
publication.

2 Lindy Allen, "Memory and the Memorialisation of Museum Collections: The
Donald Thomson Collection from East Cape York" (manuscript) describes a
current research project in which Melbourne Museum curators collaborate
with an intergenerational group of Lamalama people. Another ongoing
project, the Ara Irititja Project, which operates through the South Australia
Museum in Adelaide, is designed to bring materials of cultural and historical
significance "back home" to the Pithanthathara and Yankunythathara people
of central Australia. The project takes the form of a purpose-built computer
archive that stores repatriated materials and other contemporary items on
location. The Mulka Project, located at the Yirrkala Arts Center in North
Arnhem Land, includes a printshop, museum, galleries, archives, recording of
traditional songs, traveling to remote homelands, programs that teach film-
making, and outreach to non-indigenous people; it can be accessed at
www.yirrkala.com/index.html. Our thanks to Susan Lowish for this
information.

3 Claire Bishop (ed. and intro.), *Participation: Documents of Contemporary Art*
(London: Whitechapel Gallery; Cambridge, MA: MIT Press, 2006).

4 Nikos Papastergiadis, "The Global Need for Collaboration," 1, at http://
collabarts.org/?p=201 (accessed June 29, 2011).

5 An exception is Guisela Latorre, *Walls of Empowerment* (Austin: University of
Texas Press, 2008). Thanks to Christina Stackhouse, "Discovering the Course
of the Chicano Mural Movement," honors thesis, University of Colorado
(2010), for the argument that the Chicano Mural Movement, often repre-
sented as no longer active, continues within their communities of origin
thanks to engaged artists who often also have careers linked to the gallery
system. We have adopted the well-known quotation from Picasso for the
epigraph to this incursion from her thesis, cited from Herschel B. Chipp, with
Peter Selz and Joshua Taylor, *Theories of Modern Art: A Source Book by Artists
and Critics* (Berkeley: University of California Press, 1968), 487.

6 Stackhouse, "Discovering the Course of the Chicano Mural Movement," 6.

7 Gerardo Mosquera, "Alien–Own/Own–Alien," in Nikos Papastergiadis (ed.),
Complex Entanglements: Art, Globalization, and Cultural Difference (London:
River Oram Press, 2003), 19–29.

8 Nicolas Bourriaud, *Relational Aesthetics* [1998], trans. Simon Pleasance,
Fronza Woods, and Mathieu Copeland (Dijon: Les Presses du Reel, 2002).

9 Stewart Martin, "Critique of Relational Aesthetics," *Third Text* 21 (2007):
369–386. See also Martin's earlier "Autonomy and Anti-Art: Adorno's Concept
of Avant-Garde Art," *Constellations* 7 (2000): 197–207, which indicates some

of the reasons why he was to take up an anti-relational aesthetics position. See also Claire Bishop's excellent critique, "Antagonism and Relational Aesthetics," *October* 110 (2004): 51–79, in which she suggests substituting Bourriaud's harmonistic conceptions of the social with a more agonistic conception of political community; and Liam Gillick, "Contingent Factors: A Response to Claire Bishop's "Antagonism and RA,"" *October* 115 (2006): 95–107, who stresses the dynamic potential of collaborative art projects that are neither utopian nor dystopian, citing Susan Buck-Morss argues that the celebration of mobility and transgression in recent contemporary art camouflages the insecurity and displacement heightened by neo-liberalism.

10 George Marcus, "Collaborative Imaginations in Globalizing Systems," lecture delivered at the conference "Culture in Context," Institute of Ethnology, Academica Sinica, Taipei, Sept. 16–17, 2006, quoted in Papastergiadis, "The Global Need for Collaboration," 7–8, p. 4, who expressed skepticism about the partnership actually established between anthropologists and their subjects when the data collected was incorporated into a final, authoritative report. It is also worth noting, as Papastergiadis does (14 n. 5), that as early as 1995 Lucy Lippard argued that the incorporation of conceptual art into the institutions of art prefigured capitalism's investment in social relations. See Lippard, "Escape Attempts," in *The Dematerialization of the Art Object from 1965–1975*, exh. cat. (Los Angeles: Museum of Contemporary Art, 1995).

11 Papastergiadis, "The Global Need for Collaboration," 1.

12 Okwui Enwezor, "The Production of Social Space as Artwork: Protocols of Community in the Work of Le Group Amos and Huit Facettes," in Enwezor (ed.), *Collectivism after Modernism: The Art of Social Imagination after 1945* (Minneapolis: University of Minnesota Press, 2007), 223–252.

13 Rustom Bharucha, "The Limits of the Beyond: Contemporary Art Practice, Intervention and Collaboration in Public Spaces," *Third Text* 21 (2007): 397–416.

14 Julian Stallabrass, *Art Incorporated: The Story of Contemporary Art* (Oxford: Oxford University Press, 2004), on whose description of the Johannesburg biennales we have drawn.

15 Stallabrass, *Art Incorporated*, x.

16 See Naomi Klein, "Democracy Born in Chains: South Africa's Constricted Freedom," in *Shock Doctrine: The Rise of Disaster Capitalism* (New York: Metropolitan Books, 2007), 194–217, on "free enterprise" Keynsian tactics that produced profit for foreign investors, while causing unimaginable hardship for an already traumatized population in South Africa following the liberation struggle – a situation repeated worldwide in many different contexts documented by Klein.

17 Carol Becker, "The Romance of Nomadism: A Series of Reflections," *Art Journal* 58(2) (Summer 1999): 22–29.

18 Robert D. Austin and Lee Devin, *Artful Making: What Managers Need to Know about How Artists Work* (Upper Saddle River, NJ: Financial Times/Prentice Hall, 2003).

19 Such a characterization parallels Lyotard's thesis on postmodernism as that which, *in the modern*, was its subordinated yet always co-present other. Jean-François Lyotard: *La condition post-moderne: rapport sur le savoir* (Paris: Minuit, 1979).

20 Namatjira's first exhibition was held in Melbourne in 1938; he was awarded the Queen's Coronation Medal in 1953. His career ended tragically when he was arrested and convicted of illegally supplying alcohol to Aboriginals, a victim of the neo-colonial paternalistic government despite his success as an artist. Vivien Johnson, *Lives of the Papunya Tula Artists* (Alice Springs: IAD Press, 2008), 17–19. On Albert Namatjira, see Kleinert, "Namatjira, Albert (Elea) (1902–1959)," *Australian Dictionary of Biography* (Australian National University), at www.adb.online.anu.edu.au/biogs/ (accessed July 24, 2010).

Further Reading

Zygmunt Bauman, *Liquid Modernity* (Cambridge: Polity Press, 2000).

Carol Becker, *Surpassing the Spectacle: Global Transformations and the Changing Politics of Art* (Lanham, MD: Rowman & Littlefield, 2002).

Howard Becker, *Art Worlds* [1982], rev. and expanded edn. (Berkeley: University of California Press, 2008).

Clifford Geertz, *Local Knowledge: Further Essays in Interpretative Anthropology* (New York: Basic Books, 2000).

Elisabeth Hallam and Tim Ingold (eds.), *Creativity and Cultural Improvisation* (Oxford: Berg, 2007).

Mark Harris (ed.), *Ways of Knowing: New Approaches in the Anthropology of Knowledge and Learning* (New York: Berghahn Books, 2007).

Tim Ingold, *The Perception of the Environment: Essays in Livelihood, Dwelling, and Skill* (London: Routledge, 2000).

Vivien Johnson, *Lives of the Papunya Tula Artists* (Alice Springs: IAD Press, 2008).

Susan Lowish, "Writing on 'Aboriginal Art' 1802–1929: A Critical and Cultural Analysis of the Construction of a Category," Ph.D. thesis, Monash University, Melbourne (2005).

Jean-François Lyotard, *The Postmodern Condition: A Report on Knowledge*, trans. Geoff Bennington and Brian Massumi (Minneapolis: University of Minnesota Press, 1984). [*La condition post-moderne: rapport sur le savoir*, Paris: Minuit, 1979.]

Kylie Message, *New Museums and the Making of Culture* (Oxford: Berg, 2006).

Katherine Park and Lorraine Daston, *The Cambridge History of Science*, vol. 3: *Early Modern Science* (Cambridge: Cambridge University Press, 2006).

Donald Preziosi, "The Multimodality of Communicative Events," in J. Deely, W. Brooke, and F. E. Kruse (eds.), *Frontiers in Semiotics* (Bloomington: University of Indiana Press, 1986), 44–50.

Jacques Rancière, *The Emancipated Spectator*, trans. Gregory Elliott (London: Verso, 2009).

Richard Sennett, *The Craftsman* (New Haven: Yale University Press, 2008).

Pamela Smith, *The Body of the Artisan: Art and Experience in the Scientific Revolution* (Chicago: University of Chicago Press, 2004).

Pamela Smith, "Science on the Move: Recent Trends in Early Modern Science," *Renaissance Quarterly* 62 (2009): 372–373.

Catherine M. Soussloff, *The Absolute Artist: The Historiography of a Concept* (Minneapolis: University of Minnesota Press, 1997).

FIFTH INCURSION
INTERSECTIONS OF THE LOCAL
AND THE GLOBAL

Any image is a good one, provided we know how to use it.
Gaston Bachelard, *The Poetics of Space*

Ideas about causality are neither singular nor fixed, but are multiply functional within the topologies of any art matrix. These may include situations where artifacts are considered to have agency in their own right. If artworks "mean" differently under different conditions, and if even "art" itself may be a local or culturally specific idea, could there be a responsibly transcultural perspective on art and artifice? This incursion explores contrasting notions of artistic signification.

Much of the discourse on *what art is and does* has been linked to the question of causality: how and why something got to be what it appears to be. This includes a sense of what its meanings and functions might be under certain conditions and for whom. In what manner a thing may justifiably be considered a representation, expression, or echo of who or what a maker or fabricator might be entails the presumption of a *concordance* of some kind: a determinate relationship between a maker's intentions or desires and what is taken to be the resultant effect or product of those intentions. Many current debates on meaning, function, and signification assume radically different positions on that putative concordance.

Art Is Not What You Think It Is, First Edition. Donald Preziosi, Claire Farago.
© 2012 Blackwell Publishing Ltd. Published 2012 by Blackwell Publishing Ltd.

To frame questions about art in such terms is to do so within the larger scaffolding of modern, largely Western conceptions about how things are said to mean or signify – questions that would have been answered differently elsewhere, as well as within the Western tradition itself in premodern times. Such questions assume that an ontological distinction or real difference exists between subjects and objects, between entities construed as active agents (such as artists or their surrogates) and those things acted upon by agents that are commonly mute, dumb stuff, raw material to be shaped or fashioned by a subject.

But the distinction also presupposes many other things. For example, it is generally *time-factored*: the agent's activity (however construed in detail) is normally taken to be *prior to* the effects it has on objects or materials. The agent is also the site to which questions about the meaning or significance of the resultant object or artifact are cogently referred. That is, the question as to the way an object or artwork signifies is commonly answered in terms of the agent's intentions, even if these are not explicitly expressed. In other words, in the most general sense, the object or artifact is taken to be above all the answer to a question. And the presumed duty of any who would interpret (read, explain, account for) the object has conventionally been to link its appearance to the maker's presumed intentions.

Artistry entails a set of normative behaviors whereby maker and receiver exist ideally in a relationship of concordance. These have included, traditionally, the assumption of a unity of being regarding the maker, a homogeneity that is reflected or effected in the maker's work, which then may exist as an *index* of the maker's identity. Everything about the work is presumed to signal the maker, who moreover is assumed to remain constant through all his or her transformations and changes over time. So, the artist and artwork exist as mutually defining and supportive artifacts in a disciplinary discourse or machinery. As much as the artist is a historical being, (s)he is also a real character in an interpretive system or machinery.

This is equally the case where the artist is not an actual identifiable human being, but is a marker of a time, place, and people. The relationship of artist to artistry is staged according to the norms of an implied *narrative* of time, growth, and change (as much as permanence). The systemic entity, "the artist," explains the presence of elements in the artist's corpus of work; it is a *principle of unity*, a point where perceived contradictions in the work are resolved. There is consequently a circularity about this semiotic system, wherein each element is a sign (index) of (aspects of) the person of the

artist, within a matrix of associations ultimately focused on confirming the identity of the maker(s). This would work similarly whether the maker is an individual human or a crowd, whether the resultant work is an object or a process of collaborative interactions or performances.

The conditions of production and use of art in colonial societies and other situations where different systems of signification (and different contexts of use) are juxtaposed, collide, and combine raise questions about the connections that are conventionally (unproblematically) assumed to exist between artistic intention, unified meaning, and communicative power. There appears to be no way to resolve the meaning of such artworks into a single, stable reading, any more than there appears to be a resolution to the complex agencies involved in their production and use. Just how highly contested and coded the discussion of national identity, for example, can become was brought home in a 2008–2009 exhibition of nineteenth-century European Orientalist art, *The Lure of the East,* which opened in London at the Tate Britain and closed in Istanbul at the Pera Museum. For the traditional dynastic Muslim elite in Turkey and elsewhere in the Islamic world, many of whom now live in modern suburbs, the ambience of nineteenth-century Orientalist paintings on display read as stylish retro. Christa Salamandra writes about paintings of Old City Damascus as a leisure destination for both tourists and local elite in exactly these terms.[1]

The contemporary reception of nineteenth-century exoticizing Orientalist painting in Syria resonates with complex and contradictory recuperations of agency elsewhere that hardly offer a straightforward alignment of agency and representation. At the Istanbul venue of *The Lure of the East* exhibition, the Pera Museum was surrounded by billboards in the neighboring streets and malls featuring contemporary women in modish but modest fashion parading though the exhibition of harem scenes and other Orientalist excess, performing Istanbul as a center of international Muslim cool.[2] At its London venue, by contrast, it was important for the gallery to field a different Muslim urban presence. As an antidote to rooms filled with paintings that presented Muslims and Muslim cultures as objects rather than as owners of the gaze, the Tate Britain recruited talking heads for its publicity and programming who would be instantly recognizable as outspoken opponents of the war in Iraq. Authenticity was still at stake, driven by the desire to appear culturally sensitive in a predominantly non-Muslim social setting. The recorded commentaries of Al Jazeera correspondent Rageh Omaar and journalist Robert Fisk were thus used to

mollify the presumed sensibilities of viewers of Muslim or Middle East descent, but the actual audience within the exhibition was the usual well-educated, visually literate audience of museum goers. Would another form of branding have drawn a different audience, for example the large Bengali Muslim population of east London?, ask the authors in a volume of critical essays about the exhibition.[3]

Critique of the fictional presentation of the Ottoman past extends to Ottoman women of the nineteenth century who challenged European stereotypes of eroticizing views inside harems, for example. Their interventions, in published memoirs and novels, were possible because Orientalizing cultural forms unintentionally created opportunities for their exercise of cultural agency. Their nuanced, at times precarious, positions in relation to the cultural forms at their disposal helped to create new matrices within the network of gender, audience, pleasure relationships. The re-presencing of such fictions today provides an opportunity for dealing cogently, ethically, and effectively with what museums do, a topic at the heart of our Seventh Incursion. In anticipation of that longer discussion, the simultaneous non-erasure and reframing of the past as monument to the present is essential for making legible the legitimacy of what the present wants to be understood as being. The museum's contents thus legitimize what is outside the museum: its contemporary social contexts in all their layered complexity. The possibilities for the same work of art to mean different things to different audiences or to the same audience at different times, or not to mean anything clearly at all, are much greater when elements are combined from different systems and/or styles of representation. Regardless, in the museum, our lured selves always seem hidden in the holes of discourse, or waiting just around the next corner in the next gallery. We are carried along a continuously twisting Möbius strip that makes up the modernist dramaturgy of "subjects" and their "objects" whose opposition is itself the artifact of a refusal to see them as the two anamorphic states of the artifice of the same modern self, each invisible to the other from the place of the other, each the ghost of the other's ghost. The forces of power and desire produce dynamically variable effects. Nonetheless, the basic problems of signification and agency hold for any work of art on display anywhere. Context is everything; there is no authenticity beyond/before/after/around/outside of its temporary, concrete fabrications whether that place is inside the museum or outside it, or on the threshold where people enter and exit the heterotopic settings of the museum's constantly parading exhibition halls.

Four Kinds of Signs

The interaction between "subjects" and "objects" in museum exhibitions also brings up the question/problem of how collaborative art practices (considered below) work to both support and undermine the ideology of identity as singular, organic, or homogeneous: whether it is an index of *dispersed agency*. But then what would indicate such dispersion if not an already agreed upon notion of unity in diversity?

What then is an *index* (or what is indexicality in general) and how has it been understood (again, in the modern, Western tradition) in relation to other possible types of relationships ("signs") between entities or phenomena? What is a sign? How exactly does a given formation signify or "mean"?

There is much confusion about these issues, as widely reflected in contemporary discussions and debates about art and artistry in a number of academic fields – especially in those practices or institutions to be more closely examined here and in the incursions to follow, namely anthropology, art history, and religion.

In the most general sense, while signs and systems of signs ("codes") have been understood in a variety of interrelated ways, most modern perspectives have been concerned primarily with *how* things are thought to mean: how entities or phenomena have been or could be staged in relation to each other (whether at a distance or in immediate juxtaposition).[4] The different ways in which things mean have served as a basis for systemically distinguishing how things signify in given circumstances. And how things signify has, in the Western tradition, been articulated in spatial terms – specifically, as *topological relations* between entities or phenomena, within a wider *temporal* framework of prior–subsequent (cause–effect) relationships.

A sign, then, is understood in the broadest sense not as a kind of thing but as a kind of connection: a causal relationship of something standing (in) for some other thing (*aliquid stat pro aliquo*) – where something makes something else come to mind.

The kinds of causal relationships most commonly cited are these three:

1 a relationship of (actual) *contiguity* between any two or more entities, objects, or phenomena – commonly referred to as an *index* or an indexical (or metonymical) relationship;

2 a relationship of (actual) *similarity* between any two or more entities, objects, or phenomena – an *iconic* (or metaphorical) relationship;

3 a relationship between any two or more entities, objects, or phenomena of a conventional or *symbolic* nature that is neither similar nor contiguous, but arbitrary and assigned in a given social or cultural environment, though it may be disputed.

4 If index and icon are *actual* relationships of either contiguity (index) or similarity (icon), and symbol is a *conventional*, collectively assigned relationship between entities, objects, or phenomena, then there is another, fourth kind of relationship that we will call *imputed*. Imputed signs are those that re-code or transform prior signifying relationships into something other.[5]

In practice, these four sets of distinctions are not always fixed – they can overlap and signifying relationships can sometimes be defined in terms of more than one of these categories. But it's useful to keep them in mind as provisional distinctions in order to understand how agency, signifying practices, and institutional authority are related in the topological matrix.

Meaning in Art History and Anthropology: Two Approaches

We make these distinctions between different types of signs because they are not commonly considered in much recent commentary in (most of) art history and anthropology, whereas (as we shall see below) they play a crucial role in a variety of ways in pre- and Early Modern Western and some non-Western *religious* traditions concerned with (what we term) art and artistry. In their modern secular formations, the disciplines of art history and anthropology have hitherto rather unsuccessfully engaged with religious concerns about artifice (we say "religious" by which we mean, more generally, in relation to a collectively held, transmissible set of beliefs and practices). As we will argue in detail in our Sixth Incursion, a not inconsiderable amount of confusion has accompanied recent controversies about imagery, blasphemy, idolatry, freedom of expression, and social responsibility.

Among the increasing number of reflections today on what art is and does, two books published during the past decade stand out for the breath of their claims and the strength and depth of the reactions to them. The earlier is by the anthropologist Alfred Gell (*Art and Agency: An Anthropological Theory*, 1998)[6] and the more recent is by an art historian, David Summers (*Real Spaces: World Art History and the Rise of Western*

Modernism, 2003).[7] Both studies received a notable number of mixed evaluations by writers in both their own and related fields. Many published reviews compared the claims of both texts to the long and diverse histories of commentaries on art both within and outside the authors' two academic fields.

Although the two texts were directly addressed to current issues and problems in their respective fields, the claims, methods, and larger implications of both are relevant to the aims and methods of this volume, although in different ways. Each with varying degrees of success attempts to take a more global perspective on the problem of art and artistry, and both attempts to do so reflect current attention (or lack thereof) in their respective academic disciplines on what could or should actually constitute a genuinely cross-cultural view on the subject today. Summers's book came to be read and evaluated relative to the "world art studies" movement in academic art history, which is the context in which we will discuss it here.[8] In contrast, the work of Alfred Gell galvanized anthropological attention to the roles and functions of artwork in the construction of social life in a variety of non-Western societies, particularly in the Pacific area.[9]

Summers's study had a double aim: to formulate a contextual method of description of all works of art and to provide a theoretical basis for a more intercultural art history (p. 19). Summers described his project in semiotic terms as an investigation of "indexical inference" that concerns "existential relations" between the appearance of a work of art and the conditions of its making. The analysis proceeds through a series of definitions, qualifications, and concrete examples, starting from the external surface of the concrete work of art, where the traces of its having been made are referred as its "facture," and proceeding through five more categories: places, appropriation of the center, images, planarity, and virtuality. (By contrast, we examine indexicality as a logic of structural relations that operates in existing art historical practices [as a facet of the art matrix] at the level of human agency.)

From the beginning, Summers rejected the category *visual art* with its ethnocentrist formalist terms of description, rooted in a European psychology of visual perception and European modes of painting, whereas most art has been made "outside the assumptions of Western representationalist psychology altogether" (p. 42). Where Summers proposed different categories to replace untenable essentializing ones, our project functions on the level of critique: our aim is to understand the structural relations that keep reproducing the same untenable formulations in the system or matrix that involves art history.

For Summers, "spatial arts" were presumed to be a less culturally biased category, involving all the senses, necessary for investigating embodied experience. From this derives his definition of "real space" where "we find ourselves sharing with other people and things," as distinguished from "virtual space," or space represented on a surface (p. 43); and "real metaphors" which "precede and condition the philosophic formulations that are properly taken as authoritative for the Western tradition" (p. 257). A "real metaphor" is "something at hand that is changed from one context to another in order to be treated as if it were something else" (p. 20). In the final analysis, "real metaphors" describe the process of signifying without reducing entities, objects, or phenomena to words. As we put it, the visible cannot necessarily or satisfactorily be "made legible."

In the ongoing discussions and debates attempting to rethink the existing discipline of art history in non-essentialist terms, *Real Spaces* was (and remains) a catalyst for formulating concepts that might be used in many circumstances in art history's multiple cultural domains.[10] The volume marks an advance upon the time when the discipline of art history was first publicly admitted as being "in crisis."[11] No one could have imagined that such openness and creativity would prevail in academic discussions three decades later, especially when the fundamental differences of approach to the practice of art history are so great.

The most serious objections to *Real Spaces* focus on methodological and conceptual problems, not least of which is the rationale for constructing a single intellectual edifice for all the world's art in the first place. The need to be more attentive to the complex processes of cultural interaction and displacement, and the incommensurability of concepts of space and aesthetics, are issues still needing further substantive attention.[12] Summers's own response to these objections focuses on the desirability of maintaining the discipline of art history, which requires a shared and useful terminology, however disputed. Nevertheless, a re-engagement with the question of universals and the hypothesis that elements of embodied experience might provide a ground for understanding artistic practices differently, a topic that receives closer attention in the Seventh Incursion.

Of course, any uncritical use of the term "art" is problematic, as we've seen, since the idea of autonomous art was conceived in its modern form during and after the Renaissance in Euro-American societies, and in other cultures what answers to this European term is inseparable from other practices.[13]

Anthropologist Alfred Gell raised a question somewhat different than Summers's: how people come to believe in the affect of a particular object. His account of agency itself, however, has been criticized for failing to analyze *how agency is imputed* because it does not describe the belief system of the worshiper, the process of socialization, or other aspects of the form of the object and the context in which it is used. His account of agency lacked precisely those factors that make it possible for members of a society to use objects as agents, including the conception that certain objects have agency in themselves.[14]

Gell analyzed agency from a position *within* the belief system, the primary theoretical interest of his account being that it appeared to avoid explaining agency from the rationalist perspective of Western epistemology. The overall argument of the book hinged on his definition of indexicality, which in his case conflated relationships of *actual* contiguity between entities and *imputed* contiguity or what others call *artifice*. The *conflation* of the two categories seriously undercuts Gell's explanatory model when he argues, for example, that the agency of artistic representations is as simple as that of natural signs – he gives the classic example of a natural index that smoke is a sign of fire.[15]

There is precedent, however, for such a conflation of actual and imputed agencies in the Christian theory of images where the most sacred object is the *relic*, made without human artistic intervention. A work made by human artifice is explained on the same model as agency emanating directly from God. We've already argued that Renaissance discussions about the artist's "divine gifts" were not simply rhetorical flourishes or classicizing topoi but efforts to account for the truth of the representation in these (Christian) terms. The agency of the artist is explained indexically on the model of a contact relic as involving a direct (indexical) relationship between the artistic representation and its divine referent. Actual and imputed indexicality are conflated, just as they are in Gell's account.

The logic of indexicality also governs other kinds of Christian religious objects (Figure 5.1). Ex-votos were (and still are) objects most frequently made of silver or wax, offered to the divine as a request for aid or as thanks for divine help received. The preferred medium itself carries powerful associations of identity due not to an artist's workmanship but to the trace of actual physical contact directly embedded in it. The ex-voto was considered an index of the individual who offers it. The life cast and the death mask function according to the same logic (Figure 5.2). They are all types of *inverse* miraculous images, impressed with human rather than sacred

Figure 5.1 Ex-votos from ancient Corinth. Photo David Padfield.

Figure 5.2 Guido Mazzoni (ca. 1445–1518). Death mask of Alfonso of Aragon as Joseph of Arimathea. Detail of *Lamentation of Christ*, Naples, Church of Sant'Anna ai Lombardi. Reproduced from Roberta Panzanelli (ed.), *Ephemeral Bodies*, exh. cat. (Los Angeles: Getty Research Institute, 2008), 28. Photo Paolo Mussat Sartor.

identity. But the indexical properties of these types of images made (in a religious perspective) without the intervention of human "art" still serve as the link between the human and the divine realms, guaranteeing its "truth."[16] Another category of "artless" art, judged by period standards, are the polychromed sculptural, usually clothed, figures assembled in *tableaux vivants*, depicting events from the Life of Christ, at the "Sacro Monte" or Holy Mountain of Jerusalem, which were popular pilgrimage destinations in the sixteenth and seventeenth centuries (Figure 5.3).[17]

The Catholic Reformation writer Archbishop Gabriele Paleotti (1522–1597), whose widely influential treatise on sacred and profane images we've already mentioned, seems to have understood the indexicality of images in just these terms when he connected but also distinguished sharply between "vestiges," which are "irrational and imperfect" traces like a footprint, and images produced by the art of *disegno*. He defined the latter as "taken from another form for the purpose of being like it." Paleotti distinguished between such lofty figures from which "copies [*ritratti*] can be made" and

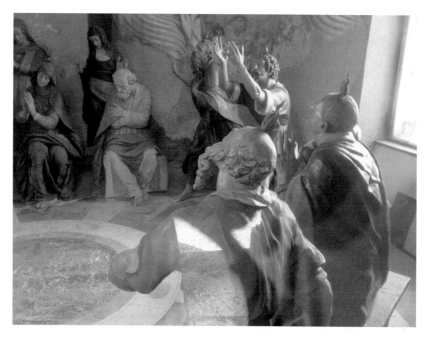

Figure 5.3 *Assumption of the Virgin.* Varese, Sacro Monte. Polychromed sculpture. Photo Donald Preziosi.

the "irrational" footprint, on the basis of St. Augustine, who conceived of a continuum of images produced by art and nature (like reflections in mirrors or clear water) as being of the same order as the resemblance between father and son. For both Augustine and Paleotti, the source of the material imprint is crucial: footprints and smoke are limited in their usefulness, while the abstract and incorporeal images used by theologians, or the *fantasmi* and *concetti* that give painters the ability to paint, are a "gift of God and a sign of the loftiness of human nature." Imitative painting, writes Paleotti in terms reminiscent of Photios and other Greek writers who defended the use of images during the Byzantine Iconoclastic Controversy in the ninth century, speaks a universal language: images are immediately recognized by everyone because such artistic images represent the similitudes of things to the sense of sight. Thus the purpose of images is to overcome "the defect of distance" between the worshiper in the church and the actual Christ, Virgin, and Apostles who are far away "above us."[18]

Paleotti clearly understood that a range of agents were responsible for an image, even an artificial "similitude" (a term derived from optics used to account for the process of vision: natural "similitudes" or "species" are the images that transmit the object immaterially into the eye). And he also understood that the value of an image made by human art – whether the figure described in words by a theologian or the figure fabricated by a painter – is due to its divine origin. There are numerous medieval and Renaissance examples that document how artists understood their work to operate within this indexical framework – for example, when they offered their work to God as gifts or votive offerings. From inscriptions found buried in crucifixes and reliquaries to drawings prepared by Michelangelo as gifts for his reformist friends, works offered to God participated in the same economy as the artless wax or silver ex-voto – they were material objects impressed with the human identity of the devotee (ultimately issuing from God) to request divine assistance.[19]

Most scholarly interest in the historical literature has focused on the *increasing agency* granted to the artist's sensate judgment in the process of art-making because the artist's autonomy and freedom to invent are central to modern, secular notions of art. However, it is also significant that the logic of indexicality provides a way of accounting for the effectiveness of the artwork from a variety of positions *within* the matrix of the Christian belief system. The new discourse on art that developed in the fourteenth century and later, in Italy and elsewhere in Europe, claimed an increasingly independent role for the artist but the Christian context in which all sacred

images functioned continued to inflect these discussions in specific ways. The perennial challenge was to establish the ontological status of the artistic representation.

Some brief examples of how the same logic of indexicality continued to present itself in texts as well as artistic practices. At the height of Tridentine reforms instituted in Milan by Archbishop Carlo Borromeo (in office, 1564–84), the painter-theorist Gianpaolo Lomazzo described how the artist's greatest challenge is to impart graceful life and movement to his figures. This depends on being personally endowed with *furor*, the quality that artists shared with poets, a divine gift that appears to be *almost* human in origin (in other words, not quite):

> knowledge of this movement [*moto*] . . . is considered to be the most difficult and is esteemed a divine gift . . . which the ancients called the *furor* of Apollo and the Muses: so it is also necessary for the painter, together with the other things required of him, to have knowledge and force and to express the principal movements *almost* as if generated out of himself and raised by him from a babe.[20]

Lomazzo was not the only non-ecclesiastical writer caught between allegiance to the artist and to the truth of sacred artistic representations when the Church of Rome redirected artistic license away from *grotteschi*, *capriccie*, and other fantastic forms emblematic of the artist's powers of invention. One of the most scholastically well-grounded writers who emphasized the importance of optical naturalism because it was in line with the viewer's intuitive way of learning, while still supporting the artist's invention of fantastic images, was the artist-theorist Federico Zuccaro, patronized by Pope Pius IV, under whose papacy the Tridentine Decree on Images was conceived, and ratified in 1564 (with considerable help from his nephew Carlo Borromeo). Zuccaro was founder and first director of the Roman Accademia di San Luca established by artists in 1577 and authorized by Pope Sixtus V in 1588. Zuccaro wrote about human *disegno* as the "internal" mirror of divine creativity that ordained the world and continually brings it into existence, while "external *disegno*" is made up of the visible world, which is "the painting of God" together with all artificial things.

Citing Thomas Aquinas's *Summa Theologiae* and St. Augustine, to whom he acknowledges being referred by theologians, Zuccaro wrote at length about the existence of "ideas" as forms separable from matter in the mind

of the artisan: we apprehend these forms in the way that is appropriate to humans, through the senses. Following Aquinas, in line with the justification of images that resolved the Byzantine Iconoclastic Controversy in the ninth century, Zuccaro called the mental image that precedes its material fabrication a "quasi-idea" that is analogous to ideas in the mind of God but received through the senses by the intellect which is a *tabula rasa*, like a "spacious, smooth canvas prepared by us painters." Navigating judiciously through ontologically dangerous territory, Zuccaro identified *disegno* with an "agent intellect" that "makes all things," and is found in the human soul itself which derives its intellectual light from God himself, the separate intellect and the soul's creator. In this way the fallible, particular intellect of the human individual is enlightened and sustained by the mind of God. Although we are only a "small copy of the excellence of divine art," the human intellective soul by its nature (that is, through sense experience) can know "spiritual forms representing all things of this world" that come from God: by virtue of this ability, man may be "almost a second God." Following Aristotle through Aquinas, Zuccaro writes about the divine image "impressed in us" as the *concetto* of all *concetti*, the form of all forms. Painting distinguished by coloring, shading, lighting, and so on gives figures such spirit and vividness that they seem "living and true," appealing intuitively and universally to all beholders: thus a well-painted image "increases devotion greatly."[21]

The idea that painting based on the scientific principles of optical naturalism was universally accessible because it conformed to human modes of cognition was exported all over the world, above all through the campaigns of missionaries, where the results were often unexpected and complex. The process of evangelization is a topic beyond the scope of this short book, but it is important to consider not only how imported objects and ideas shaped the European discourse, but also how the European discourse was transformed at its various points of reception. Jesuit activities under Pope Gregory XII, known as the "Pope of the Missions," and several of his successors have received the greatest amount of scholarly attention to date, but many other subjects are just waiting to be investigated.

In seventeenth-century Rome, the painter Guido Reni (1575–1642) was considered *divino* by his contemporaries, and the Christian context for discussing the artist's source of inspiration is more overt. Writing in 1672, his biographer Giovanni Pietro Bellori described the relationship between the artist's acquired skills (his *arte*) and his God-given talent (his *genio*) in terms similar to Lomazzo: Guido's noble genius gave him a mind uplifted

to beauty and, through the study of the most beautiful forms, he amplified his *genio* to the highest degree.[22] What is perhaps most striking about this well-documented case is the manner in which artists' biographies articulate connections between theological grace and the visual grace of Guido's painterly style by using the *same* descriptive language that appears in prayers and devotional literature dedicated to the artist's sacred paintings.[23]

Although the Christian model for explaining agency remained the logic of the index, very complex relationships developed to explain the connections between the work of art and the individual artist whose agency was linked directly with God. Another agency to consider as part of the same Christian art matrix is the beholder's share. To explain how divine immanence plays out in devotional practice, art historian Robert Nelson articulates the exchange between a Greek Orthodox icon and a worshiper as being governed by an existential relationship. The "speaker" (the holy person represented in the image) and the "listener" (that is, the worshiper) maintain a present-oriented, spatially and temporally coextensive relationship through the work of art.[24] The Greek Orthodox experience of worship animates and personalizes the cultural message contained in material form. The icon, in other words, is an instrument, a *mediator*, and an ideological machine – a way for the believer to comprehend the Christian idea of God existentially through an interactive medium.

Alfred Gell's account of Hindu "idol worship" is very similar to Nelson's explanation of the exchange between icon and worshiper told from a position *within* the belief system using modern semiotic terms, except that the Greek Orthodox explanation of the viewer's agency is calculated to avoid the charge of idolatry. Images described by Latin and Greek Christian writers alike as lifelike are said to reveal emotions such as grief and love, and to perform the gestures of speech, largely through the economy of color and light.[25] Such images are said to manifest *dynamis*, the implied movement of the image due to the presence of the soul. A Late Antique ritual was performed by priests for the "ensoulment" of the image, an act of consecration – this infused the object with an invisible *pneuma*, as descriptions from Porphyry to Proclus attest. But the point of these descriptions is to animate the *beholder*, to guide the worshiper internally to a state of grace. The materiality of the image – in the case of Byzantine icons, the actual colors themselves interacting with their environment – is responsible for moving the viewer. The shimmering effect of light passing over the surface of mosaics in a darkened church interior lit by candles is analogous to the illusionistic effects sought by Italian artists working in the Latin

tradition of Christianity. St. Augustine describes prayer as an *internal* vision in terms very similar to Leonardo da Vinci's description of how his painted imitations of *external* vision instruct, move, and delight the spectator.[26]

Understood from *within* the belief system of Christianity, the sacred image which is addressed as being "alive" functions as an instrument for enlivening the beholder by appealing to the imagination through the senses.[27] Images are therefore necessary in liturgy because they are suited to human ways of knowing. To articulate such a complex theory of signification even in simple terms calls attention at once to the problematic nature of Gell's model of agency: the apparent conundrum that a separation between entities or phenomena is at the same time a connection, a linkage through distinction, as Rancière has argued.[28] In fact, it suggests at least two problems. First, if signification is determinate only in specific circumstances – at given times and places for certain purposes – then signification is at base indeterminate. Second, it presupposes that a form and its meanings or functions are distinct in the first place, that a thing has an existence apart from its uses or references.

Such problems, however, do not exist in a historical vacuum, and in fact evoke an enormous body of discussion and debate about signification itself in theology, philosophy, politics, and ethics. Without entering into the details of those debates, consider simply the multiple ways in which a phrase in a text (such as a Bible) or a particular visual artwork (say, Picasso's *Guernica*) can be *read* differently – formally, literally, allegorically, morally.[29] In particular circumstances, one or another reading may take precedence or be in dominance, while the others may remain potentially available or co-present. Communicative activity is invariably multimodal as well as multidimensional.

A very large proportion of the debates in fields such as art history and art criticism, or the various branches of anthropology and archaeology, revolve around different ways of construing such relationships. For many practitioners, the history of those institutions is tantamount to a genealogy of variations, transformations, and oscillations between different versions of how artworks or cultural artifacts (for example, the pyramids at Giza) signify, both to current viewers, or to their original makers, users, and/or subsequent audiences, insofar as any of these might be known or reconstructed.

To some extent, such historiographies replicate and partly parallel stylistic histories of artistic form. These are also not infrequently read *allegorically* as corresponding to or in general indexing or signifying evolutions or developments in the mentality or personality of a person or people or of

a time and place. The critical historiographies of these academic disciplines are also themselves taken as representing trajectories or trends in theory or interpretation, particular styles typically read as reflecting or representing wider intellectual, critical, political, or ethical developments.

Is there anything common – a certain topology, so to speak – to these connections, these types of relationships? Different modes of reading – such as those briefly noted above in connection with medieval European rhetoric – distinguish not only between direct (or literal) and indirect (or allegorical) types of signifying, but also between (at least) two types of indirect connections, the allegorical and the moral. A Giza pyramid may literally be the tomb of a dead pharaoh (and his retainers and family), but it may also represent the ascent of that individual's soul to heaven. In which case, the pyramid form itself is a representation of an (immaterial) move-ment – to an ancient Egyptian, a literal representation; to our eyes, perhaps, an allegory of the immaterial journey of the soul to its heavenly home among the pharaoh's relatives, the gods.

The latter example, like the examples of Christian and Hindu images just mentioned, suggests that the links between an artifact and its referent are not only a function of distinct geometries of connection but a matter of who is interpreting the connection, and the purposes (social, political, religious, commercial) to which it might be put. This makes more complex the subject of how things are thought to signify. Whether the relationship between a thing and what it is claimed to refer to or to indicate is direct or indirect may be as much a function of the social *position* of the reader or interpreter of the connection. In other words, whether the person is part of or is outside a given community (or a certain class or gender or genera-tion, and so forth). The distinction between *inside* and *outside* has been implicit in certain discussions about "world art history studies," with some scholars advocating for interpretive methods based on non-Western con-cepts of art and aesthetic terminology regarding what are ultimately incom-mensurable cultural practices.[30] Others argue that the underlying problem today is an unwillingness to address the fact that translation and interpreta-tion always involve transformation – thus replaying at a meta-critical level the problems to be narrated.

To put this into the context of current debates in the discipline of art history concerning the possibility of developing a universal history of world art, authors of arguments advocating such a possibility include a number who do not take their own subject positions into account, rarely consider-ing the *performative* effect of arguments launched from an institutionally,

geographically, and culturally privileged position in a politically uneven field of discourse. Many still assume their own gaze to be a neutral apparatus of investigation and cognition, as a "neutral field in which some innocent objective 'eye' is deployed by an unsituated viewer."[31] Yet every interpretation is strategic (including ours of course), and every interpretation is offered from a (socially as well as ideologically located) address.

Without rehearsing the complex and convoluted history of ancient and modern semiotic theories, it is more to our purposes here to consider the issues we've just begun to raise from another point of view: our modern, supposedly secular one. To repeat a recent observation by Judith Butler cited in the Introduction, if we take "secularization" as a way in which religious traditions live on within post-religious domains, then with respect to the art matrix we're not really talking about two different frameworks, secular versus religious, but about two forms of religious understanding intertwined with one another.[32] Let us now turn to the secularization of religious forms of signification associated with Christianity.

Modern Theories of Signification: Forget the Eucharist, or Not

When during a Catholic mass a priest raises up in his hands a piece of bread and intones the words "This is my body" (*hoc est corpus meum* in the original Latin), what is actually being presented to the congregation? Indeed what kind of thing is it? The priest then shares the consecrated bread with the congregation, each of whom consumes it or a portion of it. Is this a piece of food or a piece of art? And does its consumption by the priest and subsequently by each member of the congregation alter what it had just been?

What exactly is imagined to take place in what some see as one of the central mysteries in the Christian religion? At the moment that the priest says the words, for the faithful participant in the ceremony *the object is truly Christ's body*. Only then and not before and not after, but precisely at the moment of speaking these words that also commemorate and refer back in time and place to the words said by Christ at his last meal with his followers before his crucifixion and death.

In 1660 the theologians and grammarians Antoine Arnauld and Claude Lancelot of the French monastery of Port-Royal-des-Champs, strongly influenced by the work of contemporary philosopher René Descartes, published a book entitled "General and Rational Grammar, containing the

fundamentals of the art of speaking, explained in a clear and natural manner."[33] In developing a general theory of language, the Port-Royal theologians addressed the central problem of the *sign* by way of a key example, that of the Eucharist. The problem of the Eucharist for these grammarians was the essential Christian problem of signification as such: the need to express and illustrate the presence of the divine word in its material manifestation as a realization of a perfect exchange between matter and spirit. The Eucharist – the piece of bread – should not be thought of as a mere (arbitrary or conventional) *symbol* of the presence of Christ's body, nor is it a simulacrum or memory of that presence. It has to be thought of as *a sign that is at the same time* not *a sign,* and also not a reference to a sign (or a representation) of Christ's body, but a *presence,* functioning like the relic: this (bread) *is* Christ's body (here and now and at the precise moment the words "this is my body" are enunciated). This claim puts at the very heart of language – a system of conventional signs whose nature is to refer to or to stand in for something else – a sign that is *not* a sign because it is identical to its referent. In the Eucharist, the signifier *is* the signified.[34] It is thus *not* an index. The artificially made thing, the consecrated Host, is treated as if it were "made without human hands" (*acheiropoieta* is the Greek term), a quality attributed to many sacred icons.[35]

The ways in which culturally constructed realities of transcendental truths blind its practitioners to the mediation process itself is currently receiving widespread attention from anthropologists, art historians, and other cultural theorists. The entire semiotic system of language theory as understood by Enlightenment thinkers is grounded in conventional relations between material entities (such as words and their component auditory parts) and mental or intellectual phenomena, or meanings. This system has at its absolute center a relationship of identity (or a non-relationship between disparate things). At the occluded foundation of a palpable system of signs, of language, is the Christian ontology of how the divine is immanent in Christ. The consecrated Host is Christ: matter is spirit.

This was no mere obscure, abstract philosophical claim nor a rhetorical sleight of hand. What was palpably at stake for the Port-Royal theologian-grammarians was something much more deeply important: the need to rationally and logically justify a spiritual or immaterial realm of being that could be seen to *coexist* with its purported opposite, the concrete material world. The place for spirit – for the immaterial within the material – would have to be not merely metaphorical or allegorical but actual. The place made for spirit would be made as a fact reflected in the very nature of human language itself.

The reasoning is like this. Human language is understood to be a system of marks or signs that are conventional or arbitrary with respect to what they refer to or signal. The sound "puppy" is culturally specific in one language but meaningless in another. If the sound conventionally references only a particular kind of young animal and then only in a particular language, then words do not have *essential* references to the notions they are used to evoke. Arbitrariness would itself be relative or relational, existing in relation to something that was *not* arbitrary or conventional but real. As is, in fact, the Eucharist: a non-arbitrary, non-referential sign. An identity, not a symbol or a metaphor or an allegory: a self-indexing index, a sign only of itself. That is, a showing or *ostensification* of Christ. A pure *monstrance*.[36]

The problems the Port-Royal grammarians wrestled with were simultaneously religious, logical, and linguistic. They focused with great clarity on the role played by theories of meaning and representation in the justification of the existence of a spiritual world. Their writings also had powerful *political* implications during the same years of the seventeenth century, a time when justifications for and arguments against absolute monarchical power were ubiquitous. As Pascal satirically argued in many of his writings at the time, the processes of legitimizing absolutist power involved obvious mystifications: portraits of the king were virtual parodies of the Eucharist, as Louis Marin has extensively argued.[37]

This latter raises an issue on which it is suitable to end this incursion and provide a link to those following: the dangers of reifying and facilely homogenizing tendencies in signifying practices in particular historical situations. Voltaire did not one day instruct his valet to open the door and declare that starting tomorrow, the Enlightenment would begin. The point to bear in mind is the coexistence of multiply interacting tendencies in signifying practices. At the same time, any system of belief invariably coexists with inflections, alternatives, replacements, and transformations, as we shall see in the next two incursions, beginning with the mutual entailments and affordances of art and religion in various traditions.

Notes

1 Christa Salamandra, *A New Old Damascus: Authenticity and Distinction in Urban Syria* (Bloomington: Indiana University Press, 2004).
2 Reina Lewis, "Cultural Exchange and the Politics of Pleasure," in Zeynep Inankur, Reina Lewis, and Mary Roberts (eds.), *The Poetics and the Politics of Place: Ottoman Istanbul and British Orientalism* (Istanbul: Pera Museum,

2011), 58. Western Orientalist paintings take on a different significance, Lewis writes, "when indigenized into local forms of nostalgia and exotica as part of the development of differentiated regional consumer cultures" (57).

3 Christine Riding, "Staging the Lure of the East: Exhibition Making and Orientalism," in Inankur et al. (eds.), *The Poetics and the Politics of Place*, 33–48; paraphrasing here Lewis, "Cultural Exchange and the Politics of Pleasure," 54.

4 The most comprehensive overview of the history of semiotics in the modern period is Winfried Noeth, *Handbuch der Semiotik* (Stuttgart: J. B. Metzlersche, 1985); rev. translation, *Handbook of Semiotics* (Bloomington: Indiana University Press, 1990). See also Roland Barthes, *Elements of Semiology*, trans. Annette Lavers and Colin Smith (New York: Hill & Wang, 1968) [*Elements de Semiologie*, Paris: Seuil, 1964]. On approaches to visual semiotics, see especially Hubert Damisch, "Semiotics and Iconography," in Thomas Sebeok (ed.), *The Tell-Tale Sign* (Lisse: Peter de Ridder Press, 1975); D. Preziosi, *Architecture, Language and Meaning* (The Hague: Mouton, 1979); D. Preziosi, "Subjects + Objects: The Current State of Visual Semiotics," in James E. Copeland (ed.), *New Directions in Linguistics and Semiotics* (Houston: Rice University Press, 1984), 179–206; and Mieke Bal and Norman Bryson, "Semiotics and Art History," *Art Bulletin* 73 (1991): 174–298. An excellent international collection of key essays on all aspects of visual, spatial, cognitive, and environmental semiotics is the two-volume *Lebens-Welt/Zeichen-Welt* (*Life World/Sign World*) (Lüneburg: Jansen-Verlag, 1994).

5 They are conventional insofar as they are arbitrary, but the significance assigned to imputed signs is not based on the results of prior negotiation. At one end of the spectrum is the solipsistic imputed sign, pure artifice intelligible to no one (except perhaps its maker) and at the other end of the spectrum, the meta-critical imputed sign, unprecedented but intelligible to others. In between these two extremes of imputed signs are various degrees of semiotically open signs – such as those produced when previously unrelated semiotic systems are conflated, as happens for example, in colonial societies or other situations where a pre-existing sign (index, icon, or symbol) is appropriated from one context and inserted into another.

6 Alfred Gell, *Art and Agency: An Anthropological Theory* (Oxford: Clarendon Press, 1998). Gell died prematurely in January 1997, just after completing the book. He was at the time a Reader in Anthropology at the London School of Economics and had published three major works on cultural history and theory: *Metamorphosis of the Cassowaries* (1975), *The Anthropology of Time* (1992), and *Wrapping in Images: Tattooing in Polynesia* (1993).

7 David Summers, *Real Spaces: World Art History and the Rise of Western Modernism* (Phaidon Press, 2003). Subsequent references to the book are given within parentheses in the text. Summers is currently a Professor in the Department of the History of Art at the University of Virginia, Charlottesville,

specializing in the art history and theory of the Italian Renaissance. Prior to *Real Spaces*, he had published numerous articles and two major books: *Michelangelo and the Language of Art* (Princeton, NJ: Princeton University Press, 1981) and *The Judgment of Sense: Renaissance Naturalism and the Rise of Aesthetics* (Cambridge: Cambridge University Press, 1987).

8 The best recent English-language introduction to the academic marketing endeavor of global art history studies to date has been Kitty Zijlmans and Wilfried Van Damme (eds.), *World Art Studies: Exploring Concepts and Approaches* (Amsterdam: Valiz, 2008), especially valuable for its extensive bibliographies in various languages.

9 See especially the fairly representative evaluation of Gell's work by anthropologist Howard Morphy, "Art as a Mode of Action: Some Problems with Gell's *Art and Agency*," *Journal of Material Culture* 14(1) (2009): 5–27. Morphy's review is directly pertinent to the methodological aims of this Incursion.

10 James Elkins (ed.), *Is Art History Global?* (New York: Routledge, 2007), organized a round table leading to this publication as a forum involving 34 participants, focused on Summers's book. Elkins himself claims that it is the methods of art history, not its subject matter, that effectively unify the field (15).

11 See Henri Zerner (guest ed.), "The Crisis in the Discipline," *Art Journal* 42(1) (1982). David Summers and Donald Preziosi were both contributors to the issue.

12 Ladislav Kesner, "Is a Truly Global Art History Possible?," 81–112, citing p. 102, in Elkins (ed.), *Is Art History Global?*, who notes these various critiques on pp. 56, 102, and 165.

13 We concur with Matthew Rampley's and others' assessment that *Real Spaces* remained entangled within the legacy of European Enlightenment aesthetics. See Matthew Rampley, "From Big Art Challenge to a Spiritual Vision: What 'Global Art History' Might Really Mean," in Elkins (ed.), *Is Art History Global?*, 188–202, citing p. 196. Rampley includes a brief comparison between Summers and Gell on p. 195.

14 Morphy, "Art as a Mode of Action"; see also Irene Winter, "Agency Marked, Agency Ascribed: The Affective Object in Ancient Mesopotamia," in Robin Osborne and Jeremy Tanner (eds.), *Art's Agency and Art History* (Oxford: Blackwell, 2007), 42–69.

15 Gell, *Art and Agency*, 13.

16 Ex-votos included life-size effigies made of wax, clothed, placed as offerings at churches. See See Megan Holmes, "Ex-votos: Materiality, Memory, and Cult," in Michael W. Cole and Rebecca Zorach (eds.), *The Idol in the Age of Art: Objects, Devotions, and the Early Modern World* (Aldershot: Ashgate, 2009), 159–182.

17 Reference to the tomb of Christ, it should be noted, differentiated Christian from pagan worship. See the excellent discussion of Holy Sepulchre replicas

in Christopher Wood, *Forgery, Replica, Fiction: Temporalities of German Renaissance Art* (Chicago: University of Chicago Press, 2008), 47–48, with further literature. For an introduction to all the Italian genres mentioned above, see Roberta Panzanelli (ed.), *Ephemereal Bodies: Wax Sculpture and the Human figure* (Los Angeles: Getty Research Institute, 2008). See, on the Sacro Monte, Annabel Wharton, *Selling Jerusalem: Relics, Replicas, Theme Parks* (Chicago: University of Chicago Press, 2006), esp. 49–96.

18 Gabriele Paleotti, *Discorso alle imagini sacre e profane* (Bologna, 1582), excerpted in Paola Barocchi (ed.), *Trattati d'arte del cinquecento fra manierismo e controriforma* (Bari: G. Laterza, 1960), vol. 3, 117–509, citing 132–142. Paleotti cites Augustine, *De doctrina Christiana* 2.1. Paleotti derives the analogy to the resemblance of father to son directly from Lactantius, *Divine Institutes* 2.2, but it originates in an ancient topos used by Plutarch, Petrarch, and many others. Our discussion here follows David Summers, *The Judgment of Sense*, 146–150, but we are responsible for understanding the arguments in terms of the Christian logic of indexicality.

19 A remarkable discovery of such an inscription followed the 1944 bombing of Siena: a polychromed wood Crucifixion by Lando di Pietro, 1338, split open by the blast, was found to contain two inscriptions inside the head of Christ, one of which is a prayer identifying the artist, who completed this similitude of Jesus, "and it is He one must adore and not this wood"; cited in Pamela H. Smith, *The Body of the Artisan: Art and Experience in the Scientific Revolution* (Chicago: University of Chicago Press, 2004), 10. See also Alexander Nagel, *Michelangelo and the Reform of Art* (Cambridge: Cambridge University Press, 2000), 170–187, on Michelangelo's connections to the Viterbo community of reformists gathered around Cardinal Reginald Pole in the early 1540, where the focus of discussion was on gift-giving and the operations of divine grace. Nagel argues that Michelangelo understood the possibility of making a work of art that would cease to be just an invention, and would instead aspire to be an inexhaustible gift.

20 Gianpaolo Lomazzo, *Trattato dell'arte de la pittura* (Milan: Pontio, 1584), 108, cited in David Summers, *Michelangelo and the Language of Art* (Princeton, NJ: Princeton University Press, 1981), 69 n. 35; emphasis added. Lomazzo was active in artistic and literary circles that resisted Borromeo's new policies and it is probable that publication of some of his other, satirical writings were delayed until after the archbishop's death in 1584. The artist had direct access to Leonardo's writings and drawings, and embraced both the scientific and the fantastic dimensions of artistic license that he found in this and other sources.

21 Federico Zuccaro, *L'idea de' Pittori, Scultori e Architetti* (Turin: A. Disserolio, 1607), cited in the facsimile edition Detlef Heikamp (ed.), *Scritti d'arte di Federico Zuccaro* (Florence: Leo S. Olschki, 1961), 158–185, 225–232. Zuccaro cites Thomas Aquinas, *Summa theologiae*, 1.15.1, 1.75.2, and 1.79.4. The resem-

blance of Zuccaro's language and ideas to Leonardo da Vinci's treatise, a copy of which Zuccaro owned, has been noted by David Summers, whose account of Zuccaro we follow (*Judgment of Sense*, 282–308), stressing here the Christian logic of indexicality that the arguments present so clearly. Zuccaro's understanding of scientific naturalistic painting, as Summers notes (these continuities are in fact at the core of his argument), are in line with discussions of painted *relievo* since Cennini (ca. 1390) and Leon Battista Alberti (1435), two touchstones in the modern understanding of painting as imitating the world we see directly through the sense of sight. Summers himself is indebted to Panofsky's reading of Zuccaro, *Idea: A Concept in Art Theory*, who associates the artist's theory with "Mannerism," while we insist on their conformity with long-standing Christian theories of images that ground the truth of artistic representation in their contact with the divine. The majority of the scholarship has been focused on but divided as to whether Zuccaro was a Platonist or an Aristotelian, whereas we stress the importance of acknowledging the Christian character of his and other period sources.

22 Giovan Pietro Bellori, *The Lives of the Modern Painters, Sculptors, and Architects: A New Translation and Critical Edition*, trans. and ed. Alice Sedgewick Wohl, Helmut Wohl, and Tomaso Montanari (Cambridge: Cambridge University Press, 2005), 347, cited in Pamela M. Jones, "Leading Pilgrims to Paradise: Guido Reni's Holy Trinity (1625–1626) for the Church of SS. Trinità dei Pellegrini e Convalescenti and the Care of Bodies and Souls," *Altarpieces and their Viewers in the Churches of Rome from Caravaggio to Guido Reni* (Aldershot: Ashgate, 2008), 261–324, citing p. 310.

23 Jones, "Leading Pilgrims to Paradise," cites testimony by Francesco Scannelli, 1657; Carlo Cesare Malvasa, 1678; Luigi Pellegrino Scaramuccia, 1674; Giovanni Battista Passeri, the poet and painter, ordained a priest in 1672, who frequently cited theological sources. She compares their language with numerous seventeenth-century prayers and poems (including Antonio Glielmo, *Le Grandezze della Santissma Trinita* (Venice, 1658)), where the same terms are used to draw connections between the theological and visual connotations of grace. The artist was credited with the ability to evoke in paint on canvas the beautiful, bright, loving, charming, majestic, grand, and eternal God filled with grace, as if seen in a vision (*bellissma, vaga, gioconda, svelata, chiara, amorosa, goisa, gaudio, felicita, lume superno, lume puro, fiamma gioconda, gioia immense, amore gelice, belo vis*). As Jones notes ("Leading Pilgrims to Paradise," 306), even in Antiquity, grace was considered a gift with both stylistic and spiritual resonances associated above all with Apelles by writers such as Quintilian, Pliny the Elder, and Plutarch.

24 Robert Nelson, "The Discourse of Icons Then and Now," *Art History* 12 (1989): 144–157.

25 See Paul Finney, *The Invisible God: The Earliest Christians on Art* (Oxford: Oxford University Press, 1994), 73; on the origin of the closely related concept

of *praesentia*, see Peter Brown, *The Cult of Saints: Its Rise and Function in Latin Christianity* (Chicago: University of Chicago Press, 1981), esp. 86.

26 Augustine, *De trinitate* 11.1.1; 1.1.2. See Margaret Miles, "Vision: The Eye of the Body and the Eye of the Mind in Saint Augustine's *De trinitate* and *Confessions*," *Journal of Religion* 63(2) (1983): 125–142, who writes about Augustine's analysis of touch as the moment of vision. On Augustine and Leonardo's defense of painting, see Claire Farago, "Introduction: Seeing Style Otherwise," in *Leonardo da Vinci and the Ethics of Style* (Manchester: Manchester University Press, 2008). The three traditional functions of images (to instruct, to move, and to delight) were transferred from ancient rhetorical theory and incorporated in many medieval and Early Modern texts. For a good introduction, see Michael Baxandall, *Painting and Experience in Fifteenth-Century Italy* (Oxford: Clarendon Press, 1972) and Michael Baxandall, *Giotto and the Orators: Humanist Observers of Painting and the Discovery of Pictorial Composition* (Oxford: Clarendon Press, 1971). Different levels of ornament or embellishment were associated with each type of writing: plain language for instructional texts; seemingly natural forms of stylistic embellishment for texts intended to move or persuade the audience; and ornate embellishment for texts intended to delight the audience, such as poetry or epideictic rhetoric. Also known as the low, middle, and high style, this system of decorum or appropriate fit between subject matter, audience, and level of ornamentation was transferred to discussions of the visual arts – mostly famously beginning with Alberti's 1435 treatise on painting, *De pictura/Della pittura*.

27 Byzantine apologists for icons at the height of the Iconoclastic Controversy in the eighth and ninth centuries held that images cannot and do not have presence: their similarity to the prototype is only formal – image and copy are not linked in an essential unity as Father, Son, and the Holy Ghost are. Speaking to this point in the eighth century, John of Damascus, the patriarch Nikephoros, Theodore of Studion, and others later on proposed a definition of icons that denied the presence of the prototype in artificially made images (as opposed to images made without human intervention). See Gerard Ladner, "The Concept of the Image in the Greek Fathers and the Byzantine Iconoclastic Controversy," *Dumbarton Oaks Papers* 7 (1953): 3–34, and Charles Barber, "From Transformation to Desire: Art and Worship after Byzantine Iconoclasm," *Art Bulletin* 75(1) (1993): 7–16.

28 What is also called by the French philosopher Jacques Rancière a *partage du sensible*: the sharing/division of what is visible, sayable, and thinkable. J. Rancière, *Malaise dans l'esthetique* (Paris: Galilee, 2004), a useful excerpt of which is translated as "Problems and Transformations in Critical Art," in C. Bishop (ed.), *Participation: Documents of Contemporary Art* (London: Whitechapel Gallery, 2006), 83–93.

29 Discussed in brief in Umberto Eco, "The Poetics of the Open Work," in *Opera Aperto* (Milan: Bompiani, 1962); English translation, *The Open Work*, by Anna Cancogni (Cambridge, MA: Harvard University Press, 1989), 1–23.

30 A position advocated by Elkins (ed.), *Is Art History Global?*, 61–63. Scholarship attentive to non-Western concepts and methods has arguably raised among the most challenging and intellectually difficult questions for "world art history" studies. Among the earliest attempts to resist a globalizing art history came from a pioneer of what was then called Oriental art history, Okakura Kakuzo, known as Tenshin, at the beginning of the twentieth century. See Sigemi Inaga, "Is Art History Globalizable? A Critical Commentary from a Far Eastern Point of View," in Elkins (ed.), *Is Art History Global?*, 249–279, citing p. 255.

31 Citing Irit Rogoff, *Terra Infirma: Geography's Visual Culture* (London: Routledge, 2000), 33, referring to an earlier critique by Martin Jay, *Downcast Eyes* (Berkeley: University of California Press, 1995).

32 Judith Butler, "The Sensibility of Critique," in Wendy Brown (ed.), *Is Critique Secular? Blasphemy, Injury, and Free Speech*, The Townsend Papers in the Humanities, no. 2 (Berkeley: University of California Press, 2009), 119–120.

33 Antoine Arnauld and Claude Lancelot, *Grammaire generale et raisonne contenant les fundamens de l'art de parler, expliques d'une maniere claire et naturelle* (1660): English translation, *General and Rational Grammar: The Port-Royal Grammar*, by Jacques Rieux and Bernard E. Rollin (The Hague: Mouton, 1975). The book was a complement to the original authors' *Logic*, published in 1662. Arnauld (1612–1694) was one of the most celebrated and controversial philosophers and theologians of the seventeenth century, and engaged in many exchanges with his contemporaries Descartes and Leibniz. Ordained as a priest in 1641, he wrote extensively on the nature of the Eucharist during the time when the *Grammar* and the *Logic* were published. He was forced into exile in the Netherlands in 1679 and remained in Liège, where he died in 1694.

34 Aspects of this question are discussed at some length in D. Preziosi, *Rethinking Art History: Meditations on a Coy Science* (New Haven, CT: Yale University Press, 1989), 102–104 and nn. 118–122.

35 Hans Belting, *Bild und Kult* (1990); English translation, *Image and Likeness*, by Edmund Jephcott (Chicago: University of Chicago Press, 1994). Belting addressed the function of *acheiropoieta* in terms that have by now received widespread attention beyond the field of Byzantine art. See, for example, Bruno Latour and Peter Weibel (eds.), *Iconoclash* (Cambridge, MA: ZKM, 2002), and, more recently, for an excellent discussion of the issues in the context of contemporary media, see Mattijs van de Port, "(Not) Made by the Human Hand: Media Consciousness and Immediacy in the Cultural Production of the Real," *Social Anthropology/Anthropologie Social* 19 (2011): 74–89.

36 A monstrance is the name of the open or transparent receptacle within which a consecrated Host (Eucharist) is exposed for veneration to a congregation.

37 An essential discussion of this question is Louis Marin, *Le portrait du Roi* (Paris: Minuit, 1981); see also a review of Marin by M. Doueihi, "Traps of Representation," *Diacritics* 14(1) (1984): 66–77.

Further Reading

Gauvin Bailey, *Art on the Jesuit Missions in Asia and Latin America, 1541–1773* (Toronto: University of Toronto Press, 1999).

Roland Barthes, *Elements of Semiology* (New York: Hill & Wang, 1968).

James Clifford, *The Predicament of Culture: Twentieth-Century Ethnography, Literature, and Art* (Cambridge, MA: Harvard University Press, 1988).

Hal Foster, *Decodings: Art, Spectacle, Cultural Politics* (Port Townsend, WA: Bay Press, 1985).

Clifford Geertz, *Local Knowledge: Further Essays in Interpretative Anthropology* (New York: Basic Books, 1983).

Nelson Graburn, *Ethnic and Tourist Arts: Cultural Expressions from the Fourth World* (Berkeley: University of California Press, 1976).

Serge Gruzinski, *The Mestizo Mind: The Intellectual Dynamics of Colonization and Globalization* (New York: Routledge, 2002).

Dean McCannell, *The Tourist: A New Theory of the Leisure Class* (Berkeley: University of California Press, 1999).

B. Meyer and O. Pels (eds.), *Magic and Modernity: Interfaces of Revelation and Concealment* (Stanford, CA: Stanford University Press, 2003).

W. J. T. Mitchell, *What Do Pictures Want? The Lives and Loves of Images* (Chicago: University of Chicago Press, 2005).

Mary Louise Pratt, *Imperial Eyes: Travel Writing and Transculturation* (New York: Routledge, 1992).

Michael Taussig, *Mimesis and Alterity: A Particular History of the Senses* (New York: Routledge, 1993).

Slavoj Zizek, *The Plague of Fantasies* (London: Verso, 1997).

SIXTH INCURSION
INTO THE BREACH OF ART AND RELIGION

A divine teleology secures the political economy of the fine arts.
Jacques Derrida, "Economimesis"

Why exactly has art been seen in some times and places as a threat to religion? Is religion a threat to art? Or are only certain kinds of art or religion threatening? If so, how did they come to be so, and for what reasons? Who decides what is theologically acceptable and unacceptable about an artwork?

Art is no innocent bystander. People have murdered each other for millennia over ideas of what may today be considered as art. It's one thing to think about being inside or outside a community of artistic interpretation when the matter is approached as an academic one, where the possibility (the illusion) of maintaining a circumspect distance might seem real. But when the truth or falsity of artistic representations erupt into the daily world of ongoing events, when lives are lost due to disagreements over the inappropriateness or offensiveness of images that in a different context or by a different community are deemed harmless or beautiful, what is to be done? What is to be done when the tacit presumption of reason's capacity to unveil error is itself problematic and culture- and context-specific? What is to be done when the idea of art is a deeply ethical or religious matter, when conventional distinctions between ethics, artistry, and religion are no longer clear?

Art Is Not What You Think It Is, First Edition. Donald Preziosi, Claire Farago.
© 2012 Blackwell Publishing Ltd. Published 2012 by Blackwell Publishing Ltd.

The two previous incursions explored various aspects of artistic agency, in particular the different ways in which the topological shape of the art matrix reflected differences in the relationships of artistic agency to artworks and to the functions and destinations of works. Simply put, individual or distributed and collaborative practices distend the matrix differently. We have seen how differences in the ways in which an artwork may be thought to signify to observers and users within or outside a given community may also affect the overall geometry of relationships within the matrix.

We have seen that within the Western tradition the agency of the artist traditionally grounded in the scientific or moral truth of his or her representations was ultimately grounded in the ontological framework of Christianity, the unthought ground of the modern idea of art as "free" and "secular." In the case of traditional indigenous Australian art practices, we've noted that an artist's reputation in a community is closely linked to the *truth* of his work's representation of the spirit of the ancestors of a community, that reputation resting upon the community's investment in the artist's initiation in shared knowledge. This renders the question of agency more subtle and complex, since the community's investment in the art-maker's proper training renders the community itself – or at least certain portions of it with respect to gender and age and kinship – responsible for the outcome of the activity.

The links between artist and artwork in Australian and many other indigenous traditions are multidimensional, in large measure entailing the establishment or ostensification of an indexical connection to ancestral spirits or divinity. In this Incursion, we go outside the art system to consider that unresolved ground in which art is taken to be a direct emanation of the divine. This ground has risen to the surface of current debates over the role of religion in art and art in religion. Within the past decade, this has been marked by a number of events foregrounding religious objections to various forms of artistry, not a few of which were notable for inciting intense sectarian passion, widespread violence, and destruction and the death of many people around the world. These events have focused upon the nature of artworks themselves and on their use.

To cite one instance of sectarian passion, in relation to the religious question of idolatry: in March 2001, on orders from the Taliban leader Mullah Mohammed Omar, two world-renowned, colossal, sixth-century Buddhas carved into sandstone cliffs in the Bamiyan Valley in Afghanistan were dynamited in a campaign lasting several weeks (Figure 6.1). In so doing, Mullah Omar reversed his public position two years earlier, when

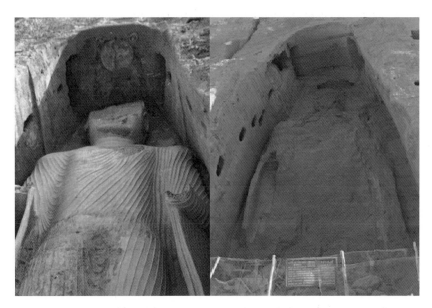

Figure 6.1 Colossal Buddha statue, sixth century: before (*left*) and after (*right*) destruction. Sandstone. Bamiyan Valley, Afghanistan. Photo Creative Commons Wikipedia.

he stated that the statues were deserving of protection. He now told the London *Times* that "Muslims should be proud of smashing idols." The Afghan Foreign Minister Wakil Ahmad Mutawakel defended Mullah Omar's new position, and in an interview with the Japanese newspaper *Mainichi Shimbun* on March 13, proclaimed that "We are destroying the statues in accordance with Islamic law and it is purely a religious issue."[1]

We will return to the problem of idolatry below. Two further recent events provoked international debate, and both condemnation and praise. On November 2, 2004 the Dutch film director Theo van Gogh was brutally murdered on an Amsterdam street by Mohammed Bouyeri in retaliation for his film *Submission* which depicted partially naked women with Qur'anic verses written on their bodies.[2] The murder took place several weeks after a local Muslim cleric Imam Fawaz gave a sermon calling upon Allah to send an incurable disease on van Gogh for blasphemy.

On September 30, 2005 the Danish daily newspaper *Jyllands-Posten* published a dozen satirical cartoons, some of which depicted the prophet Muhammad, in what the paper said was a contribution to current debates in Denmark on the criticism of Islam and the growing problem of

self-censorship there and in other countries. In the following months, a great many protests took place around the Muslim world from Europe and North Africa to Malaysia and Indonesia, resulting in widespread destruction of Danish, European, Christian, and Jewish properties, the burning of various Western embassies, and about 50 deaths.

The response to these protests varied, but in Denmark and in much of Europe it was claimed that these and any purportedly blasphemous publications (and republications) were a matter of state-guaranteed freedom of expression, and not a matter that the Danish government had any legal rights to intervene. This was a point made by government ministers and by the editor and publisher of the *Jyllands-Posten* cartoons. The latter observed that similar satirical images of figures in Christianity and Judaism had previously been published, without attracting such a strong reaction. The controversy has continued in several countries in Europe and elsewhere, and the situation has remained largely deadlocked over what are widely perceived as fundamentally incompatible understandings of what was at stake in the publication and reception of the satirical cartoons.

But what exactly was at stake, then, in these recent controversies, construed by some members of the Muslim community as blasphemous?[3] How could an image or a cartoonist blaspheme? And what would be the nature of the injury caused by this artistry? Does blasphemy even have a place or equivalent function in secular liberal democratic societies? Could blasphemy be understood in the same frame of reference as prohibitions belonging to secular society – such as those pertaining to freedom of speech and its corollaries, protection of the property rights of authors and collectors regarding works of art?

"Free" speech exists in (and as) a specific relation to legal conditions that define what may be communicated in a given social, cultural, and political situation. And offenses against a person or institution are perceived differently in different traditions whether they are privately or publicly manifested. In Christianity one can offend ("sin") with one's *thoughts* (even if these are not expressed verbally or by other means), while in Islam what matters is the subject's social practices (including verbal publication).[4] Communicating with publicly accessible signs may involve a potential seduction of others into beliefs that may be proscribed. In a sense, the debate about the offensiveness (blasphemy) is a debate about form versus content. A Muslim may blaspheme in terms of the *form* or material of a signification, the manner whereby something is manifested, while a Christian may blaspheme in the *content* of her thoughts – whence the need,

traditionally, for confession of one's transgressions, including and espe-
cially in one's thoughts. One confesses sins of thought and deed.

The World Union of Muslim Scholars stated that it allowed for a con-
siderable period of time to pass after the publication of the Danish cartoons
before calling for a boycott of Danish and Norwegian products and activi-
ties, in order to allow Islamic and Arab communities around the world to
solicit appropriate apologies from the offending individuals, organizations,
and communities. When none were forthcoming – aside from regrets by
some Western groups, who, however, continued to affirm that "free speech"
was guaranteed by their laws and therefore there could be no real (legal)
offense – international commercial boycotts began.

Thus the freedom to campaign against particular consumer goods was
set in opposition to a freedom to criticize beliefs publicly. It was difficult
for a secular Western citizen to understand the feelings of those for whom
it would have been impossible to remain silent confronted with the offense
of blasphemy. Or the offense of idolatry, as with the earlier destruction of
the Bamiyan Buddhas. In the latter case, were not the Taliban themselves
guilty of idolatry by imputing agency (hence danger) to the statues?

Images can be made to serve many purposes, depending upon how and
who uses them, and in what circumstances. The 9/11 bombers of the twin
towers of the New York World Trade Center themselves attributed dangerous
agency to those buildings. From the perspective of al-Qaeda, an attack on
buildings that symbolized a hated economic system was an attack on the
evil of Western capitalism. But the unfortunate people who worked in those
buildings on that fateful day did not lose their lives merely symbolically. The
conflation of imputed symbol with the thing itself had unimaginably gro-
tesque consequences, not least because the loss of life took place in New
York, not New Delhi or New Guinea or any other place "invisible" from the
so-called First World. Once the images of burning towers were played and
replayed endlessly in the media, they became something else again: for
viewers everywhere, regardless of their politics, the awful spectacle was
aestheticized by its repetition in this flat and odorless form (Figure 6.2). On
one hand, the event was condensed into a universal spectral symbol of a day
that changed the world. On the other, pictures of the burning twin towers
on a TV screen *really* meant a violation of the American way of life. This is
the asymmetrical logic of indexicality at work in the modern, secular world.

The reason why the "blasphemy" of the Danish cartoons was illegible to
those outside the offended community relates directly to what is at stake
in our consideration of the relations between art and religion. Between, in

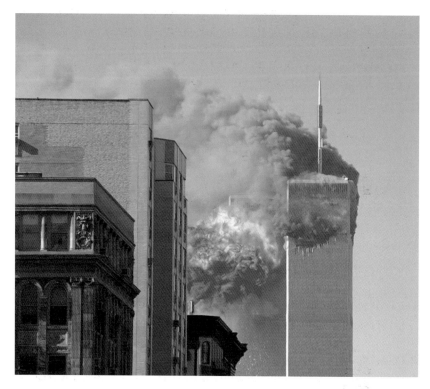

Figure 6.2 Twin towers of the World Trade Center burning, Sept. 11, 2001. Photo Creative Commons Wikipedia.

other words and on a deeper level, the relationship of objects to subjects – in this case, between an object, artifact, or image and the subject perceiving it. The relationships between a member of the Islamic community and the offending Muhammad cartoons – that is, with the form and content of the images – was not a dispassionate, disinterested, or distanced relationship such as one might be presumed to have with an artwork in a museum. In an Islamic context, the relation of the believer to the person depicted in the cartoons was more direct and immediately indexical. For Islamic pietists one "ingest[s], as it were, the Prophet's persona," emulating every aspect of his existence so that the caricatures do not merely defile Muhammad but constitute a direct assault on his followers.[5] Representing Muhammad *really* meant violating every single Islamic pietist.

Several things are at stake here. First, the disputes in all of the cases we have cited center on different understandings of the ways in which an image

is legible, that is, how a thing is perceived or seen to mean. This is a subject discussed in our Fifth Incursion on indexicality, where we considered the different contexts within which signs are thought to appear. The differences in each case had to do with the arbitrariness (conventionality) versus the necessity (essentialism) of the juxtaposition or connection between what are distinguished as form and content.

Second, these actual cases of controversies over images are the consequence of cultural differences regarding relations between public and private, and between the inner thoughts of an individual and the external manifestations of them (or the duplicities regarding what one believes internally). Let's look now at these issues in connection with broader ideas about the ownership of cultural property. We begin with another case study.

Who Owns the Past? Who Pays the Rent?

To a large extent, contemporary debates over the ownership and significance of objects duplicates the terrain long established by relics. In both cases, the significance attached to certain objects causes them to behave like symbols of entire belief systems for their interpretive communities. From the conflicting significance associated with these objects by different subgroups within a community, disputes arise over who controls the past. So it is not too far-fetched to understand the fundamental issue that the sacred raises as one of ownership: who owns your past?

Regarding the social significance of the sacred, a series of letters addressed to the Warburg Institute at the University of London in 1999 by the Hopi Cultural Preservation Office illustrate the problems that arise when communities cannot agree on who owns the past. The Hopi authorities framed their position regarding the republication of photographs of esoteric ceremonies taken by art historian Aby Warburg and his Mennonite missionary host V. R. Voth a century ago, in terms of cultural property rights.[6] Leigh Kuwanwisiwma, Director of the Hopi Cultural Preservation Office, wrote to Nicholas Mann, Director of the Warburg Institute at the University of London:

> Your intention to honor Hopi religion through the historical visit of a famous German art historian to the Southwestern United States addresses a similar misconception stated in your letter and symbolizes our concern with publications relating to our cultural and religious life Way . . . The fact is that

when our forefathers became aware of the publication of the photographs of Warburg and other westerners, they were indeed thought to be violating secrets . . . those secrets or subjects of privileged information that were violated a century ago continue to be violated today.[7]

Implicit in this statement are the effects of neocolonial economic exploitation imposed by the market in ethnic art that dates from the time of Warburg's visit in the 1890s. One effect of the knowledge thus produced is financial profit on something that should be valued for its inherent merit, another being a loss of control over the transmission of their own cultural values, with its attendant loss of the values themselves within the Hopi tribe and falsification of religious beliefs to all concerned. As Kuwanwisiwma explains in his correspondence with Mann:

The Hopi religion not only teaches peace and goodwill, Hopi people must also live it . . . Most [of the dances] also seek to improve the Hopi people's harmony with nature, thereby enhancing the prospect of its members for good health and a long, happy life. Only members initiated into these societies hold its information and knowledge, which is not written, but rather is passed on orally to society members who participate in the ceremonies. Information about the significance and function of these ceremonies can only be given by those initiated into these societies.[8]

According to the Director of the Hopi Cultural Preservation Office, Warburg did an injustice to Hopi beliefs *simply by being a historian*. The correspondence between the Hopi Tribal Council and the Warburg Institute includes a copy of the Council's "Protocol for Research, Publications, and Recordings," which opens with the Hopi people's desire to protect their "rights to privacy" and their intellectual property. Their two chief concerns are to avoid commoditization of their intellectual property, and to avoid making esoteric knowledge public. A second letter addressed to Mann in December 1998 signed by Kuwanwisiwma, states more bluntly that the Hopi religion is not for sale. Moreover, the letter explains, the photographs and other material contained in the Warburg Institute's new publication, entitled *Photographs at the Frontier: Aby Warburg in America 1895–1896* (Figure 6.3), are privileged information, handed down orally through initiation into the *katsina* society. Kuwanwisiwma reports that Hopi religious leaders were saddened by the book's publication and requested that its printing be stopped.

From these letters, it is clear that the Hopi have developed and are employing a language and institutional infrastructure adequate to address-

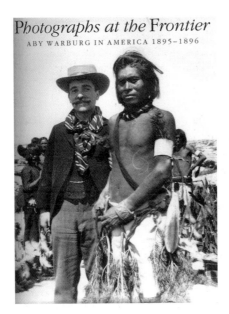

Figure 6.3 Book jacket, Benedetta Cestelli Guidi and Nicholas Mann (eds.), *Photographs at the Frontier: Aby Warburg in America 1895–1896* (London: Merrell Holberton, with The Warburg Institute, University of London, 1998). Photo courtesy The Warburg Institute.

ing the dominant culture on its own terms. Both the Warburg Institute and the Hopi Tribe are familiar with institutional forms of protocol and power, but they did not see eye to eye. The Institute responded almost immediately (in January 1999) to the director of the Hopi Cultural Preservation Office by deferring to the Institute's publishers – as, in fact, only they were in the position to recall the book, which was published in 1998 by the London firm of Merrell Holberton in association with the Warburg Institute. Yet it should be noted that had the Warburg Institute acted upon the Hopi Tribe's *first* request to review the manuscript in May 1997, the Hopi religious leaders would undoubtedly have voiced the same objections and the publication (though well advanced by this time) could have been halted.

The Institute, through its director, indicated two reasons why the Council's initial request was found to be uncompelling: first, because the authors and editors of the volume do not actually profit at the expense of the Hopi religion; and second, because the photographs that have "any

direct bearing" on a Hopi religious ceremony are already in the public domain, having been published many years ago. In any case, the Institute emphasized that the book's primary intent was to document Warburg's visit to the Southwest, and the publication attempted to maintain historical accuracy by including an essay on Hopi beliefs written by "the best Western specialist" in order "to honour, not to sell, Hopi religion."[9]

The Hopi–Warburg conflict is a good illustration of how incommensurable worldviews operate in a contemporary international standoff that discourages cultural exchange and reproduces colonial hierarchies of power. The ambiguous phrase "in the public domain" in the Warburg Institute's letter suggests an unstated but crucial connection between the Hopi Tribal Council's two complaints and the Warburg Institute's two answers. In the narrow sense, the dispute played out in the correspondence concerns the control of monetary profit, but it is also clear that this discussion is rooted in a fundamental disagreement over the legitimate use of power.

The real sticking point concerns how information about a less powerful subgroup of society is perceived and used by a more powerful one. "In the public domain" could simply mean that the photographs are no longer secret, or it can also be taken to mean that they are no longer covered by copyright and therefore, in the strict capitalist sense, it is no longer possible to make a monetary profit out of them. In either case, the Warburg Institute's defense that it is not making a profit makes "privacy" rather like virginity – once you've lost it, it's gone forever (too bad, but there's nothing we can do about it now). The Institute's position depends on viewing time strictly as a linear sequence, an irreversible succession of events: the violation of privacy pertained only to the particular moment and to the people photographed. The Hopi, on the other hand – and the same is true of every Pueblo group in the Southwest today – conceptualize sacred presentness as trans-temporal. Privacy is consequently violated *every time* someone looks at the photographs.

The following narrative is taken from the book that the Warburg Institute published on Warburg's 1895–1896 trip to the Southwest. Like many other recent accounts that could be cited, it needlessly fails to identify the very complex concerns about the ownership of intellectual property current and pressing not only in Southwestern studies but in many places in the world today, one result of which is a tone that is unhappily rather naive. In the words of Benedetta Cestelli Guidi:

> Warburg not only violated the tradition that forbade one to look at a bare-headed Kachina: he also wanted to set up a scenario, gathering the dancers'

masks and arranging them in a precise order, and placing himself at the
centre with the Indian.

There must have been some valid reasons for violating the Indians'
customs in this way.[10]

On whose terms can Warburg's violation be considered valid? Ongoing
debates about the ownership of cultural property involve not only the
physical remains of the past but also, very importantly, our perceptions of
the past and our articulations of these views. With respect to Native
American culture, the more familiar context for disagreeing over property
rights is that of repatriating sacred objects, including human remains,
housed in museum collections. Should images, in this case photographs,
be treated any differently than the esoteric objects and events they
document?

The central issue is not merely ownership of intellectual property, but
quality control of intellectual property and the ability to conserve the
healthy infrastructure of a society.[11] From the dominant culture's point of
view, trafficking in ritual objects is historically significant and quantifiable
in museological terms: the monetary value of the objects, their mode of
storage, display, attribution, ownership, materials, condition, and so on
"preserve" these differences. From the marginalized culture's viewpoint, on
the other hand, what counts is *controlling the signifying power* of the mate-
rial residue of events.

The terms of misunderstanding (and miscommunication) often hinge
on the meaning of "public," or rather, degrees of publicness. The behavior-
ist descriptions typical of anthropological field work may signal "objectiv-
ity" from the standpoint of empirical science but, in the same breath, they
deny the significance that the Hopi themselves attach to their perform-
ances. At this intersection of cultural practices, the inside–outside problem
of narrative voice resonates in a different register: the dominant notion of
"public" means the power to inscribe Native belief in an alien system of
values and activities.

The local problems that we have been discussing also feed into current
global debates about the repatriation of cultural patrimony. This is an arena
in which academics and other experts do have an ethical role to play in
broader social issues. At the International Congress of the History of Art,
held in Melbourne in January 2008, papers were presented by scholars from
49 nations, many of which dealt with repatriation issues, including the case
of a Mi'kmaq chief's cloak brought to Melbourne by a Canadian immigrant
in 1852, the return of which is being requested by First Nation peoples of

New Brunswick.[12] Negotiations facilitated by the International Congress of Art in this case became the focus for rethinking objects as ambassadors to forge human ties and cross-cultural dialogues, although this case is currently not fully resolved.[13] Another presentation co-authored by Fran Edmonds, then Ph.D. candidate at the University of Melbourne, and Vicki Couzens, a Keerray Wurrong/Gunditjmara woman from the western districts of Victoria, Australia, spoke of the bond between indigenous artists, art historians, and curators in recent years to challenge the assumptions of the art market and the museum profession.[14] Couzens reclaimed and redefined in contemporary terms the southeast Australian practice of making possum skin cloaks inscribed with local native histories by initiating multicommunity projects where people of all ages shared experiences.[15]

Nor do the issues of who controls the past pertain only to relationships between indigenous peoples and their colonizers. At the same conference, Tristan Weddigen, currently Professor at the University of Zürich, called for critical investigation of the uses and abuses of art in international politics. He analyzed the looting of 2,000 art works on Stalin's instructions, aided by the art historians who identified the works of art to be looted.[16] When these works were repatriated to the Dresden Gallery in 1956, the event was accompanied by massive propaganda that *created* the legend of the Soviet rescue of the Dresden collections from Nazi and Allied barbarism. In another presentation, Professor Kavita Singh, an art historian from the University of New Delhi, documented the reverse flow of objects from museums into shrines, from exhibitions to rituals, in exiled Tibetan communities where objects considered to be sacred reside "eternally poised on the brink of an eternally deferred return":

> The flows of objects . . . are not repatriations in the conventional sense of the physical return of goods to legal owners. Instead these are acts that deploy the idea of "repatriation" – by inverting it, mimicking it, or deferring it; or finally, by opposing it. In the mimicry, inversion, deferral or opposition lies the political potency of the gesture, as the incompleteness of the act of repatriation draws attention to the loss of the patria, the homeland, and the impossibility of repatriation to it.[17]

In the current climate of globalization, what is anyone's responsibility to society? Regardless of claims to the contrary, there simply is no knowledge that exists independently of the institutions that support it and the political circumstances that make work possible (or impossible). Questions

of from whom, to whom, through what structures of meaning anything is being transmitted are always at stake. Art, as cultural geographer Irit Rogoff stated not long ago, is an "entity that chases me around and forces me to think things differently."[18] The sacredness claimed for any object, whether or not it is considered "art," is a similarly productive entity: a legitimate subject for investigation rather than a pre-existing category, one that encourages us to dig into the ontological and epistemological issues, necessarily understood from situated subject positions.

The fundamental issues that repatriation raises – Who owns the past? Whose objects are valuable to whom? Whose interpretations count or don't count? – are the contemporary global version of the problems that sacred objects in general pose for particular cultural traditions.

Plato's Dilemma

Ambivalences and often passionately opposed attitudes toward the arts are not peculiar to the modern world, for unresolvable debates over idolatry, fetishism, iconoclasm, and iconophilia have been endemic to many societies and cultures. Artistry and sacrality or spirituality are so inextricable that it is no exaggeration to suggest that what are distinguished as art and religion are different answers to related sets of questions, different ways of phrasing fundamental questions regarding the nature and consequences of human existence itself. Alternatively, they are co-determined methods of reading human encounters with the worlds in which we live, facets of more fundamental relationships of which artistry and spirituality are themselves culturally contingent artifacts.

To raise the question of *religion* is to raise the question of what constitutes art itself. The oldest fully extant text remaining from the Western world that is devoted explicitly to the nature and social value of artistry and artifice is the long dialogic treatise by Plato (ca. 429–ca. 347 BCE) we know as *The Republic*. Throughout that remarkable work of artistry runs a deep ambivalence about the cultural, political, and religious values of art to a community and its citizens. While it is well known that in ancient Greece Plato banished the mimetic or representational arts from his projected ideal city-state, it is not as well remembered that he did so reluctantly and with a certain ambivalence. We might frame that ambivalence as a dilemma – one that goes to the heart of what it means to either connect or disconnect art and religion, artifice and spirituality, the secular and the

sacred, both then and now. The ghost or specter of what constitutes "the sacred" continues to haunt the very idea of art profoundly.

What Plato termed "divine terror" (*theios phobos*) has been and continues to be so framed in various fundamentalist religious traditions across the world, and our discussion above about the "blasphemy" of the Danish Muhammad cartoons is just one case in point, albeit a telling one. Plato invoked an already ancient and persistent ambivalence about the uncanniness of art, about its ability to simultaneously fabricate and problematize hegemonic political and religious power imagined to be materialized, embodied, or "represented" in a people's forms and practices.

This was the ambiguity of artifice as such in not simply reflecting but in fabricating the world in which we live, the problem encountered in *The Republic*.[19] Art deeply problematizes seemingly secure oppositions between what some might want to ideally contrast as fact and fiction; history and poetry; reason and emotion, sacred and secular; contrasts that are revealed to be circumstantial and mutable effects of human artistry.[20] What artistry or artifice created for Plato, then, was not some "second world" alongside the everyday world in which we live; what art created was the actual world in which we really do live our daily lives.

The "divine terror" that art induced in the soul was the terrifying awareness of precisely this: that works of art don't simply "imitate" but rather create and open up a world, and keep it in existence, as Heidegger famously put it in discussing the ontologically creative potential of artworks in his essay "The Origin of the Work of Art," where the experience of art is taken to be fundamentally religious in nature.[21] Or where, more precisely, the nominal common distinction between art and religion is itself deeply problematic. This is an issue of the truth or falsity of imitation or representation.

Both Heidegger and contemporary philosopher Giorgio Agamben argue that in the modern age we are cut off from the essential powers of art because our relation to it has been subjectivized and secularized by various (pseudo-)sciences of aesthetic philosophy, art history, and museology. Artworks have been domesticated into mere exemplifications of social-historical processes, into objects for the judgment of individual "taste." In a passage to which we already alluded in our Introduction, Agamben put it this way:

> the entrance of art into the aesthetic dimension – and the understanding of
> it starting from the aesthesis (sensory impression) of the spectator – is not

as innocent and natural a phenomenon as we commonly think. Perhaps nothing is more urgent – if we really want to engage the problem of art in our time – than a destruction of aesthetics that would, by clearing away what is usually taken for granted, allow us to bring into question the very meaning of aesthetics as the [putative] science of the work of art . . . perhaps just such a loss . . . [is] what we most need if we want the work of art to reacquire its original stature.[22]

These are strong words, and as strong in their way as Heidegger's rejection of the entire apparatus of the art industry, including aesthetics, art history, and museology. What Agamben calls "art's original stature" is close to what for Heidegger is an openness to the experience of the authenticity of art that characterized the Greek experience of art's spiritual power (*theios phobos*: divine terror, sacred fear): every work a revelation, every work a potential incitement of redemption. For both Agamben and Heidegger, then, the age of aesthetics is at its close – given the inextricable linkages of aesthetics, art history, art criticism, art practice, and museology as essential instruments in the servicing of global capital.

Let's return to Plato for a moment. He was writing about what would constitute an ideal city and social order. Plato would have banished inappropriate or indecorous artistry from his ideal city-state because of its potentially destabilizing influence on the imaginations of ordinary citizens, causing them to quite literally think otherwise. To reiterate the problem, then, "Plato's dilemma," put simply, is this: if the state and all of its institutions and artifacts, including our own identities, are recognized for what they are, contingent fabrications, then other kinds of states (and other modes of civic life or even other modes of being human) might be imagined and given form, calling into question the alleged naturalness of the state one has. Plato was clear that when it comes to the arts, everything including our identities and our very existence as social beings is profoundly at stake.

So the very real dilemma lies in needing to promote a "true" or proper or correct aesthetic order, one that reflects what a city's leaders believe expresses the ideal cosmic order of truth, all the while realizing that any artifactual order is contingent and always liable to "false" or alternative interpretations.

Yet it is precisely this acknowledgment of the existence of art as artifice that constitutes the very foundation of philosophy as critique and discernment, as a questioning of the "naturalness" of nature; as the "incessant

vigilance about how and why and what we tend to take for granted."[23] What was necessary for an ideal polity or an ideal state was, for Plato, that it be taken as truly real and grounded in some immaterial or spiritual or "sacred" order – that is, *as* natural and permanent rather than *as if it were* natural or as a (mere) aesthetic hypothesis desiring power. (To put this into the semiotic terms introduced in the fifth incursion, an artificial sign is masquerading as a natural sign, a relation of *imputed* contiguity is presented as a relation of *factual* contiguity.)

This is what is most deeply at stake in any discussion of the relations of art to something being promoted by hegemonic power as natural. Any such claims have always had very profound implications for the lives of individuals and communities, for it has consistently been the case that such claims are linked to political and legal systems of discipline and enforcement in many societies around the world, and across different religious belief systems and political cultures.

Although the role of media lies beyond the scope of this book, it is important to draw a connection between the issues raised here about the naturalization of any particular form of art by the state, the hegemonic role of naturalistic styles of representation (defined in general terms as being in conformity with the way we see the world through the sense of sight), and the uses to which photography is put as a form of documentation that actively structures our cognitive apprehension. Susan Sontag has written eloquently about the "transitive" nature of photography which, beyond its representational properties, functions as an affective form of interpretation especially when combined with text. Judith Butler has extended Sontag's account in relation to "the pain of others" to argue that photographs become a "structuring scene of interpretation" with pervasive powers in contemporary society – to such an extent that photography is "built into" the case made for truth: there can be no truth without photography, yet photographs are highly manipulable forms of media that are actively involved in showing what they show. Their framing strategies invisibly organize our perception and thinking about what is presented as evidence unless the frame itself somehow becomes part of the still photograph or moving picture. Discussing the widely circulated photographs of prisoners being tortured by American service men and women at Abu Ghraib, Butler examines the framing effects of camera angle, posed subjects, point of view, and so on which suggest that those who took the photographs were actively involved in the perspective of war. Interpretation is not simply a subjective act at the level of the individual viewer because the structuring constraints

have the power to elicit empathy or antipathy, action or inaction – depending not just on the representation, but on what is *representable*: what is included is constituted by what is left out. Butler describes the relentless logic of indexicality that we have been stressing all along at work in contemporary life, determining which of us are capable of being seen as fully human subjects, which of us are subjectified, dehumanized others. Along with many other public intellectuals, she calls for a different ontology, one that stresses our global interdependency and the interlocking networks of power that maintain differential positions in everyday life. The future ontology needs to recognize that my life "refers to some indexical you without whom I cannot be."[24]

Over the past three centuries, what we commonly refer to as art has served as the site par excellence for the production of the phantasms that make up the fabric of our modernities and postmodernities – the chimeras of identity, ethnicity, race, gender, nationality, sexuality, culture, indigeneity, and otherness. The key metaphorical conundrum of post-Enlightenment modernity has been that the form of your work should both be and be legible as the figure or physiognomy of your personal truth, the emblem, symbol, echo, reflection, expression, or re-presentation of who and what you "are" or claim to be.

Plato's dilemma is, of course, our own today as well, for these are questions which go to the heart of what we understand art and religion to entail in their essence. Both phenomena evoke what is fundamental to each: the problem of the possibilities and impossibilities of representation as such. The most basic question around which both art and religion revolve is thus what an object or phenomenon may be said to be a witness to, what its connection to an imagined cause is.

As in fact Plato was poignantly aware in trying to project an ideal society that was more pure, more homogeneous, and more aesthetically coherent than the messy democratic experiments of his own contemporary city of Athens. Such phantasms continue to drive all forms of theocracy in their struggles against democracy in our own time, with predictably catastrophic effects everywhere.

What would be the prospects, then, for openly addressing what has been aptly called by Derrida the divine teleology that (we still argue today) "secures the political economy of the fine arts" in modern life?[25] If we take art as potentially calling attention to the contingency and situatedness of all projections alleging to be independent of their expression, including and above all "the sacred," then artistry and theology are more clearly revealed

as each other's shadow: contrary yet co-determined answers to the question of the (im)possibility of the representation of the real.

To speak of or to stage any art object is still commonly taken (and not only within the academic dramaturgy of art history) to speak of or to manifest its makers, or its time, place, circumstances of production, and reception. Your stuff is you. You are the ghost in its machinery. The negative side of such ideological faith is of course the very grave danger of equating directly or literally any person's or people's art (or indeed any kind of fabrication, from jewelry to the layout of olive groves to love poetry) as "truly" expressing or materializing that person's or people's "real" nature, a nature that is simultaneously projected as pre-existing its expression, existing above and apart from its "embodiments": for example, your messy front lawn must surely be an index of the disturbed nature of your mind.

The world will not recant its ceaseless diffusion, however strongly we attempt to unite (or to annihilate) difference with words or monuments insisting on some literal or indexical connection to truth, or as holy objects, sacred texts, or monumental objects of veneration, however much we may wish to perpetuate the essentially theological separation of form from content, expression from signification, origin from structure, intention from construction, thought from writing.

Our next Incursion engages with the social and ethical conditions of museums, where issues of identity are played out in the spectacle of the staging of objects for subjects, and the disciplining of the latter for and by the former.

Notes

1 "Buddhas of Bamiyan," at en.wikipedia.org/wiki/Buddhas_of_Bamyan (accessed Sept. 15, 2010).

2 "Submission" is the direct translation of the word "Islam" and the film portrays a Muslim woman beaten and raped by a relative. It was shown on the Dutch public broadcasting network (VPRO) on August 29, 2004. Recall the work of Iranian American artist Shirin Neshat, described and illustrated in the Second Incursion.

3 The bibliography concerning this and related (and enduring) controversies, affecting communities around the world – and leading in some places to death and destruction – is quite large. To date one of the clearest and most penetrating discussions anywhere of the issues involved took place at a conference at the Berkeley branch of the University of California in 2007, and was published

in 2009 as the second in the series of Townsend Papers in the Humanities as *Is Critique Secular? Blasphemy, Injury, and Free Speech*, with contributions by Talal Asad, Wendy Brown, Judith Butler, and Saba Mahmood (Berkeley: University of California Press, 2009). One of the key problems debated was the seemingly incommensurable divide between religious and secular interpretations of the controversy.

4 Talal Asad, "Free Speech, Blasphemy, and Secular Criticism," in *Is Critique Secular?*, 39ff., considers such differences between the two communities as partly related to distributions of power relations of class and gender.

5 Saba Mahmood, "Religious Reason and Secular Affect: An Incommensurable Divide?" in *Is Critique Secular?*, 64–100; and Wendy Brown, "Introduction," in *Is Critique Secular?*, 16–17.

6 The book to which they objected is Benedetta Cestelli Guidi and Nicholas Mann (eds.), *Photographs at the Frontier: Aby Warburg in America, 1895–1896* (London: Merrell Holberton, with The Warburg Institute, 1998). Claire Farago thanks Nicholas Mann, then Director of the Warburg Institute, for making the correspondence available and discussing the issues subsequently. We alone are responsible for the views presented on these issues. See, further, Claire Farago, "Epilogue: Re(f)using Art: Aby Warburg and the Ethics of Scholarship," in Claire Farago and Donna Pierce, *Transforming Images: New Mexican Santos in-between Worlds*, with additional contributors (University Park: Pennsylvania State University Press, 2006), 259–274, on which the following discussion of the Hopi case study is based.

7 Letter dated Jan. 29, 1999, addressed to Nicholas Mann as Director of the Warburg Institute.

8 Letter dated Jan. 29, 1999, addressed to Nicholas Mann as Director of the Warburg Institute.

9 Nicholas Mann, letter to Leigh J. Kusanwisiwma, Jan. 12, 1999. The authority to whom Mann referred is Armin W. Geertz, whose essay "Pueblo Cultural History" appears in Cestelli Guidi and Mann (eds.), *Photographs at the Frontier*, 9–19. Geertz had earlier published *Hopi Altar Iconography* (Leiden: Brill, 1987). Geertz relied on information, descriptive procedures, and vocabulary that are currently in contention. The contemporary reproduction of many of Geertz's photographs, taken from ethnographical reports by Jesse Fewkes and others published around the turn of the twentieth century, is strictly forbidden, not only by the Hopi Tribal Council but by institutions such as the School for American Research, Santa Fe, which houses *tablitas* and other ceremonial artifacts from the time that Geertz discusses. In all fairness to Geertz, who may justifiably feel caught in an ethical bind manufactured by institutionalized forms of power (including the Hopi Tribal Council), in the same year that he published his monograph on Hopi altars, published another book on Hopi religion co-authored with three Hopi individuals: Geertz and Michael

Lomatuway'ma, *Children of Cottonwood: Piety and Ceremonialism in Hopi Indian Puppetry*, illus. Warren Namingha and Poul Nørbo (Lincoln: University of Nebraska Press, 1987). Geertz studied the Hopi language extensively in order to translate Hopi texts into English, translations that were checked by native Hopi speakers.

10　Cestelli Guidi, "Retracing Aby Warburg's American Journey through his Photographs," in Cestelli Guidi and Mann (eds.), *Photographs at the Frontier*, 28.

11　See, further, the excellent collection of papers, Phyllis Mauch Messenger (ed.), *The Ethics of Collecting Cultural Property: Whose Culture? Whose Property?*, foreword by Brian Fagan, 2nd edn. (Albuquerque: University of New Mexico Press, 1999).

12　As presented by Ruth Phillips in her keynote address at the conference. Proceedings of the conference have been published as Jaynie Anderson (ed.), *Crossing Cultures: Conflict, Migration and Convergence: The Proceedings of the 32nd International Congress of the History of Art* (Melbourne: Melbourne University Press; Carlton, Vic.: Miegunyah Press, 2009). See also Ruth Phillips, "The Global Travels of a Mi'kmaq Coat: Colonial Legacies, Repatriation and the New Cosmopolitanism," in *Museum Pieces: Toward the Indigenization of Canadian Museums* (Montreal: McGill-Queens University Press, in press). As of December 2009, the Melbourne Museum agreed to lend the outfit to the Gloosecap Heritage Centre in Truro, Nova Scotia. As of this writing (Feb. 2011), there has been no announcement that the loan has taken place. Our thanks to the author for this update and for making her chapter available prior to publication.

13　The complexity of issues that repatriation raises is beyond the scope of our book. In our own personal communication with Michael Green, Head Curator of Indigenous Culture, Melbourne Museum, Melbourne, Dec. 11, 2008, the issue of whom to repatriate the object to was in contention. Phillips (as in the preceding note), discusses this and other grey areas that trouble repatriation processes, with specific reference to this case.

14　Vicki Couzens, "The Reclamation of South-East Australian Aboriginal Arts Practices," in Anderson (ed.), *Crossing Cultures*, 781–785.

15　Now part of the permanent display, National Museum of Australia, Canberra.

16　Tristan Weddigen, "Raphael and Stalin at the Museums: Dresden and the Soviet Restitution Policy" (unpublished MS). Weddigen did not publish his paper in the conference proceedings, but the research forms a coda to his forthcoming book on the Dresden Gallery in the eighteenth and nineteenth centuries.

17　Kavita Singh, "Repatriation *Ante Patria*: Repatriating for Tibet," in Anderson (ed.), *Crossing Cultures*, 1094–1099. She continues: "These acts are only part of a series of acts performed by the Tibetan exile community that, typically,

set out to do what would be normal and unremarkable in an ordinary country, but which become perverse, illicit or dangerous in the Tibetan case."

18 Irit Rogoff, *Terra Infirma: Geography's Visual Culture* (London: Routledge, 2000), 13, 10.

19 Plato, *Republic*, 2 vols., trans. Paul Shorey, Loeb Classical Library (Cambridge, MA: Harvard University Press, 1953), esp. 1:243–245; 2:464–465. Much of the bulk of the discussion is carried out in book 6, esp. at the end, with the consideration of the contrast between the intelligible and the visible (pp. 511ff.).

20 With regard to history, see Hayden White, "The Fictions of Factual Representation," in *Tropics of Discourse* (Baltimore: Johns Hopkins University Press, 1978), 121–134.

21 Heidegger, "The Origin of the Work of Art," in *Poetry, Language, Thought*, trans. A. Hofstadter (London: Harper & Row, 1971) ["Der Ursprung des Kunstwerkes," in *Einfuehrung von Hans-Georg Gadamer* (Stuttgart: Reclam, 1960, 1967)]. Friedrich Nietzsche, *The Will to Power as Art*, trans. D. F. Krell (London: Routledge & Kegan Paul, 1981).

22 Giorgio Agamben, *The Man without Content*, trans. Georgia Albert (Stanford, CA: Stanford University Press, 1999), 6.

23 Samuel Weber, "Piece Work," in R. L. Rutsky and Bradley J. Macdonald, *Strategies for Theory: From Marx to Madonna* (Albany, NY: SUNY Press, 2003), vii; see 3–22.

24 Judith Butler, *Frames of War: When is Life Grievable?* (New York: Verso, 2009), 44; Susan Sontag, *Regarding the Pain of Others* (New York: Picador, 2003).

25 Jacques Derrida, "Economimesis," trans. Richard Klein, *Diacritics* 11(2) (1981): 2–25, citing p. 5.

Further Reading

Talal Asad, Wendy Brown, Judith Butler, and Saba Mahmood, *Is Critique Secular? Blasphemy, Injury, and Free Speech* (Berkeley: University of California Press, 2009).

Judith Butler, *Frames of War: When is Life Grievable?* (New York: Verso, 2009).

Susan Sontag, *Regarding the Pain of Others* (New York: Picador, 2003).

Samuel Weber, "Piece Work," in R. L. Rutsky and Bradley J. Macdonald (eds.), *Strategies for Theory: From Marx to Madonna* (Albany, NY: SUNY Press, 2003), vii, 3–22.

Hayden White, "The Fictions of Factual Representation," in *Tropics of Discourse: Essays in Cultural Criticism* (Baltimore: Johns Hopkins University Press, 1978).

SEVENTH INCURSION
THE ART OF COMMODIFYING ARTISTRY

What are the implications for understanding the idea of art in socie-
ties where certain artifacts (museums) are instruments for interpret-
ing other artifacts? If anything might be content for a museum, could
anything then serve as a museum? And if museums commodify
everything from identity to cosmology, what of the artistry of that
commodification? Finally, what does the mutual entwinement of
artistry and commodity imply for engaging with the most funda-
mental questions about how societies should operate?

Museums and the Manufacture of Meaning

*If the walls of the museums were to vanish, and with them their labels,
what would happen to the works of art that the walls contain, the labels
describe? Would these objects of aesthetic contemplation be liberated to
a freedom they have lost, or would they become so much meaningless
lumber?*

Jonah Siegel, *Desire and Excess*[1]

For a very long time it has been a largely unquestioned assumption that
museums were by nature *representational artifacts*. It is widely assumed that
in their forms and in the arrangement of their contents they mirror (on a
smaller, partial, or fragmentary scale) the societies within which they are

Art Is Not What You Think It Is, First Edition. Donald Preziosi, Claire Farago.
© 2012 Blackwell Publishing Ltd. Published 2012 by Blackwell Publishing Ltd.

located, faithfully replicating or reconstructing social or cultural histories that at the same time are presumed to pre-exist their *re*-presentation. This idea – that a museum, a collection, or an archive is (or should be) an epitome or synecdoche of a fuller and pre-existing state of things (a microcosm of a pre-existing macrocosm) has nonetheless long been deeply problematic. It has been challenged not only by recent developments in art, technology, and science, but also and equally by the spread of museums to societies and cultures outside the European world, where local and indigenous ideas about the nature and functions of objects or artifacts, as well as ideas about production or fabrication and artistry itself, are often very different than those assumed as natural or universal within the dominant Western traditions in philosophy, science, art, and religion.

But even within that tradition, the diverse and often quite antithetical purposes to which the institution has been put suggests that, as with art, a museum is not what we have tended to think "it" is. And indeed, untying the packaging of the *what* of the museum, reveals the *when* and the *how* within. A museum is fundamentally a mode of staging and making palpable preferred relationships while endeavoring to manage how these are to be received. Things are framed, contained, and stage-managed so that their preferred legibility may be palpably visible. The stagecraft *is* the meaning and the index of a dramaturgy linked to explicit or unspoken political, social, cultural, religious, and economic histories, a dramaturgy we pantomime and perform in the choreography of our visiting. As a mode of artistry and artifice in its own right, a museum is simultaneously semiological and epistemological in function and purpose, and the significance of its "content" lies both in the nature of that content and in the system or mode of their orchestration and juxtaposition.

Placing Meaning

It is commonly assumed that museums stage or contain artifacts whose significance appears to lie *elsewhere* – in absent times or places, in the hidden or lost "intentions" of their producers, or in a past that is the projective summation of its fragments and relics preserved here and now in museum space. We assume that the chief function of historical or cultural museums has been to literally and materially *make present* (to evoke) the effects of causes that lie elsewhere. What is at stake, as we have argued elsewhere in a variety of contexts, is the maintenance of an ontological

distinction separating formation and signification: *form* and *content*, signi-fication and its "expression" or *re*-presentation.

This distinction is built into the semiotic structure of our languages and forms of social behavior and discourse: we commonly speak of the impact of certain events as having implications for the next stage of an individual or collective journey or struggle toward some form of enlightenment or social justice. It's difficult to extricate ourselves from conflating or confus-ing teleology and effect. We are trained to render the visible legible, to *read* the spirit or soul in the physiognomy of things and events. Time is pre-sumed to have a real "shape," and things are believed to "have" or to "contain" meanings which might be made explicit or revealed by careful reading and analysis.[2] As archaeologists, anthropologists, art historians, or museum personnel we spend years or even lifetimes disciplining ourselves in the practice of a certain *divination*, a kind of intense *augury* in interpret-ing events as bearing traces not only of their past but of some likely future as well.

Managing Ambiguity

The underlying problem with construing museums as representational instruments has been especially evident in displays of cultural artifacts. The stories of cultures are told on the basis of the presumed *adequacies or inadequacies of their manufactured artifacts*. These are broadly construed to include forms of government, social organizations, religion, and habits, or mores. But the evidence is mainly in the form of objects – material evidence that comes without labels or explanations. The chances of misinterpreta-tion under these circumstances are considerable. So it is necessary here to consider the fundamental problem of the *artifice* of museums and museol-ogy: the interpretive mechanisms, archiving practices, aims, functions, dilemmas, and conundrums that are woven into the institution. We use the term "artifice" to refer, simultaneously, to two contradictory notions: (1) fabrication or production in the most general sense; and (2) falseness or deception. Objects or artifacts in museums – as well as museums them-selves *as* artifacts or examples of artifice and artistry – are by nature inher-ently ambiguous for this reason. Museums function above all to manage ambiguity by masking it as cultural determinism; or rather, as examples of artifice, museums function duplicitously *to appear as if* they are managing ambiguity, by disciplining visitors to see and understand in particular ways.

Nativism in Wellington (Te Papa Tongarewa)

Currently, there are two prominent but contested models for understanding culture and cultural property in academic writing, and these same models are utilized widely to motivate and organize museum displays, to debate social issues in the media, and to establish government policies. One model is dependent upon neo-liberal notions of diversity, hybridity, and migratory and transitory identity. The other, which might be termed a nativist model, emphasizes social cohesion, and the permanence and persistence of individual and group identity. Judging from the repetitious nature of the debates, these two models of multiculturalism present deeply incompatible and mutually exclusive alternatives. Less evident is the *oscillation* between them: being wedded to one model or the other renders its other dim or invisible, the effects of which form the basis for the following discussion.

Cultural anthropologist Nicholas Thomas endorses a nativist position for its *political effectiveness* in promoting cultural pride and civil rights. Arguing that the same anthropological theories are heard differently when they are used by what he called "First World" and "Third World" peoples, Thomas describes the success of two traveling exhibitions of Maori culture. The exhibitions' "radical aesthetic decontextualization" excluded European influences of all kinds, yet the theoretical interest of this self-presentation lies in its reproduction of anthropological systematizations.[3] Thomas is sympathetic to the transformation of such discourses to suit native positions; nativist consciousness, he argues, cannot be deemed undesirable merely because it is ahistorical and uncritically reproduces colonialist stereotypes. Colonialist stereotypes and essential differences have *different meanings at different times for different audiences*. By promoting the legitimacy of Maori culture at a time when it was not widely respected by the dominant population, the New Zealand exhibition *Te Maori* involved "mobilization": it capitalized on white society's idea of "the primitive," that is primitivism, and created for the Maori a degree of prestige and power that did not exist before the 1980s.

In other words, in nativist discourse (of the kind Thomas discusses), essentialism arguably plays a progressive role in forming a self-determined (or at least self-named) national identity that can be appreciated only in its *performative* realm. In New Zealand today, over two decades after the *Te Maori* exhibition, the federal government has officially adopted a "bicultural

model" of national identity that recognizes a certain synthetic Maori identity alongside that of settlers. This federal fabrication of the nation's indigenous heritage is presented to the Maori as their own construction – and yet the representation is problematic. Meaning is indeed always determined by context – and strategic essentialism in the hands of the government simultaneously becomes a disciplining instrument.

To brand Maori presence today as unified and homogeneous continues to impose settler perspectives on otherness that originated in the colonial era – European settler perspectives that erase, collapse, or override palpable distinctions between native social and cultural communities. At stake for the Maori, as for Australian Aboriginal groups, the Indians of North and South America, the Tibetans, the Palestinians, and many other indigenous people, has been the maintenance of land and property rights (and the maintenance and transmissibility of esoteric knowledge) in ways that might be effectively "heard" by settler governmental powers. In New Zealand, what is at stake for the official governmental construction of a bicultural model of national identity based on coherence and unity, longevity and persistence, is control of Maori peoples *in their own name*.

Similar conditions have of course persisted elsewhere, for example in the co-option of indigenous forms of self-representation in Central and South America during the Spanish Viceregal era. The *casta* paintings of the seventeenth and eighteenth centuries exemplify the way that colonists at the upper end of the social system reconfigured actual cultural and ethnic diversities by picturing the daily lives of people of lower social status who differ from one another (and from their European and elite creole viewers) in terms of their shades of skin color, costumes, domestic settings, and behavior (Figure 7.1). An abbreviated version of the customary series of 16 scenes combined in a single panel illustrated here includes depictions of local flora and fauna, daily pastimes, and a Virgin of Guadalupe over-painted on the panel top front and center. The combination suggests that this work was intended as a souvenir for a tourist or traveler, a keepsake of all that made New Spain unique and memorable lumped into one portable, virtual curiosity cabinet.

The continuing thread from Viceregal Spain to contemporary New Zealand is the discounting of indigenous forms of self-representation in favor of a mega-category of otherness within which differences are classified according to scientific taxonomies and epistemologies that originated in sixteenth-century European cultural geographies and other scientific literature. The problems entailed in the bicultural paradigm at the Te Papa

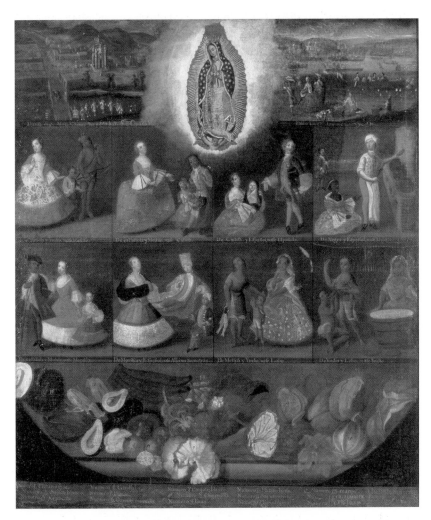

Figure 7.1 Luis de Mena. *Casta Painting*, ca. 1750. Oil on canvas. Collection Museo de America, Madrid. Photo courtesy of the museum.

Tongarewa Museum in Wellington is perhaps most clearly apparent in its museum stagings of Maori others such as Scots settlers wearing kilts, Italian settlers eating pasta, and so forth – wherein national culture stereotypes mirror the representation of Maori identity as a homogeneous culture with recognizable traits and traditions (Figures 7.2 and 7.3). Meanwhile, in the same museum, rather short shrift is given to "mixed" ethnic identities – only a very small display is devoted to Pacific Islanders

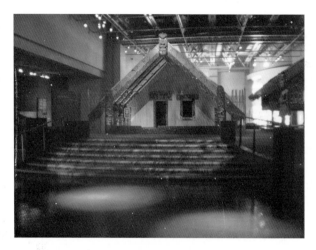

Figure 7.2 Installation view of the Maori Meeting House, Sept. 2008. Te Papa Tongarewa Museum, Wellington, New Zealand. Photo Claire Farago.

Figure 7.3 Installation view of the Waitanga Treaty display, Sept. 2008. Te Papa Tongarewa Museum, Wellington, New Zealand. Photo Claire Farago.

who have intermarried either before or after arriving in New Zealand. Asian immigrants – settlers of recent origin – are not represented at all, and issues of cultural hybridity are skirted. Clearly, this is biculturalism based on a nativist model that originated as the critical inversion of a Eurocentric understanding of cultural identity and evolved into the state's representation of the nation's multiracial heritage.

Eurocentric schemes of cultural identity may be globally disseminated, but they are always locally staged. From place to place, the effects can seem contradictory; the historian or critic's job is to understand the epistemologies or structural logic that drive them. For example, the lack of hybrid models of multiculturalism that typify museums and popular culture in Australasia may at first seem perplexing or undertheorized to someone familiar with Euro-American discussions of complex collective identity. In Australia where the historical situation is different from New Zealand, the historical backdrop includes colonialist miscegenation policies. These were based on the explicit assumption that the "native blood" of "savages" could be "bred out" of the population through intermarriage. Naturally, the hybrid model of ethnic identity resonates very differently against this background – cultural sensitivities are entirely different, owing to different historical events leading up to the present.

Even without such a colonial policy, the idea of genetic survival translates differently in countries where indigenous people have not been alienated from their lands, where people are trying to hold onto their cultural heritage, often by revitalizing traditions effaced by colonial policies of assimilation in ways that fit the contemporary world.[4] However, when the state-funded Te Papa Tongarewa Museum features a documentary film about a red-haired, blue-eyed individual of Maori descent smilingly "getting in touch with her Maori roots," much more is involved than acknowledgment of indigenous ancestry and self-determination in contemporary society. There is also the explicit erasure of an individual's multi-ethnic, complex cultural heritage (whatever that might be). And the same erasures exist elsewhere – in Australia, in the United States, in many formerly colonized parts of the world. Indeed, wherever indigenous peoples are trying to advance their rights, the complexities of cultural heritage tend to get reduced to struggles between the nation-state and indigenous groups seeking sovereignty. In New Zealand, however, where the government itself adopted a bicultural model, this reductive scheme was widely criticized as an institutional accommodation of diversity that does not adequately address the possibility of Maori models of self-determining autonomy.

Bi-nationalism, by contrast, entails constitutional changes and genuine power sharing. Should cultural distinctiveness be a condition of sovereignty at all?[5]

Museums as Other than Representational Artifacts

Neither the nativist model of "strategic essentialism" nor the neo-liberal model of cultural hybridity work to create what Homi Bhabha called an "interstitial space" that actively accommodates nativist resistance without romanticizing or otherwise appropriating it. It is time to make visible the broader conceptual framework in which the debates over cultural identities and cultural properties are conducted. A compromise is not likely between what are broadly perceived and promoted as mutually exclusive models, as the example of the Te Papa Tongarewa Museum display suggests. Is there a way beyond the current impasse in cultural theory or are we doomed to keep orbiting forever around European ideas of art, culture, and ethnicity?[6]

Contradictions are inherent in both multiculturalist models currently in play because, on the one hand, equalizing the content of cultures articulated as homogeneous, independent historical trajectories cannot solve the underlying problem of a racial(ized) theory of collective identity. And on the other hand, a hybrid model is uncompelling to those who identify with their traditional cultural memories and places. The diaspora model of cultural identity is emphatically rejected by peoples whose collective identities are physically tied to ancestral territories and whose cultural memory reaches back eons.

How then, are institutionalized structures of governing/being governed to be reconfigured? While the governing structure of the state-run Te Papa Tongarewa included Maori administrators and advisers, as the Museum's Curator of Art Jonathan Mane Wheoke (who is Maori) told us, the structure is cumbersome: the separate departments of the museum operate like individual "silos."[7] The innovative installation of the art collection is undermined by a lack of funding for staging the display, in stark contrast to the $6 million interactive digital exhibition of New Zealand, complete with Google map underfoot, touch-screen ephemeral displays, and amusement park rides. This museum prides itself on its shopping mall/infotainment mode of educating viewers (Figure 7.4).

Could we imagine a different model of identity that recognizes that individuals and groups can have several identities simultaneously? Such a

Figure 7.4 *OurSpace*. Installation view: (*a*) exterior; (*b*) interior, Sept. 2008. Te Papa Tongarewa Museum, Wellington, New Zealand. Photo Claire Farago.

model of identity as multiple, diverse, and incommensurable puts into question the lingering essentialist assumptions in current museum display practices, in the social issues debated in the media, and in existing governmental policies – namely, that each individual or collective identity has to be distinctive and *singular* – a notion at once metaphysical and juridical.

Embracing Artifice in Denver

A recent attempt to rethink and restage museum subject–object *encountering* was an exhibition mounted at the Denver Art Museum's new Hamilton Building, a titanium-clad structure opened in 2006 and designed by Daniel Libeskind, situated in seemingly antagonistic confrontation with the older, rather fortress-like building of 1971, designed by Milanese architect Gio Ponti and clad with gray ceramic tiles (Figure 7.5). The exhibition, called *Embrace!*, opened in November 2009 and closed six months later.[8] It was organized by Christoph Heinrich, the new director of the museum, previously Curator of Modern and Contemporary art at the Hamburg Kunsthalle – an institution and building which was a quintessential "white cube" museum, to which Libeskind's Denver museum was a response and self-conscious antithesis.

The cross-section diagram indicates the functional divisions originally allotted to the museum's uniquely shaped galleries (awkwardly shaped, in the view of many when the museum opened in 2006) (Figure 7.6), but when Heinrich was appointed Mark Addison Curator of Modern and Contemporary Art in Denver, he evacuated virtually the entire Libeskind-designed building and turned it over to 17 commissioned artists from Europe, North America, Africa, and Asia to radically reimagine the museum's spaces and create diversely interactive possibilities for viewing, using *all* of the building's galleries (Figure 7.7). All of the individual site-specific works, many of which occupy more than one enclosed gallery space and in several cases occupy and visually link together more than one floor, were, like many recent installations elsewhere, designed to problematize the con-

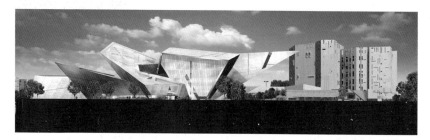

Figure 7.5 Denver Art Museum: (*left*) Daniel Libeskind, architect, Frederic C. Hamilton Building, 2006; (*right*) Gio Ponti and James Sudler, Associates, architects, North Building, 1971. Photo Studio Daniel Libeskind (SDL)/Miller Hale, Ltd., 2011.

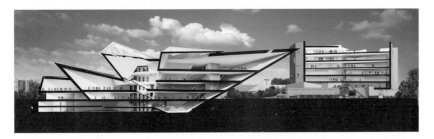

Figure 7.6 Denver Art Museum: cross section of Hamilton and North Buildings. Photo Studio Daniel Libeskind (SDL)/Miller Hale, Ltd., 2011.

Figure 7.7 Installation view of *Embrace!*, Nov. 2009. Denver Art Museum. Photo Donald Preziosi.

frontational encountering of conventional exhibitions. It was an explicit attempt to address Libeskind's artifice with a series of encounters, utilizing community members and museum and art professionals in a series of events that were intended to (and did) evolve over time and use.

In contrast to the Kunsthalle in Hamburg and many other institutions, *Embrace!* was co-organized by curator and artists to foreground the museum's own artifice in multiple dimensions using very diverse means

and materials, incorporating or embracing multiple perspectives, materially and virtually, on and with artistry. *Embrace!* highlighted the potential for diversely choreographic engagements by audiences enacting the complex topography of the building, incorporating the artifice of spectatorship itself into the dramaturgy of experiencing Libeskind's artifice as offering an expansive potential for multiplied agencies – the agencies of the artists who selected their own exhibition spaces, the agencies of the viewers who watched the installation of the exhibition as part of the exhibition and later interacted with the installations (Figure 7.8). *Embrace!* earnestly sought to render the effects of the art and its staging open to reappropriation by routines of using and construing that may be at odds with what the architect, the curator, or the artists may have intended.

The situatedness of this exhibition within the museum raises subtle questions – everything is still tightly controlled, as it is in the conventional white cube, but the liberties that *Embrace!* took in playing with the structure is exactly in line with Derrida's notion of signification and play.[9] It offers a non-authoritarian model of learning and social engagement within the museum conceived as both an educational institution and a pleasurable pastime or leisure activity. If more exhibitions tried such strategies, would the museum be a more ethical institution? Can infotainment be a good thing?

Figure 7.8 Tobias Rehberger, *Bert Hölldobler and Edward O. Wilson in the Rain*, 2009 showing young viewers interacting with the sculpture. Installation view of *Embrace!*, 2009. Denver Art Museum. Photo Jeff Wells.

The Artistry of Commodifcation/The Commodification of Artistry

"Some museum shops are strictly limited to the basics: catalogs, a few prints, and postcards. But we have more leeway here, so I try to find a range of exclusive but interesting and useful products," she said, gesturing toward a display of bracelets, pendants and earrings made of natural horn carved in swirls and vine patterns (47.20 to 118 euros). "I see these beautifully crafted accessories and I'm instantly 'feeling Giovanna.'" For as little as 4.80 euros the adorable knit Giovanna finger puppet can keep you company on the flight back home.
Andrew Ferren, "Renaissance Portrait Inspires Gift Shop Goods"[10]

Art is not what you think it is because what you think it is is largely staged within a framework that erases the traces of its own artifice. We are virtually universally exhorted to engage with artworks without distraction, as if imagining a direct and unimpeded confrontation between an ideal singular subject and a unique imaginary object. We have shown that this is a staged juxtaposition of two fictions. Art always necessarily functions between the poles of autonomous (or absolute) art and distinct or absolute commodity: two co-constructed fictions. The practices of some contemporary artists have focused directly on this sleight of hand practiced in the oscillation between those two fictions, autonomous art and absolute commodity. They demonstrate that the mechanisms for ascribing value to unique art objects and those governing the exchange value of other commodity forms are fundamentally indistinguishable.

Artists Neil Cummings and Marysia Lewandowska, for example, examined the social role of art and other objects in the definition and fabrication of cultural values, in a series of projects that treat analysis and interpretation as artistic products equal to display and exhibition. In their book *The Value of Things* (2000) they compared art and money as two symbolic systems, portraying the long history of convergence between the art museum (or gallery) and the department store as a defining chapter in the modern dissolution of previously clear (or clearly imagined) demarcations between the cultural and economic (Figure 7.9). "Value," they argue, far from being inherent in things, depends on "judgments made through encounters" that people have with their things at specific times and in specific places. They focus upon the two quintessentially modern institutions

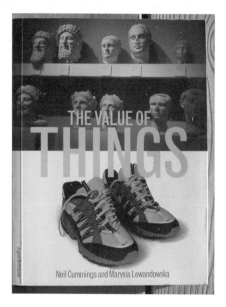

Figure 7.9 Book jacket, Neil Cummings and Marysia Lewandowska, *The Value of Things* (Basle: Birkhäuser; London: August Media, 2000). Photo courtesy of the publishers.

that occupy privileged sites within the social organization of contemporary society: the art museum and the department store. Each in its own way *renders the fundamental similarities and redundancies with the other invisible*. Cultural practice in modernity comprises at base participation in "all the glitter of the intensified aesthetic present."[11]

In commodity cultures art is an illusion mobilized to mask another illusion. In this contemporary hall of mirrors, art functions at best as a blunt and domesticated instrument within the social totality. The hope that Nicolas Bourriaud's relational aesthetic theory strove to offer was the potential role of art to create a collective subjectivity that is neither subsumed into the model of capitalist economy, nor limited to a reductive concept of society as a harmonious whole.[12] Yet in one form or another this and similar utopian fantasies have been the dream of avant-gardism throughout the twentieth century. Such a hope of configuring society as (an aesthetic) whole is as ancient as Plato's projection of an ideal city – harmonious only in relation to a central, autocratic I/eye, like the Renaissance image of the ideal city discussed at beginning of this book, or Jeremy Bentham's carceral panopticon centuries later.

We began this manifesto with a reference to a wall-text of the 2010 exhi-bition *Les Promesses du passé* ("The Promises of the Past") at the Centre Pompidou in Paris about the idea of art being to change and improve the world. The author of the first manifesto in this series, Terry Eagleton, in reviewing Eric Hobsbawm's book *How to Change the World: Marx and Marxism 1840–2011*, recently noted that "The [*Communist*] *Manifesto* initi-ated a whole genre of such declarations, most of them from avant-garde artists such as the Futurists and the Surrealists, whose outrageous wordplay and scandalous hyperbole turn these broadsides into avant-garde artworks in themselves."[13] The potential of a political manifesto to trouble accepted beliefs appeared to be blunted by consciousness of its own artistry: When the artifice becomes dominant, what happens to the political efficacy of the gesture? To what extent is the efficacy of a political manifesto the product or effect of its artistry or rhetorical stagecraft? If the artifice of a work is in *dominance*, what exactly is subordinated in function? The implication here is that a work may have multiple facets or functions, even simultaneously.

What effect would that have on how a work is to be interpreted? What guarantees the truth of a work? This is a conundrum concerning represen-tation and representability that we've looked at in a variety of ways in the incursions above and to which we now return in the context of current debates.

Confronting the Contemporary Return to Aesthetics

Attention to the increasing *self-referentiality* of artistic practices in the 1970s led prominent critics and theorists such as Rosalind Krauss to argue for a more nuanced understanding of the structural logic of how artworks were being produced and received. The logic of indexicality, a concern with the index as a physical trace, played a significant role in these debates, as did that modern emblem of indexicality, the photographic image. As the physical trace of a past presence, its literal manifestation, the photograph is at the same time uncannily opaque with respect to its meaning: its sig-nificance is deferred and interpretation is rendered indeterminate. The problems of the index and of the position of the artwork in relation to *how* it means or how it appears to offer itself for interpretation remain central to the debates about art in a number of fields over the past several decades.

Yet the articulation of such problems, we argue, has itself been opaque with respect to what we have elaborated upon in some detail above, namely

the structural logic of the theology that was its historical substrate, in relationship to which modernity's dream of "secularity" and art's autonomy was founded.

Jacques Rancière for one has called for a richer and more complex understanding of the history of aesthetics than that offered by the modernist notion of the autonomy of art dominating debates about the relationship of art to the commodity from Benjamin to Adorno to Greenberg to the critical literature on these figures. Rancière refers to a nostalgic dream haunting this "aesthetic regime" of modernity since the mid-nineteenth century for a *non*-referential, "eucharistic" sign, a sign that is identical to its referent.[14] The logic of indexicality articulated by Krauss and others in relation to the self-referential artwork of the 1970s was symptomatic of a similar dream of a non-referential sign.[15] What was at stake in those discussions was a method of grounding the authority of the work, and the apparent artlessness of the photograph, its transfer of nature "without" human intervention, was a poignant emblem of its own truth.

The question of what guarantees the truth of an image resonates with the emergence of modern scientific notions of the truth of objectivity, as Galison and Daston have recently argued in tracing the evolution of the universal ideal of truth to nature though historical stages from granting a central role of the author through a belief in an automatic transfer of nature to the page without the intervention of an author (in the early nineteenth century), to the growing recognition in the early twentieth century of a need for the judgment of experts to interpret "raw" data.[16] Some of this resonates with Foucault's discussions of the historical evolution of notions of authorship, but it also recalls the problems of the role of the artist in Early Modern discussions of the "truth" of sacred images. It also resonates with the problem of the relic as an *index*, as manifesting a direct connection with the past presence of a sacred person: an artless artistry.

We've argued that the Christian ontology of images not yet accounted for in our contemporary discourse on imagery imposes on it the structural logic of an *evacuated theology*. Central to that is the omniscient eye and mind of the ideal or divine guarantor of meaning in traditional theology, today *internalized into and as the structural mechanics of the system*, its enabling voices (authors, critics, historians) seeming to speak on its margins. This is the nostalgic, eucharistic dream that Rancière argues haunts the modern regime of art and aesthetics. The dream of a lost anchoring. A dream also of an artless art, the evocation of the problem of the authority of the artistic image. This suppressed or evaporated history has an inverse

relation to our understanding of art as "secular," where we are presumed to be drifting in an endless sea of semiosis.

The powerful articulations by Krauss and others of the logic of indexicality recalls the linguistic, semiological, and epistemological contexts in which such articulations grew and flourished. One of the most influential of those was the multifunctional paradigm of communicative activity first articulated some four decades ago by Roman Jakobson, wherein *a focus on the processes of signifying itself* constituted the poetic or aesthetic *function* of communication. The crucial point is that this always exists in a topological matrix of other co-present functions (phatic, aesthetic, exhortatory, referential, emotive, etc.), each in varying degrees of prominence or domination in a given instance.[17] Which comes down to an appreciation of art-making as a particular *mode of social behaving with respect to things*, as an awareness on the part of individuals of the artifice of their own practice.[18]

Reckoning with Things

If an artwork may be understood contextually as anything having an aesthetic function *at certain times and in certain places for certain individuals and groups for particular purposes*, then any such function is itself fluid, relational, shifting, present or absent, potent or subdued, depending on the particular conditions of its staging. The work of Danish/Icelandic artist Olafur Eliasson is especially noteworthy in this regard in encouraging self-reflexive examinations on the part of spectators of the processes of perception and their interconnected social, cultural, and metaphysical assumptions (Figure 7.10). The artist functions as a discourse enabler, playing with the dialectical engagement of the two poles of the subject as originary center of meaning and the notion that meaning exists prior to the subject and is mediated by language.

Eliasson's studio, consisting of nearly three dozen individuals in a laboratory setting of fabricators, architect/designers, discourse workers, and art historians, is anti-hierarchical in its distribution of polyphonic encounters between various fields of knowledge and scientific inquiry. This sets it apart from the factory production style of Murakami, Koons, and many others.[19] Eliasson plays deliberately on and with this paradoxical subject position, *ostensifying* the artifice of the dichotomy between "team-member" and "brand anchor" or voice of the studio.

Figure 7.10 Olafur Eliasson (Danish, b. 1967). *Dufttunnel* ("Scent Tunnel"), 2004. Stainless steel, motors, ceramic pots, soil, yellow wallflower, horned violet, and sage. Installation view, Autostadt GmbH, Wolfsburg, Germany, 2004. Photo courtesy Camilla Kragelund on behalf of Olafur Eliasson.

Which comes down to foregrounding art-making as a particular *mode of social behaving with respect to things*, as an awareness on the part of individuals of the artifice of their own practice. An alternative to "identitarian" versions of the self exists when we recognize the incommensurability between cultural worlds as a challenge in cultural translation that sets out to create a *third or interstitial space* where some level of exchange can flow without negating the private beliefs and self-represented identities of indigenous groups. In such a third space, the familiar Western discourse on the senses of sight and touch reveal themselves as but one specific manner of speaking about the highly complex interactions of material mind and body with their environment among the senses in any art-making process – as Caroline Jones has investigated recently in *Sensorium*.[20]

We join others in imagining an idea of art of the future as embodied knowledge practice that is flexible and susceptible to further rearticulation and redefinition. Articulating art-making practices as embodied forms of cognition will not in itself solve the dilemmas of the current commodified art system. But such a reconceptualization of what art does and *what that*

doing itself does, offers a responsible way forward on many fronts. Our prime responsibility in this "manifesto" was to link museology, history, theory, and criticism more strongly to the realities of contemporary social conditions, and to show how such links have structurally functioned in a variety of contexts. Unless our museologies and art histories are linked explicitly to the oldest and most fundamental questions of how our societies should be run – and how societies that value human freedom in particular might be structured – they will remain, wittingly or not, facets of the corporatized aestheticism of identity politics and the globalized industries of infotainment and edutainment whose most basic aim, as we've always known, is containment and pacification.

Art is indeed not what you (or we) *think* it is: the fundamental indeterminacy of artifice, as argued throughout this book, makes any claim about art's essence no mere benign parochial fiction.

Notes

1 Jonah Siegel, *Desire and Excess: The Nineteenth-Century Culture of Art* (Princeton, NJ: Princeton University Press, 2000).

2 As George Kubler, *The Shape of Time: Remarks on the History of Things* (New Haven, CT: Yale University Press, 1962), famously posited.

3 Nicholas Thomas, *Colonialism's Culture: Anthropology, Travel and Government* (Princeton: Princeton University Press, 1994), 184. This portion of the Incursion is an extension of our jointly authored essay, "Preface: Culture/ Cohesion/Compulsion: Museological Artifice and its Dilemmas," *Humanities Research*, special issue: "Compelling Cultures: Representing Cultural Diversity and Cohesion in Multicultural Australia," ed. Kylie Message, Anna Edmundson, and Ursula Frederick, 15(2) (2009): 1–9. We thank Kylie Message for the initial invitation, which developed out of a workshop presentation we gave at the Australian National University, Canberra, Nov. 7, 2008, for the opportunity to rethink museological practices in a cross-disciplinary, international setting outside the Euro-American axis. This has been important to the formation both of this Incursion and of the entire book.

4 The literature on nativist response is extensive, but for an excellent introduction, see Michael F. Brown, *Who Owns Native Culture?* (Cambridge, MA: Harvard University Press, 2003); and, with respect to museum practices, Phyllis Mauch Messenger (ed.), *The Ethics of Collecting Cultural Property: Whose Culture? Whose Property?* (Albuquerque: University of New Mexico Press, 1989). Many of the same issues have arisen in the American Southwest: see Claire Farago and Donna Pierce et al., *Transforming Images: New Mexican*

Santos in-between Worlds (University Park: Pennsylvania State University Press, 2006). On the complex relationship between peninsulares, creoles, and indigenous subgroups in Latin America, see Walter D. Mignolo, *The Idea of Latin America* (Oxford: Blackwell, 2005), in the same Manifesto series as the present volume.

5 For an excellent history of the issues, see Roger Maaka and Augie Fleras, "Sovereignty Lost, Tino Rangatiratanga Reclaimed, Self-Determination Secured, Partnership Forged," in *The Politics of Indigeneity: Challenging the State in Canada and Aotearoa New Zealand* (Dunedin: University of Otago Press, 2005), 97–155, which also includes the UN Working Group on Indigenous Peoples' definition of indigeneity (29ff.), which is paraphrased above. Sam Deloria, "Commentary on Nation-Building: The Future of Indian Nations," *Arizona State Law Journal* 34 (1) (2002): 53–61, puts the issues in these stark terms, regarding Native North Americans' claims for sovereignty.

6 As asked by Gayatri Chakravorty Spivak, *A Critique of Postcolonial Reason: Toward a History of the Vanishing Present* (Cambridge, MA: Harvard University Press, 1999).

7 Personal communication, with Jonathan Mane Wheoke, Sept. 30, 2008.

8 The two-volume Denver Art Museum catalogue, Christoph Heinrich (ed.), *Embrace!* (Denver: Denver Art Museum, 2009), recorded both the exhibition itself and the processes of collaboratively constructing and mounting the 17 exhibits.

9 Jacques Derrida, "Structure, Sign, and Play in the Discourse of the Human Sciences," in *Writing and Difference*, trans. and intro. Alan Bass (Chicago: University of Chicago Press, 1978).

10 *New York Times*, Travel Section (Sept. 5, 2010), p. TR2, quoting Ana Cela, director of the Thyssen-Bornemisza Museum shop in Madrid.

11 Neil Cummings and Marysia Lewandowska, *The Value of Things* (Basle: Birkhäuser; London: August Media), 23.

12 Nicolas Bourriaud, *Relational Aesthetics*, trans. Simon Pleasance and Fronza Woods with Mathieu Copeland (Dijon: Les Presses du Réel, 2002).

13 Terry Eagleton, "Indomitable," *London Review of Books* 33(3) (Mar. 3, 2011): 14, reviewing Eric Hobsbawm, *How to Change the World: Marx and Marxism 1840–2011* (London: Little, Brown, 2011).

14 Jacques Ranciere, *The Future of the Image* (London: Verso, 2009).

15 See discussion in our Preface, with references, p. xi–xii and n. 3.

16 Lorraine Daston and Peter Galison, *Objectivity* (New York: Zone Books, 2007).

17 Roman Jakobson, "Closing Statement," in T. A. Sebeok (ed.), *Style in Language* (Cambridge, MA: MIT Press, 1960), 350–377, esp. p. 357; discussed in D. Preziosi, *Rethinking Art History: Meditations on a Coy Science* (New Haven: Yale University Press, 1989), 149–152.

18 Or, with respect to the absence of things, itself an acknowledgment of presence though its absence.

19 On Eliasson, see also Caroline Jones, "The Server/User Mode"; Weibel (ed.), *Olafur Eliasson, Surroundings/Surrounded*; and Max Boersma, "Discourse, Metadiscourse, Exchange: Analyzing Relations between Art Historians and Living Artists," honors thesis, University of Colorado (2010). Eliasson works as part of a collaborative community of fabricators, critics, historians, researchers, and publicists (Studio Eliasson). It is a situation which nonetheless leaves Eliasson himself *intact* as the "central point through which all information must pass," as Jones remarks (p. 321), perhaps not unlike the grand masters of early modern European painting, such as Raphael or Michelangelo in their studios.

20 Caroline Jones (ed.), *Sensorium: Embodied Experience, Technology, and Contemporary Art* (Cambridge, MA: MIT Press, 2006), esp. her lead essay, "The Mediated Sensorium," 5–49, with extensive bibliography.

Further Reading

Homi Bhabha (ed.), "Editor's Introduction: Minority Maneuvers and Unsettled Negotiations," *Critical Inquiry*, special issue: "Front Lines/Border Posts," 23(3) (1997): 431–459.

Homi Bhabha, *The Location of Culture* (London: Routledge, 1994).

Michael F. Brown, *Who Owns Native Culture?* (Cambridge, MA: Harvard University Press, 2003).

Dipesh Chakravarty, *Provincializing Europe: Postcolonial Thoughts and Historical Difference* (Princeton, NJ: Princeton University Press, 2000).

Frank Donohue, *The Last Professors: The Corporate University and the Fate of the Humanities* (New York: Fordham University Press, 2008).

Claire Farago and Donald Preziosi (eds.), *Grasping the World: The Idea of the Museum* (London: Ashgate, 2004).

Henry A. Giroux, *The University in Chains: Confronting the Military–Industrial–Academic Complex* (Boulder, CO: Paradigm, 2007).

Margaret T. Hodgen, *Early Anthropology in the Sixteenth and Seventeenth Centuries* (Philadelphia: University of Pennsylvania Press, 1964).

Ilona Katzew, *Casta Painting: Images of Race in Eighteenth-Century Mexico* (New Haven, CT: Yale University Press, 2004).

Stephanie Leitch, *Mapping Ethnography in Early Modern Germany: New Worlds in Print Culture* (Basingstoke: Palgrave Macmillan, 2010).

Roger Maaka and Augie Fleras, *The Politics of Indigeneity: Challenging the State in Canada and Aotearoa New Zealand* (Dunedin: University of Otago Press, 2005).

Janet Marstine (ed.), *New Museum Theory and Practice* (Oxford: Blackwell, 2006).

Phyllis Mauch Messenger (ed.), *Whose Culture? Whose Property?* (Albuquerque: University of New Mexico Press, 1999).

Walter D. Mignolo, *The Idea of Latin America* (Oxford: Blackwell, 2005).

Bill Readings, *The University in Ruins* (Cambridge, MA: Harvard University Press, 1996).

Chris Shore, "Beyond the Multiuniversity: Neoliberalism and the Rise of the Schizophrenic University," *Social Anthropology* 18(1) (2010), special issue, "Anthropologies of University Reform."

Moira Simpson, *Making Representations: Museums in the Postcolonial Era* (London: Routledge, 1996).

Samuel Weber, *Institution and Interpretation, expanded edn.* (Stanford: Stanford University Press, 2001).

INDEX

Page numbers given in *italic* refer to illustrations.

Art Is Not What You Think It Is, First Edition. Donald Preziosi, Claire Farago.
© 2012 Blackwell Publishing Ltd. Published 2012 by Blackwell Publishing Ltd.